ARCHITECTURAL DRAWING COURSE

Mo Zell

ARCHITECTURAL DRAWING COURSE

A QUARTO BOOK

First edition for North America
published in 2008 by
Barron's Educational Series, Inc.

All inquiries should be addressed to:
Barron's Educational Series, Inc.
250 Wireless Boulevard
Hauppauge, NY 11788
www.barronseduc.com

Library of Congress Catalog Card No.:
2007941877

ISBN-10: 0-7641-3814-6
ISBN-13: 978-0-7641-3814-0

QUAR. ADE

Conceived, designed, and produced by
Quarto Publishing plc
The Old Brewery
6 Blundell Street
London N7 9BH

Senior Editor Liz Dalby
Copy Editor Ilona Jasiewicz

Art Director Caroline Guest
Designer Karin Skånberg
Photographer Evan Witek
Picture Research Claudia Tate

Creative Director Moira Clinch
Publisher Paul Carslake

Colour separation by Modern Age
Repro House Ltd., Hong Kong
Printed by Toppan Leefung Printing
Limited, China

9 8 7 6

Contents

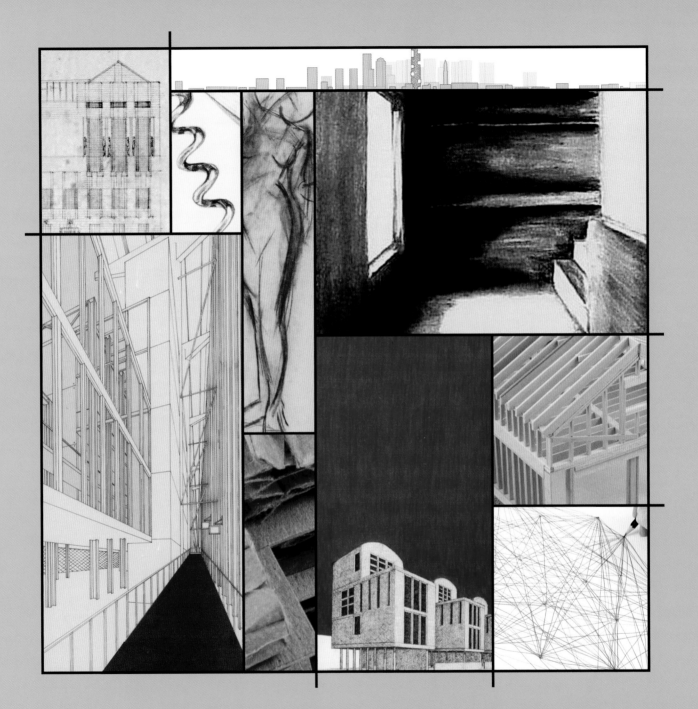

Foreword

Architecture is an intellectual and physical endeavor. That is, architecture is the amalgamation of intention (idea) with iteration (the process of problem solving with each investigation building upon the preceding one) manifest in a building or space. Architects illustrate and study their intentions and ideas through drawings and models. These architectural representations exemplify a visual language with rules, conventions, and meanings. These visual tools convey ideas, reinforce concepts, and otherwise try to persuade others. They are essential tools for designing, describing, and exploring your surrounding environment.

This book is an introduction to the visual language of architectural representation. It is intended to familiarize readers with basic concepts of architecture through a series of design exercises that develop necessary skill sets supplemented with examples, references, and research recommendations. It will challenge your preconceptions about architecture while enabling you to become critical of your built environment. This book explores architectural representation from the point of view of a designer. It is a foundation course book that is ideal for someone who is debating about attending architecture school, starting at architecture school, or generally interested in the creative aspects of architectural design.

Through a series of three-dimensional design problems, the reader will explore issues of proportion/scale, space/volume, composition/sequence, and material/texture while simultaneously learning the language of architectural representation. In addition, a series of exercises that explain the process of conceptualizing architectural ideas and how to represent those ideas in both drawings and models is provided.

Much like the process of architectural design, the approach of this book is cumulative in nature. Skills are taught incrementally and build upon prior exercises.

Architectural representations are utilized both for processing ideas and documenting those ideas for presentation. They are both a means to an end and an end in themselves. Ideas conceptualized in your head need to be translated onto paper so that they can be tested. When ideas are manifest in physical form (on paper or as a model), those ideas are forced to address questions. By physically representing your ideas, you can begin to see them for what they are, make changes, and revise them. When you draw or build your ideas you can react to them physically and visually, but when they are isolated in thought you can only react to them conceptually. This suggests a process of recording all of your thoughts and ideas in a physical manner. While making representations of your ideas, ask yourself the question "why?" Why this size, this shape, this many, and so on. At the end of the iterative process, these models and drawings are finalized and presented for particular audiences.

Architecture is taught through design, process, and technique. With the use of precedents, background information, clear instruction, examples, and exercises, this book will have you investigating your surroundings by being a curious observer. The goal is to urge you to think and see spatially, in three dimensions.

mozell

About this book

This book is divided into seven chapters that cover architectural representational techniques supplemented by design problems based on a college-level beginning design curriculum. Within each chapter the process of design is emphasized. Each chapter is further broken down into units that include step-by-step tutorials to explain the processes of representation. Hands-on exercises allow you to practice and refine your new skills, from the conceptualization of a space to visualizing it two- and three-dimensionally to describing it through sections, elevations, and fully-realized perspective drawings.

This book also includes professional examples of architectural projects. These real-life scenarios demonstrate building techniques and materials that impact design decisions. Case studies show different designers' interpretations of a range of project statements. You will also find professional advice about entering the architecture profession and what to expect when you get there. Common myths about architecture will also be dispelled.

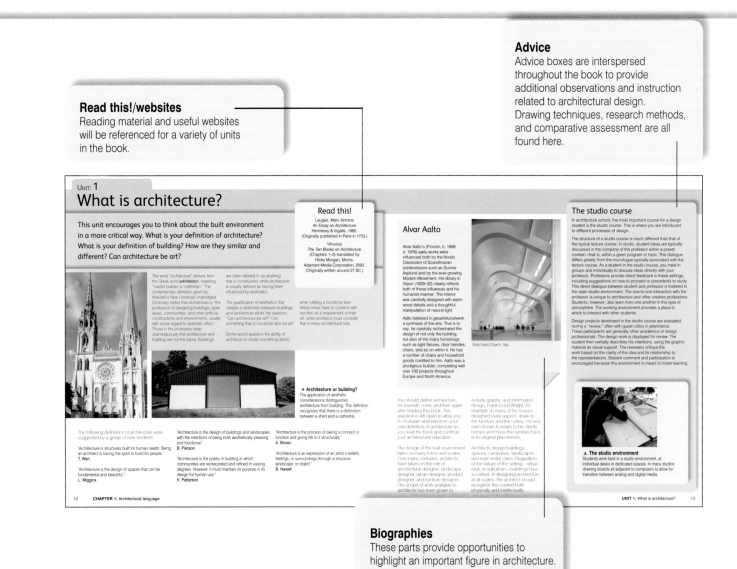

Advice
Advice boxes are interspersed throughout the book to provide additional observations and instruction related to architectural design. Drawing techniques, research methods, and comparative assessment are all found here.

Read this!/websites
Reading material and useful websites will be referenced for a variety of units in the book.

Biographies
These parts provide opportunities to highlight an important figure in architecture.

Physical vs. digital models

During the design process, there are several benefits to making a physical model over a digital model. Physical models let you experience the building as a three-dimensional material object, allowing the design to be understood simultaneously through all of its parts and as a whole. There is tactile immediacy to grasping and understanding the form visually and the composition through physical movement and rotation. This process compels the designer to be empathetic to the force of gravity and encourages him or her to think of the material connections and their tectonic implications for the architectural idea. In essence, the designer responds to his physical connection with a handcrafted model.

While the digital model also allows a type of visual immediacy through the rapid selection of views, these views are ultimately limited by the screen size and the limitations of the software interface. The designer needs to input a command using the keyboard or mouse in order to rotate, move, or modify the image. There is a type of hesitation to the designer's engagement with the concept. However, digital models can also provide opportunities to simulate travel through and into spaces, providing views that a physical model might not allow.

◀ ▲ **Material construction**
These two images depict transparency studies of the same architectural project through the use of a digital model (below) and a physical model (left). The digital model is more diagrammatic, emphasizing the continuity of spaces, while the physical model allows the viewer to understand the massing of the addition (in basswood) with greater clarity.

Typical modeling materials

Models do not have to be made from a single material. Using two materials can distinguish between existing and new, or between materials.

Chipboard
Pros: no grain, easy to cut, cheap, consistent color and material throughout, comes in large sheets.
Cons: doesn't look as refined, slight variations in color

Basswood
Pros: grain can emphasize directionality of materials, more refined look, easy to cut, comes in sticks, sheets, and blocks.
Cons: has grain, sheet size is limited, costs more than chipboard

Modeling clay
Pros: good for carving and landscape models.
Cons: dries out quickly, messy, imprecise

Museum board
Pros: easy to cut, no grain, comes in big sheets.
Cons: hard to keep clean, not always consistent material throughout, more expensive than chipboard

Foamcore
Pros: for making large scale models, comes in a variety of thicknesses.
Cons: not consistent material throughout, need to adjust edges when joining pieces together

Plexiglass
Pros: provides a transparent material allowing interior views, comes in big sheets.
Cons: difficult to cut, especially holes in the middle; transparency is sometimes misunderstood

Cork
Pros: comes in rolls and sheets, looks finished, easy to cut, used as contours or landscape.
Cons: expensive

Styrene
Pros: highly-polished smooth surface ideal as a mold for casting plaster; comes in a variety of sheet sizes.
Cons: more expensive than basswood

Corrugated board
Pros: affordable and accessible material, can use boxes and other packing material.
Cons: quality of material is rarely sufficient for final presentation models, must consider exposed edges in model

▲ **Combining materials**

Case study: 1
Architectural mock-ups

Architects should be conscious of the impact of their design ideas on a site. Smaller-scale representations can be limiting in presenting the full considerations of the design project.

In some cases, architects support deeper investigations by constructing full-scale mock-ups to test impacts on a site, constructibility, or material effect. The following images demonstrate a full-scale mock-up of the Northeastern University Veterans Memorial. The scale of the Memorial Wall, along with its placement on the site, was being tested.

Some mock-ups can be made using non-traditional materials to replicate the design impacts while others require real materials to be tested. The wall-detail mock-up is typically constructed on site at full scale to test the construction techniques, color, and pattern choices relative to the context.

▲ ▶ **Defining wall**
The relationship of the wall to the surrounding context and the relative size of the space being created were verified with a full-scale mock-up. The height of the wall was altered when tested on the site, while the location and length were found to be appropriate.

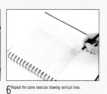

Digital applications
Typically included at the end of each chapter, the digital applications category provides an opportunity to discuss the changing role of digital media relative to both the traditional modes of architectural representation and the education of an architect.

Assignments
Each chapter includes a number of project assignments that provide opportunities for you to test your skills and challenge your creative thinking. Student examples will provide lessons and strategies to design approaches.

Case studies
These sections will highlight professional projects that exemplify the topic being introduced. Professional examples ground the representational assignments with real-world applications.

Unit: 12
Sketching the line

Lines are manmade creations that provide information about changes in form, depth, material, or brightness.

"Line does not exist in nature and so, in fact, is all of drawing... the reason for the invention of line... those who would venture into the formlessness that surrounds us on every side; a guide that leads us to the recognition of form and dimension and inner meaning."
George Grosz, painter, 1893–1959

One technique that is extremely helpful in improving sketching is the mastering of the straight line. The language of the line is an essential component to understanding drawing. The line is a continuous mark on a surface that is defined mostly by its length relative to its own width or thickness. The thickness of the line can vary with different media.

The line, if properly drawn, can delineate sharp edges or soft contours. Through the pressure, thickness, and angle of application, it can suggest different textures, shapes, and forms.

You should come to understand your own natural hand pressure. This affects the marks made on the page by graphite. It is important that you know this so that you can determine which leads; hard or soft, are best suited for you. If you have a heavy hand you will want to work more with the harder leads, while if you have a light touch on the page you will want to work with softer leads so that your lines appear appropriately darker.

Pen and digital line weights
Pen and digital line weights do not vary in the same way as graphite. Various types of line types is achieved through pen thicknesses rather than hand pressure. Pens have a consistent stainless steel tip and ink flow and therefore maintain their line consistency and type throughout the length of the line, as well as throughout the entire drawing.

The pen weight range includes: 0.13 mm, 0.18 mm, 0.25 mm, 0.30 mm, 0.35 mm, 0.50 mm, 0.70 mm, 1.0 mm, 1.4 mm, and 2.0 mm. The range of lines available in digital output may vary, but typically includes 0.05 mm–2.1 mm. The number of pens available in both digital output and as individual drawing instruments offers a large variety of line weights with which to draw. As with the lead range,

A range of digital line weights.

it is not necessary to maintain all the pen sizes. A good range includes small, medium, and large tips: 0.13 mm, 0.25 mm, and 0.50 mm. You should have the variety of pens necessary to convey depth properly in a drawing.

Graphite line weights
Graphite line weights include the spectrum of marks made by both hard and soft leads. There is a range of graphite weights associated with hard-lined drawing (drawing with your parallel rule and drafting board), freehand drawing, and sketching. Leads range from a soft 6B to a hard 9H. The harder the lead, the lighter, crisper, and thinner the line will be. It is important that you find your own appropriate range of drawing weights as each lead has a variety of associated marks depending on your own hand pressure. For example, an HB lead (middle-range lead weight) can actually provide a number of different line marks, ranging from light to medium to dark, based on how much pressure is applied. Variation in graphite is made through pressure and lead choice.

▲ **Proper line weights**
The section cut is clearly visible as the various line weights, from dark to light, depict the depth of the space.

▲ **Single line weights**
The lack of a strong section cut and other line weights renders this section illegible. The strongest component of the image is a series of closely packed vertical lines. In the previous section, the line weight is lightened quite a bit to reduce the emphasis.

...own hand pressure and to achieve straight line accuracy. It is... ...ation to draw. You will need to move your entire arm while... ...h stability as you move the lead holder across the page. Twist the lead holder between your fingers as you move it across the page to maintain a consistent point on the lead.

1 Place at least 10 dots randomly on a page in your drawing pad. Use the entire space to distribute the dots. Do not align more than three. Now draw freehand lines connecting one point to each of the others. Look ahead to where the line will end and try to make each line straight and of a consistent line weight.

2 Connect every dot to every other dot. Do not use a ruler or straight edge for these exercises. Use an HB sketching pencil. Sharpen your pencil often. Do not lift the pencil up or pause in the middle of a line. Use your entire arm to draw—not just your wrist—from your shoulder to your fingers. Remember to roll your pencil to help keep the point consistent.

3 On another sheet, draw a series of horizontal lines. Keeping the lines parallel and around ½ in (12 mm) apart. Draw each line continuously from one side of the paper to the other. Vary your hand pressure after every five to eight lines.

4 Now cross vertical lines over the horizontal ones to create a grid. Try a range of lead hardnesses, and both lead holder and pencils, to experiment with your own hand pressure. Compare the lines created with the lead holder and a sketching pencil. In addition, use an HB lead in the lead holder for five lines, then press harder for five lines, then lighter for another five lines. Next try the HB pencil using the same methodology of five lines regular, five lines harder, and five lines lighter.

5 Carefully draw horizontal lines across the width of another page. Maintain a 1-in (25-mm) distance between the lines at the top quarter of the page. For the next quarter, keep a spacing ½-in (12-mm) spacing between the lines, followed by a ¼-in (6-mm) spacing for the next quarter. Finally, the bottom quarter of the page should be filled with lines ⅛ in (3 mm) apart. Keep the lines straight and parallel. Work on line control and consistency.

6 Repeat the same exercise drawing vertical lines.

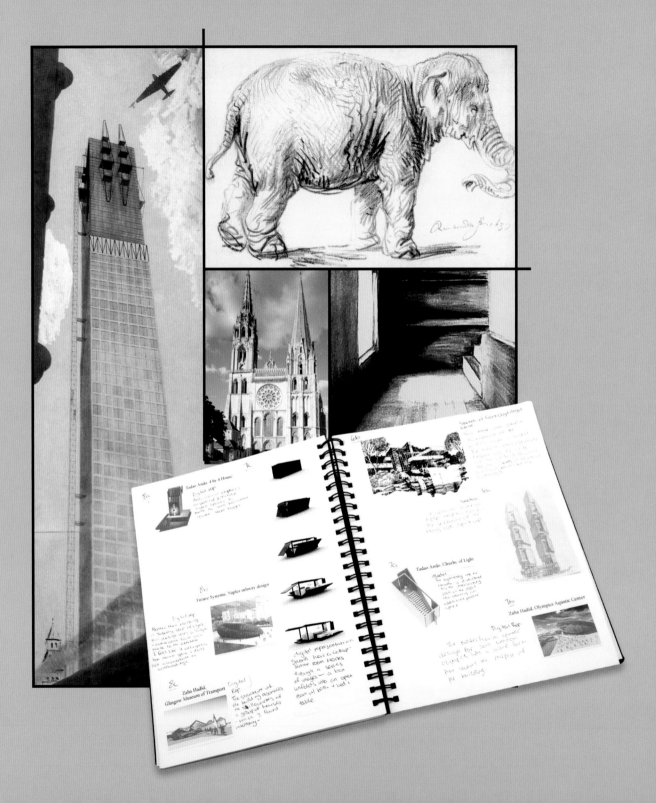

Architectural language

This chapter establishes a foundation for architectural education. It is divided into a series of units that describe in detail architectural drawing types and representation methods while establishing the fundamental architectural language necessary for future success in the profession. Preparation for the profession begins with the introduction to each communication tool, coupled with the identification of your intended audience.

Knowledge of the fundamental architectural language is necessary for clear communication of architectural ideas. The units in this section define the basic concepts, representation types, and conventions used to create and communicate architectural ideas. You will learn about architectural representation, to whom architects want to communicate, why they draw and make models, and what implements they use to create those representations.

What is architecture?

This unit encourages you to think about the built environment in a more critical way. What is your definition of architecture? What is your definition of building? How are they similar and different? Can architecture be art?

Read this!

Laugier, Marc Antoine
An Essay on Architecture
Hennessy & Ingalls, 1985.
(Originally published in Paris in 1753.)

Vitruvius
The Ten Books on Architecture
(Chapters 1–3) translated by
Hicky Morgan, Morris.
Adamant Media Corporation, 2005.
(Originally written around 27 BC.)

The word "architecture" derives from the Greek word *arkhitekton*, meaning "master builder or craftsman." The contemporary definition given by Webster's New Universal Unabridged Dictionary states that architecture is "the profession of designing buildings, open areas, communities, and other artificial constructions and environments, usually with some regard to aesthetic effect." Those in the profession state unambiguously that architecture and building are not the same. Buildings are often referred to as anything that is constructed, while architecture is usually defined as having been influenced by aesthetics.

The qualification of aesthetics that creates a distinction between buildings and architecture elicits the question, "Can architecture be art?" Can something that is functional also be art?

Some would question the ability of architects to create something artistic while fulfilling a functional task. Artists never have to contend with function as a requirement of their art, while architects must consider that in every architectural task.

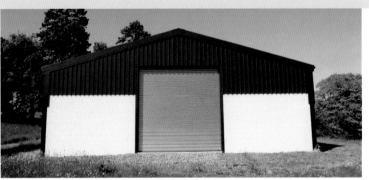

◄ Architecture or building?
The application of aesthetic considerations distinguishes architecture from building. This definition recognizes that there is a distinction between a shed and a cathedral.

The following definitions of architecture were suggested by a group of new students:

"Architecture is structures built for human needs. Being an architect is having the spirit to build for people."
T. Wen

"Architecture is the design of spaces that can be fundamental and beautiful."
L. Miggins

"Architecture is the design of buildings and landscapes with the intentions of being both aesthetically pleasing and functional."
B. Pierson

"Architecture is the poetry in building in which communities are reinterpreted and refined in varying degrees. However, it must maintain its purpose in its design for human use."
K. Patterson

"Architecture is the process of taking a concept or function and giving life to it structurally."
A. Brown

"Architecture is an expression of an artist's beliefs, feelings, or surroundings through a structure, landscape, or object."
B. Newell

Alvar Aalto

Alvar Aalto's (Finnish, b. 1898 d. 1976) early works were influenced both by the Nordic Classicism of Scandinavian predecessors such as Gunnar Asplund and by the ever-growing Modern Movement. His library in Viipuri (1929–32) clearly reflects both of these influences and his humanist manner. The interior was carefully designed with warm wood details and a thoughtful manipulation of natural light.

Aalto believed in *gesamtkunstwerk*, a synthesis of the arts. That is to say, he carefully orchestrated the design of not only the building, but also of the many furnishings such as light fixtures, door handles, chairs, and so on within it. He has a number of chairs and household goods credited to him. Aalto was a prodigious builder, completing well over 100 projects throughout Europe and North America.

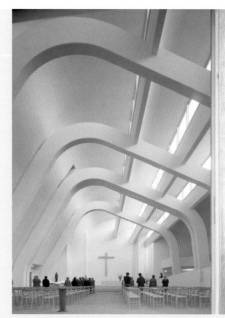

Riola Parish Church, Italy.

The studio course

In architecture school, the most important course for a design student is the studio course. This is where you are introduced to different processes of design.

The structure of a studio course is much different than that of the typical lecture course. In studio, student ideas are typically discussed in the company of the professor within a preset context—that is, within a given program or topic. This dialogue differs greatly from the monologue typically associated with the lecture course. As a student in the studio course, you meet in groups and individually to discuss ideas directly with your professor. Professors provide direct feedback in these settings, including suggestions on how to proceed or precedents to study. This direct dialogue between student and professor is fostered in the open studio environment. The one-to-one interaction with the professor is unique to architecture and other creative professions. Students, however, also learn from one another in this type of atmosphere. The working environment provides a place in which to interact with other students.

Design projects developed in the studio course are evaluated during a "review," often with guest critics in attendance. These participants are generally other academics or design professionals. The design work is displayed for review. The student then verbally describes his intentions, using the graphic material as visual support. The reviewers critique the work based on the clarity of the idea and its relationship to the representations. Student comment and participation is encouraged because this environment is meant to foster learning.

▲ The studio environment
Students work best in a studio environment, at individual desks in dedicated spaces. In many studios drawing boards sit adjacent to computers to allow for transition between analog and digital media.

You should define architecture for yourself—now, and then again after reading this book. This question is left open to allow you to modulate and transform your own definition of architecture as you read the book and continue your architectural education.

The design of the built environment takes on many forms and scales. Over many centuries, architects have taken on the role of architectural designer, landscape designer, urban designer, product designer, and furniture designer. The scope of work available to architects has even grown to include graphic and information design. Frank Lloyd Wright, for example, in many of his houses, designed every aspect, down to the furniture and the cutlery. He was even known to return to his clients' homes and move the furniture back to its original placements.

Architects design buildings, spaces, campuses, landscapes, and even entire cities. Regardless of the nature of the setting—urban, rural, or suburban—buildings have a context. In designing architecture at all scales, the architect should recognize this context both physically and intellectually.

Representation and drawing

In reality, architects produce representations of buildings, not actual buildings. In many instances, drawings and models are the closest an architect comes to constructing a building. These methods of representation require careful thought and articulation. This unit focuses on the art of drawing.

Read this!

Ambroziak, Brian
Michael Graves: Images of a Grand Tour
Princeton Architectural Press, 2005.

Le Corbusier
Le Corbusier Sketchbooks
The MIT Press, 1982.

Fraser, Ian and Henmi, Rod
Envisioning Architecture: An Analysis of Drawing
John Wiley & Sons, 1994.

Drawing, as an artifact, is a two-dimensional representation used by architects. It is a form of visual communication, based on a common, agreed-upon visual language that conveys ideas, depicts existing conditions, and creates as-of-yet unbuilt environments. Drawing transposes three-dimensional images, both real and imagined, onto two-dimensional surfaces.

Technical or architectural drawing operates under an established set of conventions and rules. It serves to provide visual representations for the discussion and understanding of design ideas and intentions. Just as a common set of codes and symbols allows us to communicate verbally with one another, a common language in architecture makes it possible to communicate ideas.

Drawing, as a skill, improves with practice. Contrary to a common myth, it is also a skill that can be learned. Though some people seem to have a natural inclination for drawing, everyone can be taught the skills to create informative, competent, and beautiful drawings. However, repeated construction of drawings will not necessarily result in becoming a good architect, although it might produce a

good draftsman. Therefore it is also necessary to motivate and exercise the creative mind while learning the skills to craft drawings.

▼ **Representation breakdown**
Digital programs provide an additional method of generating architectural representations—but manual representation will always be a valuable, necessary skill.

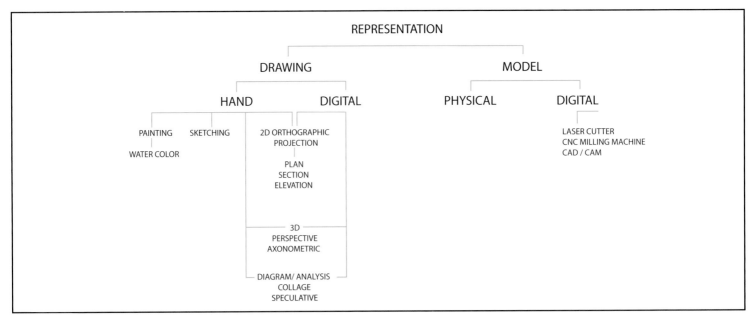

Le Corbusier

Le Corbusier (Swiss/French b. 1887 d. 1965) was undoubtedly one of the most influential architects of the 20th century. His Five Points of Architecture challenged previous methodologies of designing, namely the Beaux Arts tradition, and reshaped the built environment. These five points included the piloti, ribbon window, free plan, free façade, and roof garden. This approach to architecture was formalized in many of his residential designs. He is not only credited with designing some of the most important buildings of the 20th century, but also for influencing the instruction and curriculum of countless architecture schools around the world. His paintings and sculptures were equally renowned and respected.

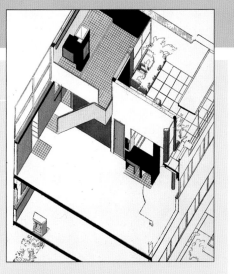

▲ **Plan as the generator**
Le Corbusier has been credited with the notion of the "plan as the generator."

Sketchbooks

● One of the tools that you will want to keep handy at all times is your sketchbook. Having multiple sketchbooks can be useful—a small one about 3½ x 5½ in (89 x 140 mm) is convenient to carry in your back pocket, and a mid-sized one about 8½ x 11 in (216 x 279 mm) allows you to work in a larger format.

● The smaller sketchbook should travel with you everywhere. It is the place to record ideas, sites that interest you, and architecture that excites you. The other sketchbook is ideal for working out ideas regarding your own projects and collecting images for your image folder.

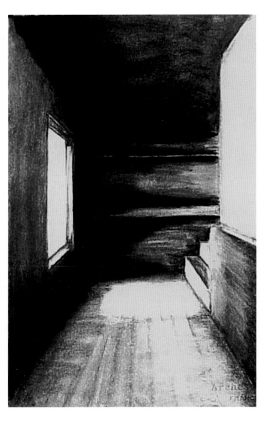

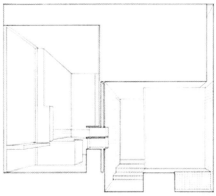

◄ ▲ **Design intentions**
Different drawing methods are used to represent different design intentions. Charcoal drawings (such as the one shown on the left) can capture the mood of a space while line drawings (such as this sectional perspective, above) provide a more precise technical depiction of a space.

Representational intention

Architects envision, design, and think through drawing and modeling. They record ideas, test scenarios, and produce lines that capture thoughts. These representations can have meaning beyond a purely functional one of displaying the project. Drawings and models can reinforce a designer's idea through representational intention.

This intention—the methodology and choices behind the representation—has the potential to create a more meaningful connection between project depictions and the architectural idea, making possible a stronger argument for the project. By asking the questions, "What will the drawing convey? What is the design idea that needs to be narrated through the representations? What types of drawings best convey those architectural ideas?" you begin to establish the criteria required to reinforce the architectural idea.

For example, in perspective drawing, the vantage point of the viewer can strengthen design ideas. A dramatic effect can be reinforced by placing the vantage point lower on the page. This lowered viewpoint, in combination with a closeness to the object, emphasizes the building's monumentality.

Intentions that support architectural ideas can also be conveyed through an editing process. When making considerations about a drawing, what you leave out is just as important as what you include. You should be aware that every line you construct is part of the decision-making process.

◀ Ideology
The exaggerated low viewpoint in this Russian Constructivist perspective drawing reinforces a political ideology as well as an architectural one.

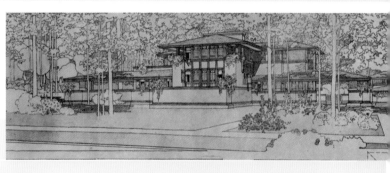

Frank Lloyd Wright

Frank Lloyd Wright (American, b. 1867 d. 1959) is one of America's most recognizable architects. His buildings are characterized by flowing spaces and a rich palette of natural materials such as brick, stone, wood, and glass. His early houses, known as "Prairie Style," were organized around the hearth, both symbolically and spatially. Wright later designed a series of houses, known as the Usonian Houses, that he hoped would create an affordable, democratic, distinctively American house type. Wright's important works include not only residences, but also churches and temples, office buildings, and museums.

▲ Connection with the land
The horizontally-oriented perspective representation of a house reinforces Wright's interest in low, horizontal designs that hug the land.

Fold and crumple

In this assigment, you will take a limited set of materials and use them to express your intention: to represent a specific space that you have experienced. This assignment is meant to get you interpreting and making at the same time. You will be thinking through the act of doing. This is your first of many spatial exercises.

Make a representation of your home. Begin by defining the term "home." You do not have to think literally about the term. You can and should interpret this place through the act of making. The model you create will be a representation of this interpretation.

What you need

- Three sheets 8½ x 11 in (216 x 279 mm) regular opaque copy paper, each cut into six strips 1.5 x 11 in (38 x 279 mm)

- Two sheets 12 x 12 in (305 x 305 mm) trace or other transparent material

- Hand-torn piece of newsprint— approximately 8 x 10 in (203 x 254 mm)

1 Take the materials listed and lay them out on a flat surface so they are all easily accessible.

2 Without the use of tools or glue (no scissors, pencils, or tape) start to create a representation of your favorite space from memory. Try to give form to your visualization. You need not be literal in your representation.

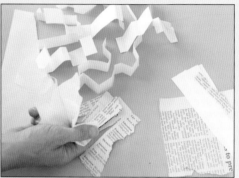

3 Fold and crumple the materials to connect and integrate them. Think about the spatial relationships created between walls, objects, buildings, or planes.

Assignment rules

- Be creative—you don't have to be literal. Try to capture the essence of the space.

- You must be able to pick up the creation with one hand and NOT have anything fall off—meaning all the items must somehow be integrated and physically connected.

- Think about the intention of your representation.

- You cannot tear any pieces once you have them sized to the given dimensions.

- Give yourself 15–20 minutes to create your abstract representation.

- Understand that there is no wrong answer or wrong model to make. This is solely about your interpretation of the assignment.

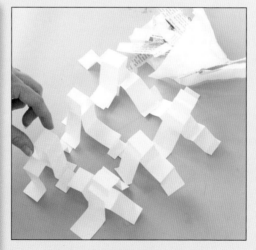

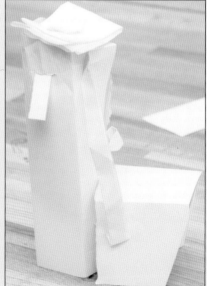

Two finished representations (above and right). The volumetric representation on the right is more abstract than the model above.

Study the sketch

Myth: A good drawing must be beautiful.

A successful drawing is one that clearly conveys intentions and ideas. It does not have to be rendered in an artistic, beautiful manner for it to be "good."

One method to help you understand the successful nature of drawing is to study sketches by master artists and architects. The study of these drawings provides you with insight into the mind, abilities, style, technique, and subject matter selected by the artists and architects.

Drawing techniques have different associated intentions; therefore not all sketches appear to be beautiful artistic renderings. Very clearly conceived sketches by some of the most famous architects are not always the most beautiful. During the drawing process, each artist edits or omits information that does not support the intention of the sketch.

This editing process allows the artist to emphasize a particular aspect of the view or design, clarifying the idea.

Find two sketches, one from each category listed below. Reproduce the renderings by hand in your sketchbook by copying the method of sketching. The purpose is to replicate the sketching technique used by the artist. Do not trace the sketch. Attach a copy of the original sketch into your sketchbook adjacent to your own sketch.

Examine the technique of sketching while you copy the work. Notice the medium of sketching, the sketch surface, and the size of the sketch.

Sketches to study:

Architects	Artists
Louis I. Kahn	Michelangelo
Alvar Aalto	Leonardo da Vinci
Le Corbusier	Raphael
Tadao Ando	Rembrandt
Michael Graves	Fra Angelico

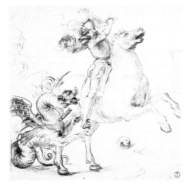

▲ ▶ Edge contours

Note the various techniques used in these drawings by Leonardo da Vinci (right) and Raphael (above). Profile lines in conjunction with hatching patterns clearly define the edges of the figure.

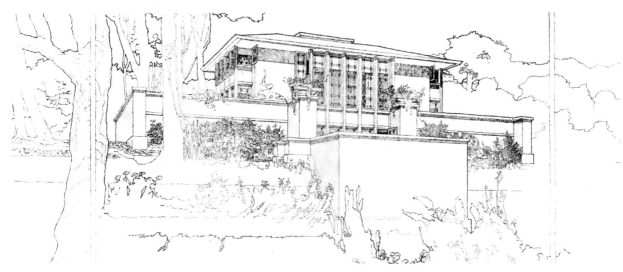

◀ Line and rendering

The rendering of this Frank Lloyd Wright drawing emphasizes the form and mass of the building.

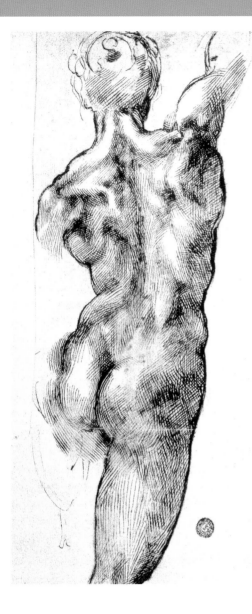

◄ ▲ Sketching with lines

Lines vary greatly among sketches.
Transparency and contours provide
objects with form and shape in these
drawings by Michaelangelo (left)
and Rembrandt (above).

▼ Spatial quality

The spatial quality of the architecture is
captured by this sketch. The energy and
orientation of the linework reinforces the
character and quality of the space.

Concept sketch by
Norman Foster

Types of drawing

Architects give their ideas physicality through drawing. They employ a variety of different drawing types, typically selected based on the criteria of design intention and the audience.

Two-dimensional drawings, referred to as orthographic projections, include plans, sections, and elevations. Perspective and axonometric are examples of three-dimensional drawing types. Drawings that overlap or combine linework with photographs, color, or some other graphic material are referred to as collage. Any of these drawing types can be constructed as hardline drawings or as freehand drawings.

▶ **Multiple sections**
Multiple sections depict the changing conditions of the light in the space. Each section captures a wall elevation showing the changing nature of the poche (or thickened service) zone. The darkest areas depict the deepest parts of the poche.

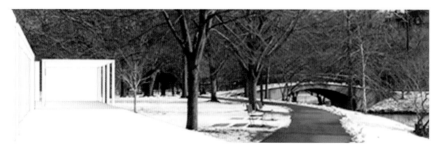

◀ **Site collage**
Constructed perspective drawings can be combined with exisiting images through collage techniques. The spatial continuity of the bathhouse design with the adjoining park pathway system is depicted in this collaged image.

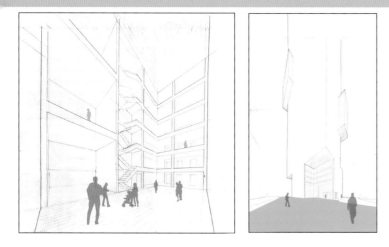

◀ Finding scale

Interior and exterior perspectives can be linked through colors indicating the same spaces viewed from different vantage points. The interior perspective (left) abstracts glazing as a blue film. The blue additionally indicates a subtractive move, carved out of the solid mass of the building. Abstract figures provide scale in both images while the blue coloration provides another reading of scale when considered from the exterior (right).

▶ Exploded axon

Details of construction and material patterns are exposed in this exploded axon. Repetitive material patterns are grouped and pulled apart to demonstrate the parts relative to the working of the whole.

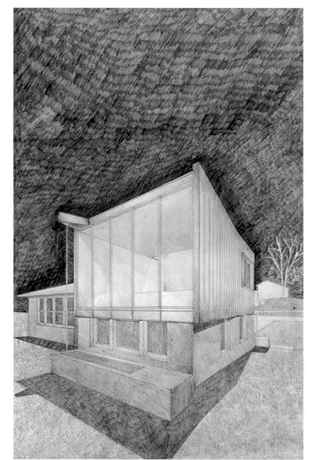

◀ Perspective rendering

The graphite-rendered drawing showcases material transparencies and light qualities in spaces. In the perspective, the depth of the interior space is discernable even from an exterior view of the building.

Using an architectural scale
(Metric)

The triangular scale rule, usually having six measurement gradations, is commonly used for drawing and modelling constructions. Most use increments of one millimeter to create a wide range of scales. The appropriate scale is used to take measurements from the drawing in meters or parts thereof.

Other scale rules are a more conventional flat format. They generally have two scales on each edge, one being 10 times the size of the other, i.e. 1:20 and 1:200. Specialist rulers are available to read measurements in meters from imperial scales, i.e. 1:96 (⅛ in. to a foot) or 1:48 (¼ in. to a foot).

Each scale is indicated as a ratio at the far edges of the measurement increments. For instance, the 1:50 marked on the far left indicates the scale of 1 cm being equivalent to 50 cm on a drawing scaled at one to fifty.

On some scale rulers, smaller increments are marked outside the "0" mark. Therefore, it is necessary to measure the meters and add on fractions of a meter outside the mark.

▲ ▶ Scale and level of information
The type and amount of information conveyed by a drawing depends on its scale. A drawing at 1:100 scale requires less detailed information than one at 1:50 or 1:20 scale. For example, the delineation of brick at 1:100 scale may be abstracted as horizontal lines, while at 1:50 or 1:20 scale the details of the individual bricks are more appropriately drawn.

"Things I like" image folder

This assignment provides you with an opportunity to collect images of things that you like, find interesting, or are curious about. Build a folder of images of spaces, materials, and construction techniques to influence and inspire your design work. In developing your image folder, ask yourself not only what you like, but why you like it. Try to boil it down to a single idea. Use the following representation categories as a guide to help you maintain a variety of drawing examples:

• plans
• sections
• elevations
• axonometrics

• one-point, two-point, and three-point perspectives
• freehand sketches
• ink drawings
• graphite drawings
• computer drawings
• renderings
• physical models.

In all, collect any image related to drawing and representation that is aesthetically appealing to you. These images will be a resource and inspiration for your own designs.

The focus of the assignment is on representation, so do not use photographs of existing buildings. Take images from books and magazines. Include the source of each image, the name of the magazine or book title, and the publication date. By recording this data, you will discover which books and magazines most appeal to you. Keep your images in a clearly organized binder or in your sketchbook.

It is important that you expand your knowledge of representational methods. By seeing what others have done before you, you can learn to develop your own style.

Website

Professionals create their own image folders in a variety of ways. New York architects Tod Williams and Billie Tsien include on their website a link to a section called "things"; representing a collection of images and objects that inspire them.
www.twbta.com

Research tip

The physical act of looking for information in books and magazines in the library encourages a kind of exploration that the Internet has not quite offered yet. The Internet, though good for searches in which you know what you are looking for, is limited in making non-linear connections.

▲ ▶ **Captured images**

It is important to become familiar with precedents in architecture; look at designs and drawings from contemporary and historically significant architects. Images of interest might range from conceptual to finished drawings, and from plans to perspectives. Being familiar with contemporary and historic representations allows you to learn from past examples and develop a visual library of precedents.

Models as representations

Drawings and models are both abstract representations: they provide methods for expressing architectural ideas and concepts. Drawings are typically constructed on two-dimensional surfaces, while models provide a three-dimensional abstraction of space and form.

As in drawing, both the process and the presentation of ideas are recorded in models. In comparison to drawings, models provide a clear representation of space, operating in three dimensions. Because of their abstract nature, do not attempt to make them too realistic. For instance, models made out of basswood are not meant to indicate that the building is made out of wood. The model is used as an abstract representation of the space and form of the building, not the materials. If material distinction is necessary, abstract those as well.

As in drawings, models can reinforce architectural intentions, be they spatial, formal, or tectonic. For example, the base of a model can be exaggerated to reinforce a connection between the building and the ground. By enlarging the depth of the model base, there is a greater emphasis placed on the rooted quality of the project with the earth. Architects can also edit the information in a model. This enables control over the model's intention which can result in the reinforcement and clarity of the design ideas.

Model practicalities

Questions to ask yourself:

- What material should I use?

- How can I successfully abstract real building materials?

- At what scale are the materials to be depicted?

- Is the whole model made out of the same material?

- What are the limits of the site versus the limits of the model? Is it the property line, or the strong edge in the neighborhood? The context provides a comparative element to judge your own building against.

- At what scale should I make the model?

- What do I want to show? Remember, entourage can be included to demonstrate scale in a model.

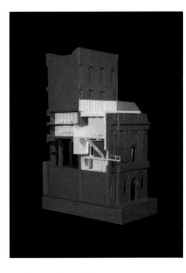

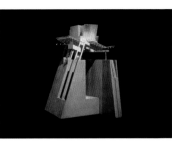

▲ **Site connection**
The exaggerated base of this model of the Newton Library by Patkau Architects emphasizes the connection between the building and the site. The angle and form of the exterior columnar system is carried through in the depth, form, and articulation of the model base.

▲ **Parasitic design**
Material distinction establishes clarity between existing and new elements. This design intervention is constructed of basswood and inserted into a model of chipboard and corrugated cardboard to represent the existing building.

▶ **Detail model**
This large-scale model depicts structural and framing systems. Abstract models of this nature force you to become familiar with actual construction techniques. They allow you to understand the tectonics of the building and how components join together. These models can also inform the design process. This means that once these models have been built, you can study and reevaluate the construction and make changes to the geometry, proportion, and scale of the design.

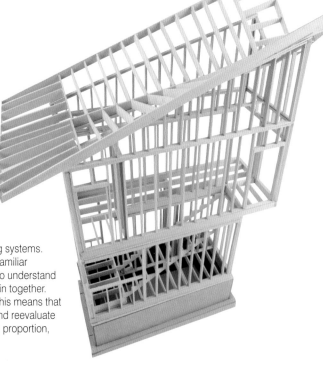

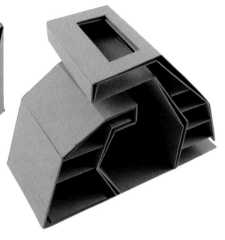

◀ ▼ Study models

The study model is a type of model meant for the assessment of ideas. These models can be manipulated and remade quickly. They provide opportunities for discovery, inspiration, and investigation. You should consider these types of models as developmental and not final renditions of the idea; they are part of the iterative design process. Therefore, you should feel comfortable manipulating and molding these models. Don't be afraid to rip them apart to test different ideas.

This series of models depicts a three-dimensional design process that enables ideas to be tested and changed in a fluid manner.

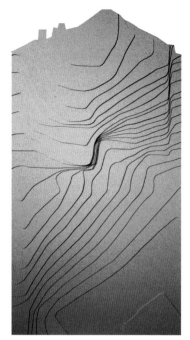

A topographic model made from cork.

▲ Topographic model

Topographic models depict the changing landscape of the site. The scale of the model determines the thickness of each contour depicted on the model.

▼ Massing model

A massing model depicts the volumetric qualities of a building without much detail. Massing models are used to assess and compare the relative form and scale of a building to the adjacent building context. Contextual information is often included in these models to show how new buildings and spaces interact with the existing conditions.

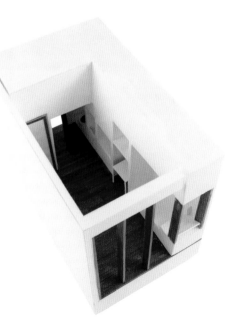

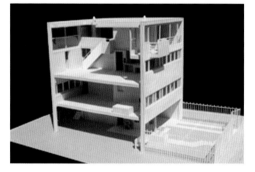

◀ ▲ Presentation models

Presentation models are used to show final design ideas for either your own projects or studies of other precedent examples. In the profession they are used for client and community meetings. These models are not about process but product; they are usually the most well-crafted models produced for the project. The model shown above represents a precedent study of Le Corbusier's Maison Cook. The model on the left shows a room for repose, using hydrocal and wood.

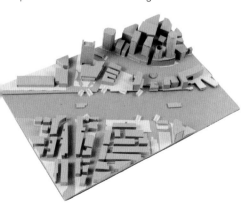

Massing models are used to explore form.

Physical vs. digital models

During the design process, there are several benefits to making a physical model over a digital model. Physical models let you experience the building as a three-dimensional material object, allowing the design to be understood simultaneously through all of its parts and as a whole. There is tactile immediacy to grasping and understanding the form visually and the composition through physical movement and rotation. This process compels the designer to be empathetic to the force of gravity and encourages him or her to think of the material connections and their tectonic implications for the architectural idea. In essence, the designer responds to his physical connection with a handcrafted model.

While the digital model also allows a type of visual immediacy through the rapid selection of views, these views are ultimately limited by the screen size and the limitations of the software interface. The designer needs to input a command using the keyboard or mouse in order to rotate, move, or modify the image. There is a type of hesitation to the designer's engagement with the concept. However, digital models can also provide opportunities to simulate travel through and into spaces, providing views that a physical model might not allow.

◀ ▲ **Material construction**
These two images depict transparency studies of the same architectural project through the use of a digital model (below) and a physical model (left). The digital model is more diagrammatic, emphasizing the continuity of spaces, while the physical model allows the viewer to understand the massing of the addition (in basswood) with greater clarity.

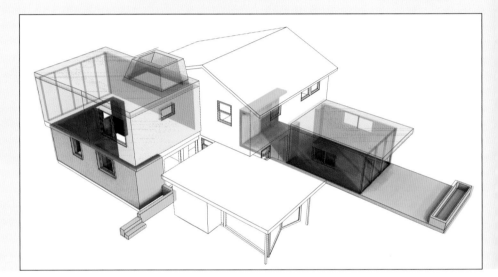

Typical modeling materials

Models do not have to be made from a single material. Using two materials can distinguish between existing and new, or between materials.

Chipboard
Pros: no grain, easy to cut, cheap, consistent color and material throughout, comes in different thicknesses, comes in large sheets
Cons: doesn't look as refined, slight variations in color

Basswood
Pros: grain can emphasize directionality of materials, more refined look, easy to cut, comes in sticks, sheets, and blocks
Cons: has grain, sheet size is limited, costs more than chipboard

Modeling clay
Pros: good for carving and landscape models
Cons: dries out quickly, messy, imprecise

Museum board
Pros: easy to cut, no grain, comes in big sheets
Cons: hard to keep clean, not always consistent material throughout, more expensive than chipboard

Foamcore
Pros: for making large scale models, comes in a variety of thicknesses
Cons: not consistent material throughout, need to adjust edges when joining pieces together

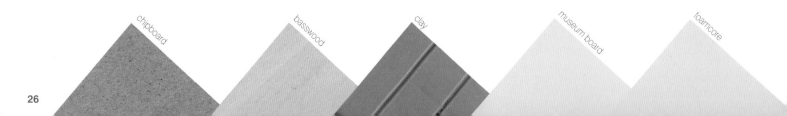

chipboard basswood clay museum board foamcore

Architectural mock-ups

Architects should be conscious of the impact of their design ideas on a site. Smaller-scale representations can be limiting in presenting the full considerations of the design project.

In some cases, architects support deeper investigations by constructing full-scale mock-ups to test impacts on a site, constructability, or material effect. The following images demonstrate a full-scale mock-up of the Northeastern University Veterans Memorial. The scale of the Memorial Wall, along with its placement on the site, was being tested.

Some mock-ups can be made using non-traditional materials to replicate the design impacts while others require real materials to be tested. The wall detail mock-up is typically constructed on site at full scale to test the construction techniques, color, and pattern choices relative to the context.

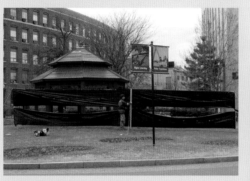

▲ ▶ Defining wall
The relationship of the wall to the surrounding context and the relative size of the space being created were verified with a full-scale mock-up. The height of the wall was altered when tested on the site, while the location and length were found to be appropriate.

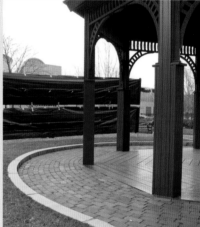

Plexiglass
Pros: provides a transparent material allowing interior views, can model curtain wall easily
Cons: difficult to cut, especially holes in the middle; transparency is sometimes misunderstood

Cork
Pros: comes in rolls and sheets, looks finished, easy to cut, used as contours or landscape
Cons: expensive

Styrene
Pros: highly-polished smooth surface ideal as a mold for casting plaster; comes in a variety of sheet sizes
Cons: more expensive than basswood

Corrugated board
Pros: affordable and accessible material, can use boxes and other packing material
Cons: quality of material is rarely sufficient for final presentation models; must consider exposed edges in model

Plexiglass cork styrene corrugated board

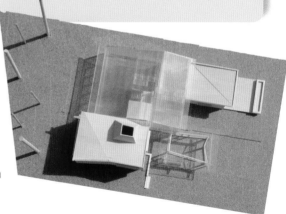

▲ Combining materials
The plexiglass depicts the existing house while the basswood is used to depict the house addition. The plexiglass allows the connectivity between the two wood masses to be seen.

Who is the audience?

Depending on the audience to whom they are presenting ideas, architects produce different types of drawings. Through representations, architects try to convey their ideas and intentions. There are three main audience groups: the fellow student, academic, or architect; the builder or contractor; and the client.

Read this!

Allen, Stan
Terminal Velocities—the Computer in the Design Studio
pages 242–255, from
The Virtual Dimension
Beckmann, John, (Ed.)
Princeton Architectural Press,
New York, 1998

Presenting to architects and students

Architects understand the abstract nature of representation; therefore, the presentation of your ideas can be made using the full spectrum of representation techniques—freehand and hardline, conceptual and realistic—and using all of the drawing techniques. In addition, these representations can reveal the process of your design thinking. The design process is stressed as a presentation component in academia. It is not only the design that gets evaluated; it's also the process of arriving at that design that is critiqued and assessed in school. School is one of the best places for learning and experimenting with design process representations. Be creative, adventurous, and inventive. Design feedback is provided in this arena.

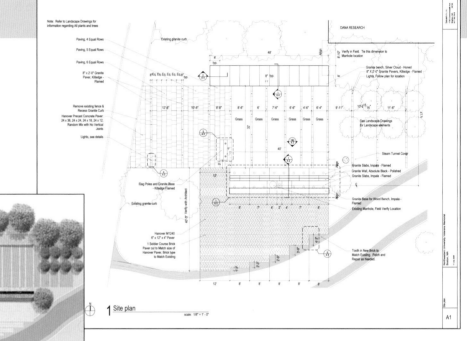

1 Site plan
scale: 1/8" = 1'-0"

◀ ▲ Conveying ideas

These two plans for a veterans' memorial, were created for two different audiences. The rendered plan (left) was presented to a design review committee. It demonstrates the qualitative aspect of the project. The monochrome plan (above) is a construction document. It delineates clearly the qualitative description including exact number, type, and location of all the building elements so that the contractor can construct the project.

Planning board/community group

Architects need to be able to communicate directly to the public. In an age of greater community involvement in the design of many public and private buildings, an architect's ability to communicate clearly and effectively with this group is key to the success of a project. A variety of presentation-style drawings are used in the public forum. Architects use these representations to convey their vision to the audience. In this role as community liaison, architects need to learn how to listen to their audience. The public generally wants to understand how the project might benefit their community through improved landscaping, reduced traffic congestion, increased accessibility, and façade treatment, to name a few. Similar modes of representation techniques presented to the client, including perspectives, models, and sketches, are also those that the community understands.

Design decisions

This example demonstrates the decisions an architect makes when determining the appropriate representations for a specific audience. The variety of drawing types associated with the design process in a professional architectural office is explained.

Pre-design

In this phase, the architect can assist the client in establishing the program and site. Zoning issues are explored, including maximum buildout due to Floor Area Ratio (FAR). FAR is the total building area that can be constructed on a site. For example, a site might have a FAR of 2, which means that a building two times the area of the site can be built. This does not limit the number of floors; it limits only area. Other factors, such as setbacks, participate in defining the maximum building envelope. The FAR is established by zoning codes.

The program is the project statement that often includes specific room types and associated square footage areas. Some architecture firms specialize in helping clients establish project programs and square footage requirements.

This part of the design process is sometimes the least graphic and often includes interviewing user groups who will occupy the finished building.

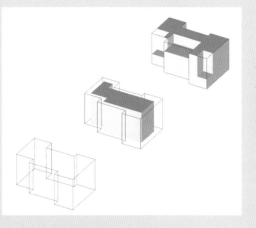

◀ Building envelope

Architects use spatial diagrams to demonstrate the possible zoning volumes based on the site FAR. This image depicts the volume of the buildable area on a given site. This should not limit your ideas about formal building compositions and other design aspects. For a series of zoning models for this project, see **www.ssdarchitecture.com**

Schematic Design (SD)—sketches, study models, perspectives

Architects generate lots of ideas through drawing and model-building during this phase. Some architects work simultaneously at a large scale, exploring the form of the building relative to the neighborhood, and at small details like material selection. This phase of work is typically generative and exploratory. The architect explores the possibilities and limitations.

Design Development (DD)—drawings, models, perspectives, mock-ups

Architects generally describe, through drawings and models, the project in more detail during this phase. Often, drawings increase in scale from $\frac{1}{16}$ in or $\frac{1}{8}$ in to $\frac{1}{2}$ in for more detailed information.

Construction Documents (CD)—full-scale mock up, details developed at larger scales

These drawings graphically depict the instructions to the contractor. They explain the design intentions of the architect. They constitute legal documents for the design project, emphasizing the importance for clarity and legibility in visual representation. The scale and number of drawings increase during this phase.

Construction Administration (CA)—on site

During the construction process the reality of site conditions, changing availability of building materials, and cost issues may require that changes to the original construction drawing set be made. Architects often use sketches to depict these desirable changes, thus modifying the original construction document set.

Digital communication

Digital technology is changing the ways architects and contractors communicate. For example, the use of computer-aided design (CAD) software, computer-aided manufacturing (CAM) systems, and Building Information Modeling (BIM) have modified typical standards for communication. CAD software and CAM systems create more functional connections between the architect and the manufacturer or fabricator. This streamlined process of production promotes effective organizational structures and helps to reduce inefficiencies of data transfer. BIM ties three-dimensional modeling to the data information of each component part of the building. BIM is a relatively new paradigm to the design and building industry which has the potential for creating a more seamless transition of information between architect, contractor, and subcontractor.

Presenting to clients

As an architect, communication with your client is critical. Their feedback is necessary to the development of the project. Two-dimensional representations are difficult for most untrained people to understand, since they are unfamiliar with the conventions of the drawing language. Typically, the most challenging representations for clients to grasp are the orthographic projections like plan and section, due to their abstract quality. It is difficult for some people to translate information from two-dimensional lines to three-dimensional space. Therefore, it is imperative that you learn to communicate with clients in a manner that is lucid and understandable to them. Since plans and sections are typically more challenging for

clients to understand, architects often use constructed perspectives, sketches, and models. Seeing spaces and forms is clearer with these methods. Ultimately, clients want to understand spaces being created relative to their desired program and project statements.

Presenting to builders and contractors

Architects communicate with builders through the construction drawing document set. These drawings are considered the instructions that convey the design intentions to the builder through detailed prescriptive drawings. They are part of the legal documents that explain to the builder what the architect wants built, and how. Builders are well versed in architectural drawing and understand the representations made in the construction document set.

Concept

Purely functional solutions to problems often lead to the design of buildings, not architecture. When generating ideas about possible architecture solutions to a given problem, consider both the functional and the artistic/spiritual aspects.

Read this!

Arnheim, Rudolph
Visual Thinking
University of California Press, 1971.

Generating ideas

- Too many ideas do not make a better project.

- Simplify your ideas; simple does not mean boring.

- Represent your ideas graphically.

A concept is a generating tool; it is a way to organize the component parts of the project under a single idea.

There are many ways to arrive at a concept. There are formal approaches, tectonic approaches, intuitive approaches, analytical approaches, narrative and metaphorical approaches, and site responses, to name a few. You can derive architectural concepts from just about anything: a folded piece of paper (Rem Koolhaas), a jumble of pixie sticks (Coop Himmelblau), analysis, or whatever works for you.

Even within a single approach there are many methodologies of generating ideas. For example, a system of analysis is one way to grasp as many tangible existing conditions as possible that then might provide the generating idea for the project.

You can analyze the site, context, program, or relationships between these topics and others to generate a concept. You can start developing a conceptual idea by asking questions. Start with what you know—program and site. Analyze these to understand what each might mean for the given project. Then ask the question: "what is important and why?".

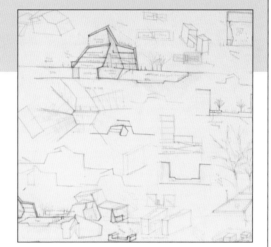

▶ Documenting thoughts

Recording your ideas is a vital part of the design process. Brainstorming can generate a series of ideas and sketches that lead you to other investigations. Recorded images allow you to react visually to a concept. Do not limit your conceptualization process to just words or images—use both.

Design does not occur in a vacuum. Ideas can be generated from other projects. Understand that ideas are not sacred; that is, similar ideas can be copied from other architects and buildings. These ideas can then be translated into your own design. The key to borrowing ideas in architecture is to translate them and make them your own. Learn from precedents and apply your own design sensibilities to the knowledge you have gained.

When trying to arrive at a conceptual idea, it is helpful to try to think physically about the idea. For example, you should sketch the idea, model it, or draw it. It's important to remember that the idea is not the architecture— it provides a way to arrive at the architecture.

Research is a vital component of the design process. It provides you with a more in-depth understanding of a project. Research can involve a number of possible investigation methods. You can research the history of the building type, the history of the site, contemporary versions of the building type, or even similar-scale buildings with a different program. You can also research the program itself.

Conceptualizing an idea

Imagine being asked to design a pencil holder without any further design parameters. Here's a possible method of conceptualizing the idea:

- Research the pencil (ask the pencil what it wants to be).
- Consider how many pencils will be held.
- Analyze precedents—what form do other pencil holders take; what questions do they answer? By looking at precedent you can think about what questions the previous designer asked and answered.
- Study the hand—this is the one element that will be interacting with the pencil.
- Consider the ergonomic relationships of the hand to pencil when removing it from the holder.
- Ask: how long are the pencils? How thick? How heavy?
- Think how you can organize the space related to each pencil. How do you want the pencils to sit: vertical? horizontal? What material to use?
- Investigate form relative to the given pencil.

Iterative process

Once you have a conceptual idea, you need to develop it into architectural forms and spaces, details and materials, circulation and experience. The process of design is one of iteration; that is, a repetitive process of development that changes over time. Each successive iteration builds on the lessons from the previous one. The iterative process emphasizes an exploration of several options before settling on one single manifestation of a project. Through an iterative process of problem solving, you will be graphically and theoretically testing potential design solutions.

In every phase of the process, ask yourself why—Why that form? Why that space? Why that location?

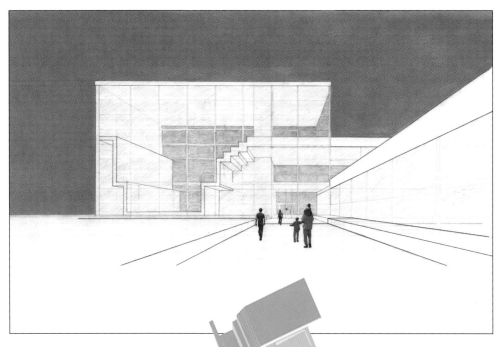

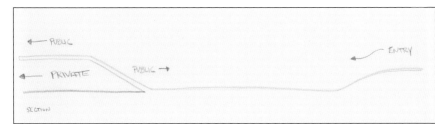

The continuity of the public area, shown by the blue line, is most important here.

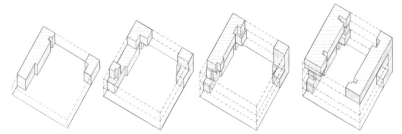

Diagrams help explore the circulation zones in this precedent study.

▲ Simplifying ideas

Diagrams describe the essence of the idea. These diagrams are used to describe the various elements of one project. The sectional diagram provides the main idea for the project, one of the continuity of the ground plane as it extends into the bathhouse project. Secondary diagrams simplify additional supporting ideas.

◄ ▲ Diagramming form

Folded colored planes depict the floor plates for a natatorium (left). The overlapping quality represents the conceptual idea: a connection between swimmer and spectator. The material continuity, represented in the diagram as the continuous plates, connects the water in the pools with the spectators. The folded plates are visible in the constructed perspective (above).

Realizing intentions

In the iterative process of design you are ultimately trying to translate what you are saying and thinking to what you are making. The process requires you to be critical of your own work. It is important to analyze your own design throughout the process. Synthesize your concepts into simple reductive drawings, or analytical diagrams (see Unit 21, page 78).

Tools for success

Some basic tools and techniques are essential for well-crafted drawings and models. As with any skill, technical ability comes with practice. The challenges met with the first drawing and first model will disappear with experience.

Papers and pads

Sketchbooks
One spiral-bound hardcover sketchbook 8½ x 11 in (216 x 279 mm) and one 3½ x 5½ in (89 x 140 mm).
Keep a sketchbook with you at all times. Use it to record things that you see around you, ideas for assignments, or anything else that inspires or interests you. Think of the sketchbook as a "diary" of your observations and architectural thoughts.

Large perforated recycled pad
9 x 12 in (229 x 305 mm).
A drawing pad is ideal for sketching assignments where pages need to be removed for presentation.

Newsprint pad
18 x 24 in (457 x 610 mm).
A newsprint pad is ideal for quick sketches. The quality of the paper is not suitable for finished drawings or for the preservation of drawings. This type of pad is not ideal for use with charcoal.

Large-format drawing pad
18 x 24 in (457 x 610 mm), 100# paper.
A large-format drawing sheet is ideal for figure drawing and still-life drawing. Backed by a clipboard, this drawing pad can be taken into the field for on-site sketches. The paper quality in this drawing pad is much more durable than in the newsprint pad and is therefore better for more finished types of work. This pad is ideal for use with charcoal and pencil.

Vellum roll or sheets
24 in (610 mm) roll 20 lb.
Vellum is a semi-transparent material. It is relatively easy to erase and is a durable material to construct presentation drawings.

Roll of cream, yellow, or white tracing paper
12–18 in (305–457 mm) wide.
Tracing paper is ideal for sketching and working in overlays. Overlay your trace on top of other drawings to make modifications and change ideas.

Tools for freehand work

Large box
For carrying and storing tools.

Pencil sharpener with shavings receptacle

Charcoal sticks

White charcoal pencil

Spray fix
Use this to seal your charcoal drawings.

Kneaded eraser
Use a kneaded eraser to dab lines when you want to dilute their strength or weight.

White eraser

Pencils
Hard: 2H, H; **Mid:** HB;
Soft: B, 2B, 4B, 6B.
The ideal pencils for sketching include the range from HB to 6B; softer leads give you a variety of line weights and types. You will need to develop a rapport with the pencils to establish your own line weights.

Colored pencils
Start with primary colors, then experiment with others.

Tools for hardline work

Swing-arm lamp
Lighting is key to creating beautiful drawings and models. Use task lighting to highlight your desk surface.

Drafting board
32 x 48 in (813 x 1219 mm) minimum; a hollow-core door or other smooth portable surface. Your drafting board must be sturdy and smooth without nicks or dents. A large surface is ideal for flexibility of drawing sizes. A lightweight board is ideal for carrying.

Drafting surface and board cover
A self-healing vinyl membrane covers and protects your drafting board and is ideal for drawing on. It is not a good idea to draw directly on wood or other hard surfaces.

Double-sided tape
Use this to attach the drafting surface to your board.

Leadholders
Having multiple leadholders lets you use a variety of thicknesses simultaneously without exchanging leads.

Tools for hardline work (continued)

1 box of each of the following leads: 4H, 2H, H, F, HB, and B
The leads for drafting range in the H, with a few darker leads of HB and B. The harder leads offer more precision and sharpness of line.

Lead pointer
Use a lead pointer for sharpening your lead. To sharpen, pull slightly outward, using centrifugal force when rotating the lead around in the pointer.

Tweezers
In model building, use tweezers to help you connect small pieces together.

Erasing shield (with small slots)
Use a shield to erase short lines or specific lines in areas where there are lots of other lines you want to keep.

Drafting dots or tape
Use dots or drafting tape to attach drawings to the board. These adhesive materials won't leave residue on your paper.

Drafting brush
A drafting brush prevents smudging. Use this tool rather than your hand or sleeve. Oils from your hands must be minimized on the drawing surface.

Parallel edge
42 in (1,067 mm) long with rollers on underside.
Use the parallel edge to construct hardline drawings. Never use it as a guide to making cuts—preserve and protect it at all times. Make sure each time you come to your board that it is aligned properly. You can test this by bringing the edge down to the bottom of the board.

Compass
Use this for constructing circles.

Sandpaper (200-grit)
Use sandpaper to clean the edges of any wood surface. A sanding block is helpful to maintain 90-degree corners on wood. You can make a sanding block by wrapping the sandpaper around a scrap piece of square-edged wood. Light sanding can remove pencil marks and minimize joints between two pieces of wood. Too much sanding, however, can round the edges of the model. You can also sand plexiglass to change the transparency to appear translucent. Reduce the amount of scratches apparent in the plexiglass by sanding on both sides.

Drafting powder
Sprinkle drafting powder onto the vellum to protect the drawings from smudging.

6-inch (152-mm) metal-edge ruler
A metal ruler is good for measuring and cutting smaller model pieces.

Permanent marker
Use a marker to label your tools.

18-inch (457-mm) 30/60/90° triangle

14-inch (356-mm) 45° triangle

Triangular scale
Use the scale for measuring and dimensioning your drawings.

Aluminum or plastic push pins
Use pins to hold your work up for display or reference.

10-inch (254-mm) adjustable triangle
Use this to construct axonometric and perspective drawings.

Tools for model making

Blade holder
Use a blade holder to cut most model making materials. Thicker materials require either more cuts or the use of a utility knife.

Blades (x100)
Buy blades in bulk, since you will be replacing them often.

Utility knife
Make long cuts with a larger knife. Cutting into thick surfaces like foam is easier with a long blade that is adjustable up to 4 in (102 mm) long. Remember when cutting with large knives to score the material first with a light stroke. In general, aim to use less pressure and more strokes. Change blades often.

White glue
White glue dries clear and is very strong. Use in small amounts to maintain a clean appearance.

Acrylic glue
Use this for gluing acrylic materials.

Cutting mats
18 x 24 in (457 x 610 mm) and 8 x 10 in (203 x 254 mm). Cutting mats are designed to "heal" after cuts. It is useful to have more than one size. They protect your tabletop and drafting board.

36-in (914-mm) long metal edge with cork backing
A cork-backed metal edge provides a slip-resistant tool for cutting. You can also use any straight-edged metal object like a metal triangle. Plastic triangles and parallel bar edges are susceptible to nicking and should never be used to cut along.

Caring for equipment
It is important to maintain your equipment in a careful manner. Properly stored and cleaned tools provide a strong foundation for crafting high-quality drawings and models.

Optional tools

Portfolio for carrying drawings, and/or a **drawing tube** (tubes are not ideal for Arches paper)

French curve

Triangles, 4–6 in (102–152 mm) long and 16–20 in (406–508 mm) long: 30/60/90°, and 45° triangles

Triangular engineer's scale

Calculator

Scissors

Electric eraser

Cleaning solution to maintain your drafting board

Circle template (inking bumps optional)

Oval template (inking bumps optional)

Measuring Tape (25 ft [7.6 m] or longer)

Graphite sticks (6B or softer)

Clamps and fasteners: binder clips, small clamps, and rubber bands. These can be used to hold pieces in place while glue is drying.

Miter box and saw

Wax paper: useful as nonstick gluing surface.

Chopper: used for making repeated accurate cuts across the grain of the wood. Used most often with stick basswood pieces.

CHAPTER 2
Learning to see: sketching

Sketching is a technique of documenting ideas in a quick, uninhibited fashion. Learning to sketch is like learning to see in a new way for the first time. It is a method of visually thinking on paper, and it can be observational or invented. The quick fashion or loose methodology does not imply that the sketch is sloppy or uninformative. Quite the contrary—sketches provide architects with a method of representation that isolates, recalls, and documents ideas. They give architects some of the first opportunities to make design ideas physical as well as being useful for gathering information.

Like drawing, sketches can reinforce design intentions. With the fluidity of a single line or the movement found in a group of thoughtfully composed lines, sketches can reinforce the architectural narrative.

As with architectural skills, sketching can be learned, developed, and mastered with patience and time. With practice you increase your ability to capture ideas quickly, efficiently, and accurately.

This chapter will demonstrate different ways to facilitate your ability to observe and record ideas and visual data in the world around you. It will teach you to demonstrate the ideas in your mind on paper.

Sketching types

The types of sketches used by artists and architects vary depending on intent. Sketching involves the translation of existing visual information or an idea to a two-dimensional surface—the paper. To do this effectively you must know what you want to draw and how best to represent it.

Sketch vs. photograph

Sketching teaches you to see, not just to look. The act of careful observation of a scene and then the translation of that information onto paper requires a serious understanding of the subject. When sketching you can critically assess relationships, sizes, and spaces between objects. In addition, the editing process gives you control over the translation of an image to the paper. Removal of superfluous information brings clarity to the image. Like sketching, photography enables the artist to capture a moment in time. One striking difference between the two formats is that the sketching artist is forced to make conscious representational decisions about what to draw. These decisions act as a filtering process. Limit sketching from photographs because these are already filtered environments.

▼ Observational sketching

Observational sketching is one of the most common ways to record the environment. The first rule is to draw what you see and not what you know, or think you see. Sketching involves seeing, not just looking. By not letting your knowledge of an environment or familiar object muddle your observational skills, you will be able to transfer existing information to the page more easily. Look at observational drawing as an exploration, not mere documentation. As the artist, you are making decisions about what to edit and include as part of the exploration process. You can use this process to emphasize aspects of the drawing or clarify the visual information. In general, drawing from life is complex. You provide clarity and your own self-expression through your sketches of the built environment. Start each sketch with a purpose. Think about what aspect of the view you want to capture. Ask yourself what you want the narrative of the drawing to be; that is, what story you want it to convey.

▲ Blind sketching

Blind sketching, another type of observational drawing, captures an object or space without the artist being distracted by accuracy. In this type of drawing, the hand and eye communicate an image onto the paper without the eye watching the hand construct the image. Your hand is not inhibited by the observations of your eyes trying to make the image "correctly." This method of sketching allows you to concentrate on what you are seeing, and helps to develop and strengthen the control of your hand in regard to what you want to depict. Sometimes blind sketches capture the essence of the view better than a longer, observational sketch. This technique teaches you how to move your hand according to what you see. It also improves intuitive spatial coordination when practiced often.

The plan of a space is something experienced, but not seen in its totality. By sketching the plan, you can begin to understand the forms of spaces and relationships between elements.

Multiple drawings of the same building on a single spread can provide a more complete story.

ASSIGNMENT: 4

Plexiglass sketch

Take a piece of plexiglass, roughly 10 x 14 in (354 x 356 mm), and hold it 16–24 in (406–610 mm) away from your face in a comfortable position. Go outside and direct the plexiglass toward something that interests you. Close one eye. Literally trace over what you see using a washable marker.

This assignment allows you to understand the fundamental elements of observational sketching through the method of tracing. In constructing some of your first sketches, it is much easier to trace the lines of the view. This technique focuses on what you see over what you know. It provides the structuring elements that will aid your confidence in sketching.

ASSIGNMENT: 5

Unusual viewpoint

This method of observational drawing teaches you to see without being distracted by what you think you see. Find a sculpture or bust of a Greek or Roman statue. Sit obliquely to it, relatively low and close, so that the contour of the nose, cheeks, and chin become foreshortened and are presented to you in an atypical manner. This unique view forces you to look closely at the relationships between these elements (the nose, eyes, and chin) rather than drawing what you think you know. By drawing in this manner, the face becomes more of a landscape and less of what we recognize as a face.

Contour sketching

The contour sketch is a single-line drawing that focuses on the outline of the form or figure. When drawing, you should be attentive to the edge of the form and the quality of the line creating that edge. There is no tonal value expressed in this sketch type, but by varying the thickness of the line, it can express the mass of the object. In graphite, lines can accentuate, accelerate, become thin and then become thick. With each change, they indicate a subtlety in the form of the object representing roundness, a crisp edge, depth, and thickness—all with a single line.

Design sketching

Design sketches allow you to think on paper and draw what does not actually exist. The nature of the design sketch is one of exploration; it can take on any physical manifestation, including a variety of drawing types that are both two- and three-dimensional in nature. Design sketches can also be intermixed with text, photography, and other graphic images. Most of what you design does not exist until you construct it on paper; therefore it is important to learn how to draw what does not exist. Frequent sketching of existing objects hones your invented drawing skills.

Analytical sketching

Analytical sketches are less pictorial; they don't necessarily depict spaces or objects as you would see them, but are more abstract and reductive in nature. These types of drawings help reorient a project or an existing condition to understand it better. Analytical sketches assess the essential component parts and relationships of an object or idea and record them in a visual manner.

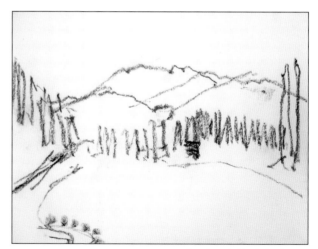

A gesture sketch of a landscape.

▲ Gesture sketching

The gesture sketch is a very quick sketch that captures the essential weight and movement of a scene. It captures an initial reaction to a view. It is made with a series of gestural lines, usually in a matter of about 30 seconds. It conveys the essence of the object, the "bones," without being distracted by the details.

Sketching techniques

The line is the basic building block of any sketch. The quantity and quality of the lines determine the type of sketch and the technique employed. Line variations occur with different medium types, and a series of lines graphically conveyed in similar fashion can create tonal value.

Read this!

Laseau, Paul
Freehand Sketching: An Introduction
W. W. Norton and Company,
New York, 2004

Kahn, Louis.
The Value and Aim of Sketching
Writings, lectures, and interviews, 1931

Tonal value emphasizes the creation of a surface rather than the contour or edge of an object. These sketches map the lights and darks of objects and spaces. The space between objects is shaped and formed with value. Value sketches represent a series of comparisons of visual relationships—they are a tool to see those relationships in an abstract manner. When blocking out for value sketching, concentrate on the major organizing elements in the initial layout, then work the detail into the drawing. There are a number of sketching techniques that can be used to create tonal values.

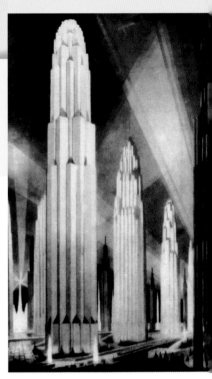

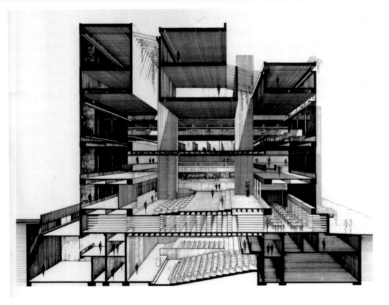

Hatching
Hatching is created by a series of diagonal lines in one direction. Cross hatching is created by a series of diagonal lines in two directions to provide tonal values in sketching.

▲ Vertical or horizontal lines
Lines without cross hatching can also be used to create a surface tone. The collection of lines in this Paul Rudolph drawing of the Art and Architecture Building creates density, providing areas of tonal value.

Scribbling
Scribbling is a technique used to create tonal value. It employs random rounded lines that numerously overlap to create a tonal value. The emphasis is not on the individual squiggle or line but on the totality of all the lines creating a tone.

Stippling
Stippling uses a series of dots marked on the page quickly—the collection of dots is used to create tonal values and gradations. The density of the dot pattern determines the legibility of the forms. By varying the number of stipples in an area, the impression of depth or the curvature of an object can be achieved. Though this method can be very time consuming, the outcome can be quite wonderful due to the control of each individual point.

▲ Shading
Shading, as in this example by Hugh Ferriss, emphasizes areas of tonal space over the production of a single line. The drawing is made by concentrating the marks on a surface as opposed to an edge. A sense of depth is achieved when changing values of the tone. This technique is typically associated with drawing media that quickly create large surface areas, such as charcoal, pastel, and loose graphite.

Achieving tonal variation

On a sheet of paper from your drawing pad create six rectangular boxes 2 x 8 in (51 x 203 mm) divided into 1 in (25 mm) increments. Practice a different method of sketching in each box. Start at the left and label the boxes as follows: "stippling," "shading," "scribbling," "crosshatching," "vertical lines," and "horizontal lines."

To achieve tonal consistency, build up a series of layers rather than using hand pressure to vary tone. For example, start with the stippling method. In the top eighth

of the vertical box, begin to put a few dots on the paper. Put the same density of dots in the whole box from top to bottom. Repeat this exercise from the top, but this time skip the first eighth. Repeat the exercise again, this time skipping the first two eighths. Continue until you have repeated this eight times. Within the eight divisions of the vertical box you will see the variety of tonal variation it is possible to achieve with the layering technique. The goal is to achieve a smooth gradation from one tonal range to another.

Stippling provides tonal variations for sketching and rendering.

Composition

● The foreground and background areas can provide a transition between the viewer and the object or space in the drawing.

● The white of the page, along with the edges, is just as important as the black of the line being created. Don't be afraid to leave lots of white on the page. Understand the role of the white on the page; it should have some meaning.

● Understand the relationship between form and space. Consider the effects of light, volume, weight, shadow, edge, and space.

● Consider the size of the image relative to the size of the paper—the size determines the amount of information necessary and feasible.

● Consider the location of the sketch on the page. The finished size of the image to be drawn determines where it is possible to locate the sketch and the page orientation. The overall composition of the page can affect the legibility and power of the drawing. The page orientation, either landscape or portrait, can reinforce the intentions of the sketch (see page 16).

Louis I. Kahn

Louis I. Kahn (Estonian/American b.1901 d. 1974) is one of the best-known architects and teachers of the 20th century. For Kahn, architecture was the resolution of the interaction of materials and light—without light, architecture would not exist. Kahn's travel sketches depicted not only the architecture he observed, but more importantly the way buildings interacted with light. He was a keen observer, and is known for his insightful and inspirational quotes.

▲ Mass and light

Louis I. Kahn's travel sketches document ancient Italian architecture like the Campo in Siena. The appreciation of mass, geometry, and light in his travel sketches would later inspire his own architecture.

"The capacity to see comes from persistently analyzing our reactions to what we look at, and their significance as far as we are concerned. The more one looks, the more one will come to see."

Louis I. Kahn

▼ Capturing space

The travel sketches of Alvaro Siza provide an excellent case study for architectural sketching. The beauty of these sketches is not found in their representational quality, but rather is derived from how clearly they convey mass of buildings and the space in between.

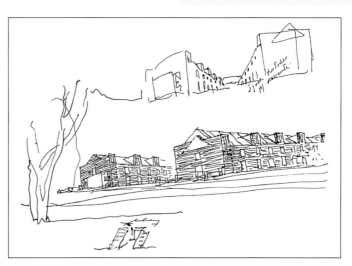

Sketching media

There are not only a number of different media that help determine the legibility of your intentions, but also a variety of paper types on which to sketch. Both can reinforce the intentions of the drawing and should be considered before starting the sketch. Some papers are better suited to certain media.

Medium choices include graphite, ink, wash, charcoal crayon, Conté crayon, and pastel or colored pencil. Time, location, intention, and audience determine which medium choice to use as well as which technique would be most appropriate. Each medium can provide a variety of effects.

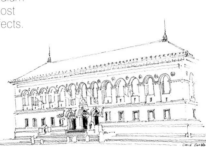

▲ Ink
Ink is a permanent, non-erasable material with a consistent line-weight and thickness. Drawing with it is about commitment. Tonal variation is achieved with variations in pen thickness, overlapping lines, pattern, and density of lines rather than variations of hand pressure. Ink is appropriate for gesture drawing due to the fluidity of the material.

▲ Graphite
Graphite is a flexible material. It makes readily controled marks and is easy to erase. Soft pencils are typically used for sketching, as they have the flexibility to create a number of different marks on the page based on hand pressure and the angle of the lead. With a soft pencil, it is easy to create an illusion of depth on a two-dimensional surface. With the pressure on graphite you have more opportunities for creating different types of marks on the page including shading, cross-hatching, linework, and tones. If not protected with spray fix, graphite will fade over time.

▼ Water-based washes
Water-based washes include watercolor, gouache, and ink wash. Watercolor is a water-based paint that is applied like a wash. It is good for showing transparency, tonal variation, and color, but it is difficult to correct and hard to control the location of the wash, and you cannot overpaint. Watercolors are created from the lightest to darkest value. Gouache is a water-based opaque wash that can be overpainted. Ink wash can be made by diluting ink. You can use bamboo or brushes and can create both line and value.

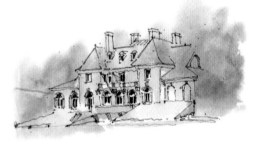

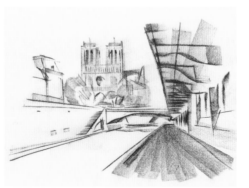

◄ Conté crayon
Conté crayon is a square-profiled drawing stick made of compressed chalk. It is similar to charcoal—often harder—but you can still achieve a soft line. Conté crayons are ideal for creating drawings on rough paper. They offer a variety of line types from the thin line to the thick line to the tone achieved by using the flat of the stick. Different from the charcoal stick, you cannot smudge with Conté crayon.

Making marks

- Map out a few light lines that indicate the general structure of the object or space; start with the general and proceed to the specific. Use guidelines to establish relationships between elements.

- Think about the location of the first marks—understand the limits of the page. Where you set your first marks will determine size and scale of the image, so design the sketch on the page.

- Pay close attention to proportion and scale of elements.

- Use a pencil or your index finger to create alignments of objects in the view (setting up vertical or horizontal relationships). Use construction lines to help define relationships between parts of the object.

- Don't be afraid to put the first mark on the page.

- Develop hierarchy in the sketch.

- Build up detail.

- While sketching, never apologize for any line that you make on the page. Do not erase. Redraw over any part of a sketch that seems incorrect; this is part of the process of learning to sketch. Start light and build up.

- There is an editing process that occurs when transferring what you see or invent onto paper. This allows you simultaneously to process a specific intention for the drawing while making decisions about what to include and what to leave out.

- Sketching is not only about developing your style—your voice,

if you will—but developing the understanding of when and which media and papers to use to convey your ideas best. Your drawing medium and type should reflect the nature of your design and the architectural intentions.

▶ Transferring data
To establish accurate proportions, scale, and distance, use a pencil (or other straight device such as your finger) to transfer approximate dimensions and angles onto the paper.

Pastel crayons
Pastel crayons are created from powdered pigment and adhere to rough paper easily. They are similar to charcoal sticks, but come in a variety of colors. They provide similar qualities to the charcoal and Conté crayon, but with a focus on color.

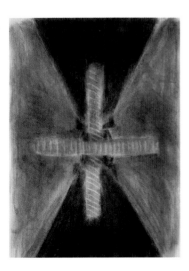

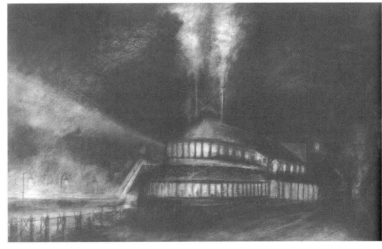

◀ ▲ ▶ Charcoal
Charcoal is a workable material that has the flexibility to create various types of marks and tonal values. It is ideal for depicting the dramatic effects of light on a surface, and providing textural qualities of space, light, and materials. The "messy" quality of charcoal allows an artistic freedom to describe space —it liberates any fear of drawing incorrectly. As in the drawing by Turner Brooks of the Eugene O'Neill Theater in Waterford, Connecticut (above), the strength of the medium derives from the high contrasts in light and shadow: even quick sketches take on a dramatic effect when rendered in charcoal. Vine charcoal is good for quick gesture drawing, while compressed charcoal, with different qualities based on different thicknesses, is good for large tonal drawings. With charcoal, always start light and work into the darks.

Papers and pads

Newsprint
Newsprint is a thin, inexpensive paper with a natural gray tone, ideal for practice sketches. It does not have the same durability as other types of drawing papers. It tears easily and it is therefore harder to develop or work a drawing on this type of paper. It has no tooth.

100# all-purpose acid-free paper
Acid-free paper such as Strathmore is a thicker white paper ideal for sketching with charcoal, ink, and pencil. It is more durable than newsprint.

Arches
Arches paper is a French watercolor paper better for line and tonal drawings. It comes in a variety of weights ranging from 90 lb to 140 lb. "Hot press" is a smooth paper with less tooth, while "cold press" is rougher and more textural. The paper is archival quality and very sturdy. The rougher tooth holds the marks of Conté crayon, charcoal, and pastel very well, while the smooth tooth is ideal for graphite.

Mylar
Mylar is a clear film that takes ink well. It is relatively easy to erase ink on mylar using an electric eraser and a little bit of moisture.

Vellum
Vellum is a translucent material that is ideal for working with graphite. The paper comes in a variety of weights. Linework, rendering, and shade/shadow tonal work can be created on vellum. It is ideal for layering drawings on top of one another due to its translucent quality.

Craft paper
Craft paper is a smooth brown paper. It works well with pastels and charcoal and it provides an excellent non-white surface on which to draw. White and colored pencils can be used with ease on this surface.

Trace
Trace is a transparent material used for overlay sketches.

newsprint

trace

vellum

all-purpose acid-free paper

Still-life sketching

Create a still life using a combination of chairs, stools, and other small-scale objects. Place them in a manner that is atypical to their normal orientation; this helps to relieve familiarity with the object. This assignment asks you to challenge your preconceived notions of recognizable things, and will help you to push yourself beyond what you are most familiar with. You are asked to see the object in different ways, as a solid, as a space definer, as a surface, and as a void. One goal for the project is to push your own observational skills by re-examining something that is familiar. You are also asked to think about the drawing as a way to tell the story of the object. It is a method of intentional description of a given object.

You should experiment with media and techniques to find those that are interesting and expressive for you. You should consider issues of layout and composition (how you fill the page with the object). This assignment should give you drawing confidence as you become familiar with your object as well as an opportunity for you to challenge yourself with new approaches.

Brief
Construct a series of six timed sketches using a variety of the techniques and media described in this chapter.

- Two rounds of 30-second blind drawing
- 30-second sketch
- 1-minute sketch
- 5-minute sketch
- 10-minute sketch

Redraw the same composition using another medium.

1 Start with a 30-second blind drawing to attune your hand and eye control. Work to get the whole object on the page within that timeframe. Detail is not important in this drawing. Concentrate on proportion and the relative scales of each object to itself and to the other objects.

2 Begin a new drawing by sketching the spaces between objects as opposed to objects themselves. This will enable you to work on proportion and scale without being distracted by foreshortened elements.

3 Use guidelines to verify the location of elements in the sketch. For each timed drawing, your goal is to get a complete image on the page. Your drawing techniques will change slightly as the time increases.

4 Return to areas of the drawing to provide additional details, tone, or corrections to the alignment, proportion, or scale of the elements. Build up the drawing. Do not develop one area too much prematurely.

Steven Holl

Steven Holl (American b.1947) founded a critical journal in 1978 entitled "Pamphlet Architecture." These small booklets became avenues for architects to disseminate theoretical architectural treaties. Holl balances theoretical work with built work, exploring and testing ideas pertaining to the links between science, technology, and art. He has designed important cultural buildings throughout Europe and North America. Steven Holl's work can be characterized with his insightful investigations of how light enters and interacts with a building. He studies these relationships through watercolor sketches.

▶ Investigative watercolor sketch
This Steven Holl sketch of the Chapel of St. Ignatius in Seattle captures his concept of the seven vessels of light entering and energizing the building. The characteristics of watercolors, transparency, overlapping, and color perfectly allow him to study the interplay of light and form.

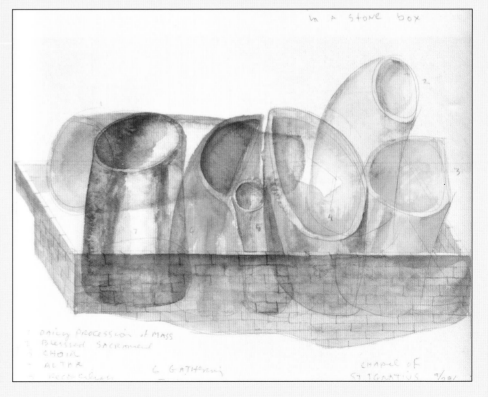

Sketching the line

Lines are manmade creations that provide information about changes in form, depth, material, or brightness.

"Line does not exist in nature. Line is an invention of man; so, in fact, is all of drawing… There must have been a reason for the invention of the line. Yes, it is a guide for those who would venture into the formlessness that surrounds us on every side; a guide that leads us to the recognition of form and dimension and inner meaning."

George Grosz, painter, 1893–1959

One technique that is extremely helpful in improving sketching is the mastering of the straight line. The language of the line is an essential component to understanding drawing. The line is a continuous mark on a surface that is defined mostly by its length relative to its own width or thickness. The thickness of the line can vary with different media.

The line, if properly drawn, can delineate sharp edges or soft contours. Through the pressure, thickness, and angle of application, it can suggest different textures, shapes, and forms.

You should come to understand your own natural hand pressure. This affects the marks made on the page by graphite. It is important that you know this so that you can determine which leads, hard or soft, are best suited for you. If you have a heavy hand you will want to work more with the harder leads, while if you have a light touch on the page you will want to work with softer leads so that your lines appear appropriately darker.

Pen and digital line weights

Pen and digital line weights do not vary in the same way as graphite. Variation of line types is achieved through pen thicknesses rather than hand pressure. Pens have a consistent stainless steel tip and ink flow and therefore maintain their line consistency and type throughout the length of the line, as well as throughout the entire drawing.

The pen weight range includes: 0.13 mm, 0.18 mm, 0.25 mm, 0.30 mm, 0.35 mm, 0.50 mm, 0.70 mm, 1.0 mm, 1.4 mm, and 2.0 mm. The range of lines available in digital output may vary, but typically includes 0.05 mm–2.1 mm. The number of pens available in both digital output and as individual drawing instruments offers a large variety of line weights with which to draw. As with the lead range,

A range of digital line weights

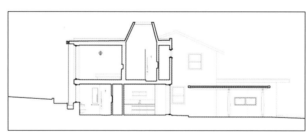

▲ Proper line weights
The section cut is clearly visible as the various line weights, from dark to light, depict the depth of the space.

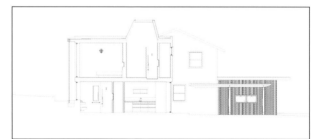

▲ Single line weights
The lack of a strong section cut and other line weights renders this section illegible. The strongest component of the image is a series of closely packed vertical lines. In the previous section, the line weight is lightened quite a bit to reduce the emphasis.

it is not necessary to maintain all the pen sizes. A good range includes small, medium, and large tips: 0.13 mm, 0.25 mm, and 0.50 mm. You should have the variety of pens necessary to convey depth properly in a drawing.

Graphite line weights

Graphite line weights include the spectrum of marks made by both hard and soft leads. There is a range of graphite weights associated with hard-lined drawing (drawing with your parallel rule and drafting board), freehand drawing, and sketching. Leads range from a soft 6B to a hard 9H. The harder the lead, the lighter, crisper, and thinner the line will be. It is important that you find your own appropriate range of drawing weights as each lead has a variety of associated marks depending on your own hand pressure. For example, an HB lead (a middle-range lead weight) can actually provide a number of different line marks, ranging from light to medium to dark, based on how much pressure is applied. Variation in graphite is made through pressure and lead choice.

Line-drawing exercises

Line drawing exercises allow you to gauge your own hand pressure and to achieve straight line accuracy. It is important to develop the proper hand-eye coordination to draw. You will need to move your entire arm while making long straight lines. This provides you with stability as you move the lead holder across the page. Twist the lead holder between your fingers as you move it across the page to maintain a consistent point on the lead.

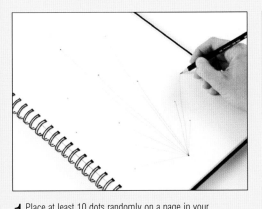

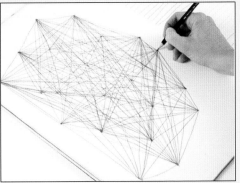

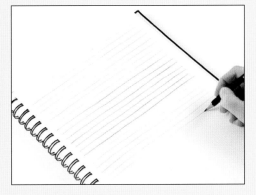

1 Place at least 10 dots randomly on a page in your drawing pad. Use the entire space to distribute the dots. Do not align more than three. Now draw freehand lines connecting one point to each of the others. Look ahead to where the line will end and try to make each line straight and of a consistent line weight.

2 Connect every dot to every other dot. Do not use a ruler or straight edge for these exercises. Use an HB sketching pencil. Sharpen your pencil often. Do not lift the pencil up or pause in the middle of a line. Use your entire arm to draw—not just your wrist—from your shoulder to your fingers. Remember to roll your pencil to help keep the point consistent.

3 On another sheet, draw a series of horizontal lines, keeping the lines parallel and around ½ in (12 mm) apart. Draw each line continuously from one side of the paper to the other. Vary your hand pressure after every five to eight lines.

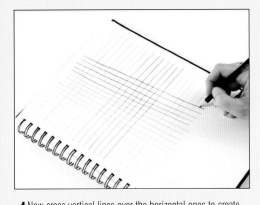

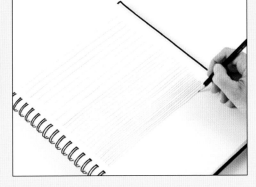

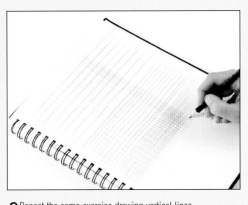

4 Now cross vertical lines over the horizontal ones to create a grid. Try a variety of lead hardnesses, and both lead holder and pencils, to experiment with your own hand pressure. Compare the lines created with the lead holder and a sketching pencil. In addition, use an HB lead in the lead holder for five lines, then press harder for five lines, then lighter for another five lines. Next try the HB pencil using the same methodology of five lines regular, five lines harder, and five lines lighter.

5 Carefully draw horizontal lines across the width of another page. Maintain a 1-in (25-mm) distance between the lines at the top quarter of the page. For the next quarter, keep a consistent ½-in (12-mm) spacing between the lines, followed by a ¼-in (6-mm) spacing for the next quarter. Finally, the bottom quarter of the page should be filled with lines ⅛ in (3 mm) apart. Keep the lines straight and parallel. Work on line control and consistency.

6 Repeat the same exercise drawing vertical lines.

Selecting an object

Architects draw for a number of reasons—sometimes just to practice. There are many opportunities to practice sketching from the built environment.

Read this!

Chaet, Bernard
The Art of Drawing
Wadsworth Publishing, 1983

Cooper, Douglas and Mall, Raymond
Drawing and Perceiving
Van Nostrand Reinhold, 1992

Crowe, Norman and Laseau, Paul
Visual Notes for Architects and Designers
John Wiley & Sons, 1986

Edwards, Betty
Drawing on the Right Side of the Brain
Tarcher, 1979

Yee, Rendow
Architectural Drawing (Chapter 3)
John Wiley & Sons, 2007

Deciding what to sketch can sometimes be difficult—you can pick from a variety of elements based on size and opportunity. You can select an object small enough to hold in your hand or something as large as a city. You can also sketch buildings or spaces—but to be able to practice, choose an object that is convenient to draw. When practicing, pick an object that has lots of physical and visual variation that allows you to draw it with a variety of media.

Finding a small object to draw can be quite easy. There are many objects in your everyday environment that are ideal for sketching. It is good to practice sketching the same item over and over again, as this will help you evaluate and practice with a variety of media. Vary the lighting and the viewpoints of the same object to provide further areas of study.

Object
Pick an object that can sustain your interest for a long time. The object you choose should be portable. It would be best if it moves in some fashion; it could be a tool. You will be using the tool and the sketch as a way to discover your own particular drawing interests and passions. Tool examples that have movable parts include pliers, scissors, leatherman/multitools, stapler, corkscrew, can opener, nail clippers, architectural compass, and corkscrew.

Additional qualities to look for in choosing an object include:

- Multi-sidedness
- Complex lines
- Geometric variation
- Reflectivity
- Transparency
- Irregular surfaces
- Shadows it casts on itself and on surfaces below and behind.

Building
Select a building that has a regular geometry, repetitive elements, and non-curvilinear forms. It would be useful to sketch both the interior and exterior conditions of a building, so access is important. Selecting a building like a public library is a good place to start.

▼ Tonal sketches
Rendered graphite sketches can highlight details of an object. The curvature of metal, its reflective quality, and deep shadows can all be captured with graphite.

A close-up view of the penknife shown on the left

Space
Find a space to sketch that is open and well-defined. That is, the buildings that surround the space clearly define the shape of the space. This could be a large room inside, a large space outside like a plaza or courtyard, or an alleyway between two buildings.

Sketching small objects

▶ Shadow and form

Complete a series of sketches that convey the shape and form of the object. Try a technique of sketching everything but the tool itself. In another sketch use shadows to ground the tool to a surface. Transparency sketches will show the interior form and structure of the tool.

▲ Quick studies

Complete a series of experimental sketches. Utilize different drawing types and techniques to represent a variety of scales, views, compositions, and contexts. Careful "seeing" is required. Pay particular attention to the proportion of the object and the scale of the elements in relation to one another.

Figure drawing

Drawing the nude figure is an important way to practice recording proportion and scale and establishing the relationship of the whole with its parts. Drawing the figure explores gravity, structure, and light, and trains your eye to understand balance and form.

Drawing figures

There are many opportunities to draw the figure:

● Art museums, schools of art or architecture, and community colleges often host figure drawing sessions. Call to find these sessions or check with local artist organizations.

● Figure drawing does not have to be nude. Ask your friends to pose for you or go to a public place and draw. This will develop your speed, because unknowing subjects move a lot.

● Draw statues that you find in public spaces or museums.

The body does not have sharp edges, yet the contour is delineated with a line. It is important that this contour be depicted so as to indicate the form of the body.

One technique for drawing the nude figure is to imagine a vertical line—a plumb line—that establishes relationships between distant elements. Imagine a line running from the center of the model's nose to a point at the base of the body. Where does the line end? Does it align with the heel, toe, or a void space? You can use your pencil to mimic the plumb line, to establish these vertical and horizontal relationships. When using this technique, closing one eye allows you to align your pencil with what you are viewing. The imagined lines or the pencil establish a direct relationship between parts that may not be on the same plane. The imagined lines allow you to visualize relationships between elements without having to consider depth or foreshortening.

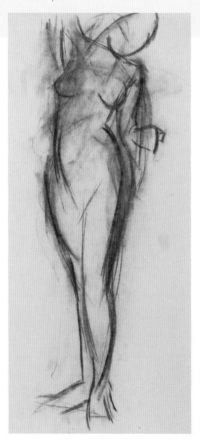

◄ Figure as contour
This representation of the figure by artist Mary Hughes uses the changing thickness of the line to capture movement and curvatures in the form of the body. Elements like the hands and feet are abstracted to concentrate on the figure as a whole.

Figure drawing encourages you to practice drawing what you see rather than what you think you see. The figure is very familiar to you but, by looking, you see the figure accurately. You see the spaces between parts as opposed to the parts themselves. You see the contour of the form as opposed to the body part that makes the form. With the figure you can concentrate on drawing the contour of the form itself, the positive space, the shape that the figure makes, or even the negative space. When mistakes of proportion or form are made, you will immediately notice it. The process of drawing trains you to see the figure and not just draw what you think you see.

When drawing the figure for the first time it is important to get the whole figure on the paper. Draw to fill the page—that is, don't draw too small on the paper. These drawings should be considered working drawings that can be fixed by redrawing over existing lines. Realize that you are intellectually and physically working out what you see.

Look for the weight of the figure. Let stronger lines emphasize this weight. There is value in the line that can develop the weight of the figure. The shadows cast by the figure provide opportunities to highlight the curvature of the body and the space between the body and the surface it is on. Study how the light interacts with the body and vice versa.

Image folder exercise

Find examples of drawings, models and sketches from a 19th century architect from the following list: Henry Hobson Richardson, Frederick Schinkel, Louis Sullivan, Frank Furness, Henri Labrouste, Sir John Soane, and Charles Rennie Mackintosh.

For each drawing, examine the technique of the drawing, medium of the drawing, and size of the drawing (if listed). For the models, note the material, size of the base, and level of abstraction. Store the sketches inside your image folder.

This exercise will allow you to tie a specific time period with the typical representations and techniques associated with the era. As you continue this study, examine what changes occur over time, and what stays the same.

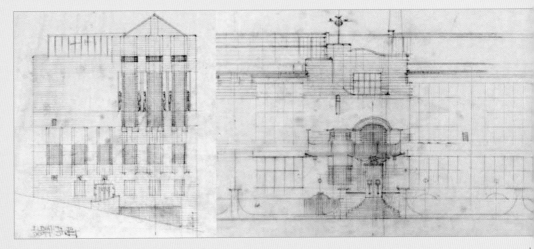

Elevations of the Glasgow School of Art by Charles Rennie Mackintosh.

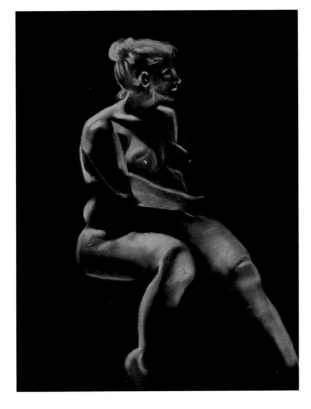

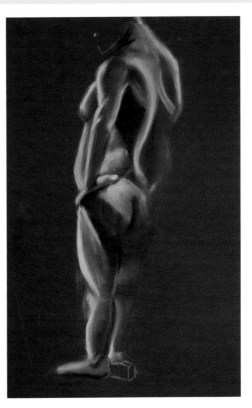

◀ Paper options

Drawing on colored papers allows you to try a variety of different sketching techniques. White pencil can be used on dark paper. The color of the paper is incorporated into the figure sketch.

Generally the feet and the head are the most difficult elements of the figure to appropriately scale. Practice drawing them so that your future drawings capture the appropriate scale and proportion.

Orthographic projection

Plans, sections, and elevations, known as orthographic projections, are some of the most fundamental tools of representation. They are two-dimensional abstractions that convey both horizontal and vertical information. They have strong relationships to one another and the representations of such drawings can facilitate a clearer understanding of a project. The successful understanding and implementation of these skills is fundamental to communicating with different audiences, including the builder, the client, the community, and other architects.

Orthographic projections are abstract drawings that do not represent objects as we see them. Because orthographic projections lack the three-dimensional qualities of perception, they have none of the foreshortening or distortion that we see in real life.

The method and construction of orthographic projection can reinforce the design ideas of the architect. Therefore it is important to understand the basic structuring devices for these drawings to equip yourself with tools that can develop your design ideas.

By drawing a variety of orthographic representations of a building, you can isolate particular design investigations. For instance, program and circulation can be studied in plan, while stairs, double height spaces, and windows can be investigated in section.

Since it is difficult to convey a project in a single drawing, multiple drawings or orthographic sets are used to present a more complete picture.

This chapter introduces fundamental skills of orthographic projection through the work of Albrecht Dürer. Drawing techniques and line weights are discussed.

Plan, section, and elevation

A compilation of two-dimensional orthographic drawings can describe the space of a three-dimensional object. There are three drawing types that make up the collection of orthographic (90°) projections: plan, section, and elevation.

Each drawing type flattens or projects two-dimensional information onto a corresponding picture plane. They can be referred to as sections, since the basic manner in which all orthographic drawings are constructed is the same; a plan, for example, is a horizontal section. Orthographic drawings are cuts through space, whether horizontal or vertical, and whether directly through an object or just outside of the object. They are not perspectival; it is best to imagine that you are able to look directly at each component part of the object, thus eliminating the perspectival aspects of the object.

Plan

A plan is a horizontal cut through an object, building, or space, typically directed down. Imagine the cut as a plane, parallel to the ground plane, intersecting a building or object. The cut is drawn using appropriate line weights, but is always rendered as the darkest element in the drawing. There are a number of types of plan drawings.

▲ Cut lines

Plans and sections are essentially the same. They are cuts taken through an object. The elements that are cut through are rendered as the darkest line weight in the drawing. This typically corresponds to an HB or B lead.

▶ Floor plan

The floor plan is a means to convey architectural space. It is a horizontal cut through a building, typically at 4 ft (1.2 m) above floor level. The cut-height convention is set so that you generally include doors and windows in the plan cut and elements such as counters, and half walls not cut through are shown from above for spatial clarity. This convention is not absolute. It is important to learn how to draw plans that clearly show the nature of the space. For example, if a clerestory window at 7 ft (2.1 m) is important to the idea, then include it in the plan by moving the cut plane to cross through that area. Floor materials can be depicted in the architectural floor plan. Scales include ⅛, ³⁄₁₆, ¼, and ⅜ in.

◀ Roof plan

A roof plan is a horizontal cut above a building mass looking directly down onto the roof. Shadows are often constructed on a roof plan drawing to demonstrate the mass of the building relative to the space around it and to distinguish it from the context. Scale: ¹⁄₁₆ or smaller.

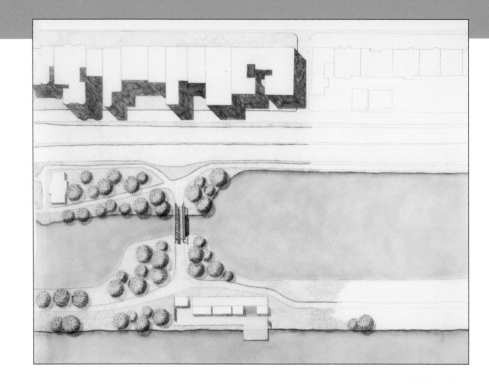

▶ Site plans

A site plan can be drawn from above all of the buildings including the new design and the surrounding context, or can include the first floor plan to demonstrate the relationship between the interior and exterior spaces. Shadows are often constructed on these drawings. Your building intervention does not need to be centered on the page. Page composition will be discussed in Unit 16. Scale: typically uses engineering scales 1 in = 20 ft or 1 in = 40 ft.

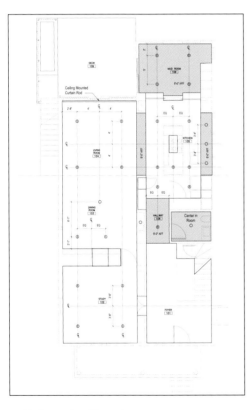

▲ Reflected ceiling plan

A reflected ceiling plan is a horizontal cut that depicts the ceiling plane of the building as if it could be seen from above. This is typically used to indicate ceiling grids, lighting locations, or orientation of material on the ceiling surface. This drawing type is typically used in practice and not in school.

▶ Figure-ground plan

A figure-ground plan usually depicts an entire neighborhood, district, or city. It is used by architects and urban designers to describe the building patterns. It is an abstraction of building and space. Typically, buildings are rendered as black poche and non buildings or spaces are white. These maps are useful for analytic and pattern studies.

The figure-ground plan was derived from the traditional Roman city survey map of 1748 created by Giambattista Nolli (b. 1692 d. 1756). Nolli constructed his plan of Rome by rendering buildings in dark gray poche and non buildings or space in white, with the exception that enclosed public spaces such as churches and piazzas were rendered in white. These interior spaces of churches, piazzas, and enclosed public spaces were intended to be continuous with the space of the public realm. Colin Rowe (b. 1920 d. 1999) and Fred Koetter (b. 1938) pioneered the use of the figure ground map in analyzing the city in their book, *Collage City*.

A figure-ground plan.

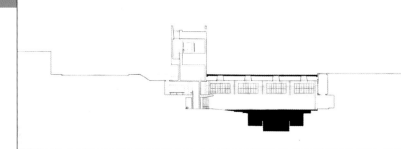

◀ ▼ Building sections

A building section depicts the spaces inside and directly outside of a building. The scalar relationship between these different spaces is visible in a section. Scales: ⅛, 3⁄16, ½, ⅜.

Section

A section is a vertical cut through an object, building, or space. Sections describe vertical relationships and help define the spatial characteristic of the building. A scaled figure shown in section clarifies the height relationships in the spaces. Imagine the cut as a plane, perpendicular to the ground plane, intersecting a building or object. As in the plan, the information that is cut is rendered using appropriate line weights, but is always rendered as the darkest element in the drawing. There are a number of types of section drawings.

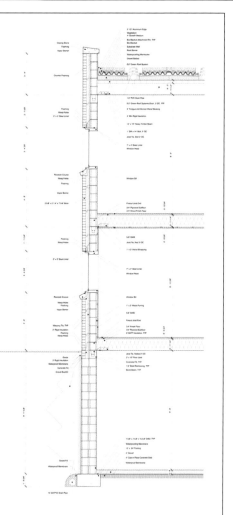

By including a profile of a person in the section you can instantly understand the scale of the space. The figure is never drawn in section, but is rendered abstractly.

▶ Wall section

A wall section of a building depicts detailed construction systems and material choices.
Scales: ¼, ⅜, ¾, or as large as can fit on the page.

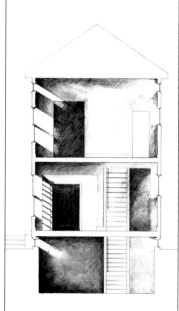

Sections can be rendered to depict the quality of light affecting the space.

▼ Street section

A street section depicts the section through a building and includes the space of the street and buildings directly adjacent to or across the street from the building. Scale: 1⁄16 or larger.

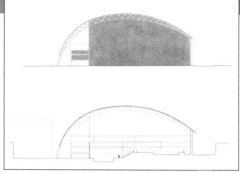

This drawing combines a building elevation and section, making the relationship between the two clear.

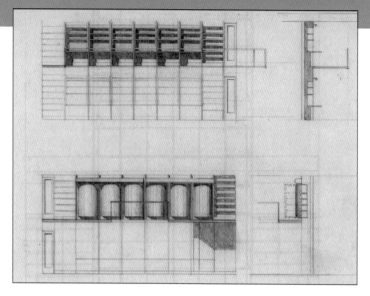

This detailed building elevation and section has been partially rendered and shadowed to give an impression of the construction and materials.

Elevation

An elevation is a vertical section cut outside of an object, looking back at its face. Imagine the cut as a plane, perpendicular to the ground, that does not intersect with the building or object. The ground outside of the object should be rendered as a cut line. The object or building itself is not cut through; all of the lines related to the building are elevation lines. Elevation lines vary with distance from the projected picture plane. Elements farther away are lighter than those that are closer.
Scales: ⅟₁₆, ⅛, ¼.

Continuity of section cut

Architectural drawings highlight space as defined by the walls, ceilings, and floor. Its representation is manifest in the continuous cut. These drawing types do not distinguish between materials, and therefore all elements cut in section are continuous with one another with one exception. The variation from this rule occurs when cutting through glass or some other transparent or translucent material. Glass is never rendered as a dark, cut element. If so, it would appear as a solid wall—contradicting its transparent nature. It is rendered as if it were in elevation, even when cut through. Typically, construction sections depict the building systems employed to construct the wall, ceiling and floor, and are meant to convey material and construction information to the contractor.

This building elevation drawing at the scale of the city explores the relationship of a new building to the city skyline.

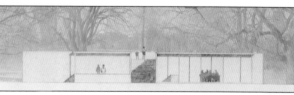

◀ Combination of section and elevation

Aligning the section and elevation drawings allows one to see the transition between materials and spaces on the interior and exterior.

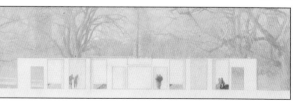

◀ Building elevation

A building elevation gives an impression of how one face of the building will look from the outside. The building can be considered in isolation or in context.

▶ Combination of plan and elevation

The plan provides a sense of space and movement in this bathhouse design while the complementary elevation exposes the material quality and characteristics of those spaces.

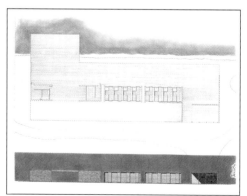

▲ Column cuts

Cutting a section through a column (middle image) deceptively depicts two separate spaces with a wall between. Always cut a section in front of the column (never through it) and render the column using elevation line weights.

There are a number of techniques for constructing orthographic projections and for distinguishing cut elements in plans and sections from non-cut elements. One method uses line weights, the second uses a coloring technique called poche, and the third uses rendering techniques.

Poche comes from the French word *pocher*, "to make a rough sketch." It is typically understood to be the solid elements in a building rendered in solid black. This method, when constructing orthographic drawings by hand, is often much more time-consuming than using proper line weights. Therefore it is better to use the line weight technique when constructing these drawings. The third method uses rendering of interior spaces to distinguish between the white space of the cut area.

Creating a section

Sections represent continuous vertical cuts through an object or space. The appropriate use of line weights in a section determines its legibility and can reinforce intention.

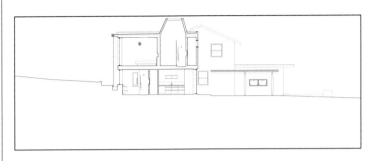

◀ Continuous section line

The white of the page is brought into the section by extending the ground line to the edges of the paper. Crop the page away from the section line so there is enough space for the section to indicate pertinent ground information. Section lines should be drawn with the darkest line weights in the composition.

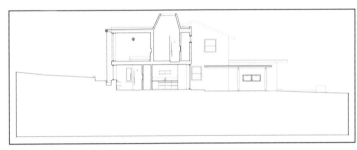

◀ Section base

The white of the page is separated from the white of the section cut through the creation of a section box. The thickness of the base should be determined by the design intent. Section lines should be the darkest line weights. The base completes the section graphically so that it has an object-like gestalt.

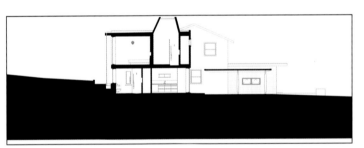

◀ Poche section

The clarity of the drawing is achieved by rendering the section with black. This poche technique does not use line weights for the section cut. Use proper line weights for the other non-section elements in the drawing to convey depth.

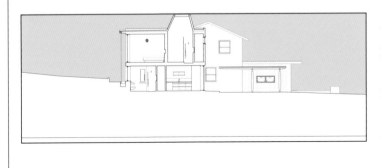

◀ Sky section

This section inverts the poche drawing by rendering the sky as a tone or color. The sky recesses and "punches" the drawing forward. Additional details in the drawing focus attention on the only element not rendered: the section cut. Consider this as a method of white poche.

Line types

There are a number of different line types that can be employed to aid in the clarity of a drawing. Graphite line types often correspond to specific line weights. Lines that represent cut objects are the darkest, while lines for objects that are further away from the cut plane are lighter. Space can be portrayed and emphasized with the proper use of line weights in orthographic drawings. Elements that are above the cut plane and not seen in the projected drawing should be drawn with dashed elevation lines.

Cut lines: section lines both in plan and section—B or HB; these are the darkest elements in the orthographic drawing.

Profile lines: lines that define the edges between an object or plane and open space—HB (often used in axonometric or perspective drawings).

Line clarity

● When working with softer leads you will need to sharpen your lead more often.

● You want sharp dark lines, not thick dark lines. It is also more challenging to make lines consistent when having to sharpen often. Take note of this when selecting your lead weight.

● The key in drafting is to make all lines sharp and crisp.

● Clarity of the architectural space takes priority.

Elevation lines: lines that define edges that are further away from the cut line in both plan and section—H or 2H. These elevation lines can also vary in weight, depending on the distance away from the cut plane. Because lighter lines recede in the view, objects further away are drawn lighter than those closer to the cut plane. This variation in line weight helps to convey depth in an otherwise flat drawing. These are middle-range lines, but never reach the lightest line weight, the construction line.

Construction lines: lines that help you organize and construct the drawing; should be used to make connections to other drawings on the same page—4H or 6H. These lines should be visible from 12 in (305 mm) away, but should disappear when standing 3 ft (0.9 m) or further from the drawing.

Hidden lines: dashed lines that depict objects or planes that are technically not visible in the drawing—H or 2H. The spacing of the dashes and the length of the dashes should be consistent. Elements in front of the section can also be rendered with hidden lines. In plans, hidden lines are used to show objects above the cut line. This is extremely helpful when roof canopies, ceiling changes, or open spaces to upper floors must be understood relative to the plan below them.

Start drawing with three line weights: HB for cuts, H for elevation, and 4H for construction lines. As you improve, increase the number of line weights. As you develop your drawing skills, you may use at a minimum four line weights distinguishing between different elevation lines based on distance: those that are closer are darker, while those further away are lighter. The darker elevation lines never reach the level of section lines.

Scale considerations

Another factor to consider in determining the proper lead weights for a drawing is the scale of the drawing. For instance, a section line at a smaller scale might be drawn with H and a lot of pressure. This same line, when drawn at a larger scale, might be drawn with an HB lead. You must make a conscious decision about how to convey information to edit at the different scales. Each weight should be distinctive.

Conveying information

When representing buildings, architects use scales to reduce the size of the building so that it fits conveniently on paper. U.S. architects use engineering and architectural scales. Both scales are based on the inch and convert a series of inch increments to equivalent foot dimensions at true scale. When drawing, you will use a variety of scales to show different types of information. Large scale plans, like ½, show construction materials, while smaller scale plans, like ¹⁄₁₆, emphasize the architectural space. See Unit 4 for more on scales.

Typical scales

Typical architectural scales include: **¹⁄₁₆ in = 1 ft, ⅛ in = 1 ft, and ¼ in = 1 ft.**

When sections are drawn larger than the plans, they might be drawn in the scale range of: **¼ in =1 ft to ¾ in =1 ft.**

The larger increments found on the architectural scale are used for detail drawings:

1½ in = 1 ft and 3 in = 1 ft.

The engineering scale is used for site plans, roof plans, and overall building massing. Typical scales used are: **1 in = 50 ft, 1 in = 100 ft, and 1 in = 200 ft.**

◀ **Line types**
1. Cut lines
2. Profile lines
3. Elevation lines
4. Construction lines
5. Hidden lines

Chair section

Find a chair that interests you. You will draft this chair freehand, without using a straightedge. Draw a multitude of plan, section, and elevation views of your chair onto a single sheet of paper. The drawing does not have to be to a certain scale, but must maintain scale and proportion between the parts that make up the chair. Work on your hand-eye coordination as you draft across the entire page. Cut a series of plans of your chair at varying heights. For example, make several horizontal "slices" at different heights: 1 ft, 2 ft, and 3 ft (0.3, 0.5, and 1 m). Align the plans vertically with the section or elevation using construction lines to maintain similar proportions across the page. Use light construction lines (4H) to draw similar elements in each plan. Take at least two sections through the chair, one at the midpoint and one off-center, and construct at least three elevation views. On a typical chair, only three elevations are needed instead of four since the side elevations would be mirror images of one another. The drawings should be constructed from one another, meaning that composition is foremost in your mind when drawing these projections. By drawing construction lines you can maintain consistency between drawings. Remember that plans, sections, and elevations all have relationships to one another and that construction lines between the drawings can help align them. Information can be transferred between the drawings without the need to re-measure. Proper line weights will be critical for a clear understanding of the drawing.

Construct your drawings on a sheet of large paper, 18 x 24 in (457 x 610 mm) and use the entire page.

▲ Compositional alignments
By aligning plans, sections, and elevations on a single sheet of paper, dimensional information can be transferred without the need for remeasuring.

Ortho construction

● When constructing an orthographic drawing it is helpful to pause midway and review your drawing abstractly.

● Ask yourself: "How legible are the lines from some distance away?" While drawing, you are too close to your paper, physically, to make this assessment. Move at least 3–4 ft (0.9–1.2 m) away from the drawing and assess the line quality.

● It is useful to pin your work up on a wall, step back 3 ft (0.9 m), and assess.

● When drafting, you should always use your lead holder. The lead in the lead holder maintains a much sharper point than the sketching pencils or even a mechanical pencil. In addition, you have greater control over the type of line you create with the lead holder.

1 Use a 4H lead to create a series of construction lines to establish the boundaries of the chair. Determine the chair's width proportion to its overall height. Continue to establish these proportions for all of the required orthographic projections. Complete this step before adding detail and line weights.

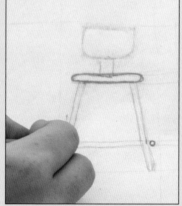

2 Use an H lead to begin to darken the elements that are seen in elevation. The construction lines remain the lightest line weight on the page and should, at this point, begin to fade naturally as other, darker, lines appear to become more dominant.

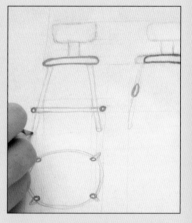

3 Use an HB lead to begin to darken in the elements that are cut in section. Section cuts are continuous and shall not be left open-ended. Make crisp dark lines with a sharp lead. The light construction lines should remain on the drawing.

Influence of computers on orthographic drawings

Manual and digital two-dimensional representations have similar evaluation methods based on the clarity of the line weight. Therefore the practical difference between the two is negligible.

Digital technology has had a great effect on office organization. The use of digital technology has enabled a more transparent integration, organization, and management of the drawing set by larger groups of people. Digital programs have revolutionized the iterative process for large-scale projects, enabling architects to draw, modify, and communicate orthographic information with ease.

It is necessary to eventually become familiar with digital applications since they are common in architecture offices. They are best mastered in a similar manner as hand drawing: the more you practice, the better and more efficient you will get.

However, even with the available software and technologies it is important that you learn to draw by hand. There is an immediate cognitive and physical connection between thinking and your drawing implement (pen or pencil) that has yet to be captured by the computer. This translation of information from mind to page is improving every year.

In digital technology, the mouse is the interface to the flat image transmitted through to the screen. There is a second interface between the brain and the graphic, or the method of getting the image onto a page. Drawing by hand facilitates a direct connection between cognitive thinking and the transfer of ideas to paper. There is an immediate result of the line being drawn on paper to a scale that is not present in the digital realm. The limitation of the screen requires you constantly to zoom in and out of an image without a real understanding of the ramifications of doing so.

Orthographic digital images are typically constructed at one-to-one scale, floating in space. The output from the computer is typically modified to a scale for feasibility with printers and paper sizes. Though the construction of images on the computer are considered one to one, the screen becomes the modulating factor that limits the size of the view available to the user. You can zoom in and out on an image, but the limitation of the screen remains.

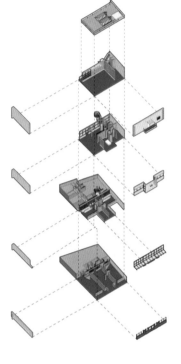

▲ ▶ ▼ Digital capabilities
Sophisticated drawings can be constructed using a number of digital programs. Which program to learn is often a product of your work or academic environment. If you can understand the framework of how any one of these programs functions, you should feel comfortable moving from one to another. The graphic rules that apply to manual drafting also apply to digital drafting.

Digital software packages

Two-dimensional packages (many have additional 3D capabilities):

- Autocad ● Archicad ● Vectorworks Microstation ● Datacad

Three-dimensional modeling programs:

- Form-Z ● Rino ● Maya ● Sketch-Up 3D Studio Viz/Max ● Revit

Presentation-drawing modification programs:

- Adobe Photoshop ● Illustrator ● InDesign

Manufacturing interface programs:

- Catia ● BIM ● Revit

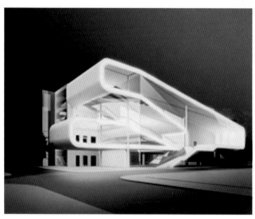

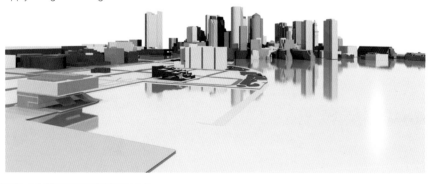

UNIT: 16
Composite representations

Orthographic drawings have simple graphic relationships to one another, making construction between the drawing types easy. Consider the collective composition of these drawings on a page. When additional drawing types are introduced, establish a hierarchy to emphasize the main ideas of the project.

Considerations

Decisions that need to be considered before construction of a composite drawing:

- Size of the page

- Page orientation—vertical, horizontal, or neutral (with a square sheet)

- Drawing size—is there a hierarchy of images that you want to present? Is one type of drawing better to present at a larger scale than the others? Sections can be typically drawn at a larger scale than the plan.

Construction

Orthographic drawings have dimensional similarities when constructed at the same scale, which can contribute to ease of constructability. That is, when drawn at the same scale, plans, sections, and elevations can be derived from each other. They inform each other—sections and elevations share height information, and plans and sections share location data. For example, a plan can be used to construct a complementary series of plans, sections, or elevations. Construction lines can be extended from elements on one plan that remain consistent on a second plan; or construction lines can be extended to an elevation drawing. One thing to make sure of is the appropriate orientation of the drawings relative to one another.

Page composition

The arrangement of drawings on a page can facilitate the construction of additional orthographic drawings. For instance, the section can be constructed from both the plan and the elevation, using the 45-degree angle for translation of information.

Before you begin drawing, understand how the page will be filled. Allow for enough white space on the page. You should err on the side of fewer drawings on a single page rather than too many.

▶ Rendered composite drawings

This collection of rendered orthographic drawings highlights the relationships between the level changes inside of the space. The inclusion of a human figure establishes the scale of the space as well as highlights the programmatic elements in the room like the soaking tub.

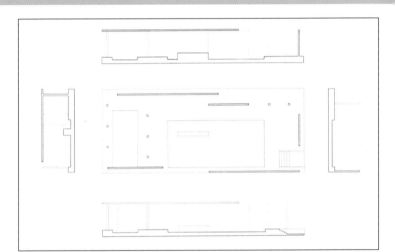

Composite drawings

Drawings which tend to overlap one another physically are considered a single drawing made up of multiple drawing types to create a dynamic quality in the presentation. Drawings can be reorganized to emphasize design intention. Plans can be combined with sections in a way to emphasize the relationship between the cut point in the plan and the constructed section.

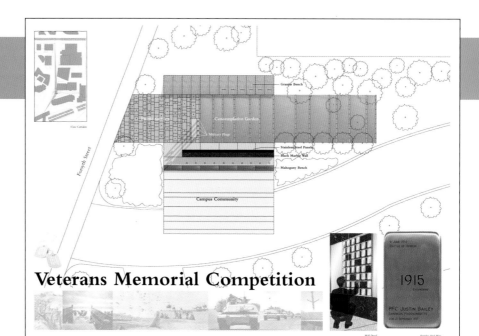

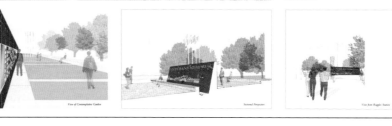

▲ Competition board

The most important image is the largest, centrally located on the page. The supporting orthographic, diagrammatic, and perspectival images and text wrap around this central image. All drawings were hand constructed and rendered using Photoshop. The composition was created in InDesign.

Modeling techniques

Models are abstract representations of ideas. In most architectural models, the replication of reality is not highly sought after. Building models is an essential part of the process of designing and refining architectural constructs, not just a presentation of the final iteration.

There are basically two types of models: ones that are process-oriented and explore ideas, and those that are presentation-oriented, built to demonstrate the final product. Of course the appropriate level of craftsmanship varies relative to the purpose of the model, but by developing your model-building skills you will be able to produce good quality models efficiently for both study and presentation.

There are a number of different types of models that architects use in the process of design. The type of model depends on the need and audience. Process models include study models and massing models. Study models developed during the design process provide ways to understand, explore, and refine the realization of your design ideas. Presentation models are typically representative of a final proposal.

Modeling safety

- When using sharp instruments, always cut away from yourself.

- When cutting materials with any knife, first score the material along a guide line, then make several passes with your knife. Attempting to cut through material with one pass can often lead to mistakes, knife dulling, and an increased risk of injury.

- Replace your blade often. It is easier to cut with a sharp knife.

- Never use anything non-metal as a cutting guide. Never use your plastic triangle, parallel edge or scale to make cuts. You will be sure to nick their plastic surfaces and ruin them.

- You will cut yourself. Be careful.

Process models

A study model is a representational tool to study architectural ideas and concepts. These models get altered, modified, or reconfigured constantly through the design process; consider them to be works in progress. Study models provide opportunities to review optional solutions and test ideas before making final decisions. They should be saved during the design process to see the physical development of the idea over time. You may want to return to an earlier idea. In addition, study models are typically smaller in scale than final presentation models.

▶ Model series

Diagrammatic study models can convey different ideas about a project. Different design strategies relating to the same project are represented using a series of small-scale studies that emphasize volume, containers, overlapping continuous planes, and structure. These models are easy to construct, and visualize the ideas in a three-dimensional way.

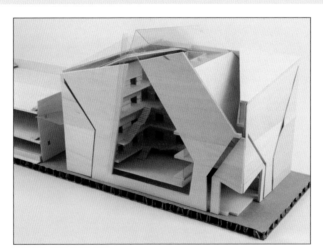

◀ Interior space

When making a model it is important that your audience can see both the interior and exterior components of your design. If only showing exterior elements, then the model can typically be smaller in scale. This final presentation model for a school project demonstrates both interior and exterior design components as seen through the large transparent window.

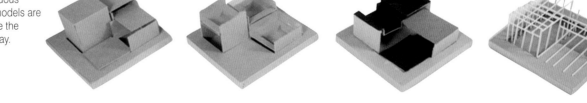

Model construction

When building a model, you should have a clear sense of the direction in which you want to build. First, establish the goals of the model, deciding on the scale and then proceeding with an accurate method of assembly. It is good to know what you are building before you build it. Use developed plans, sections, and elevations as your blueprints for building the model.

Façade emphasis

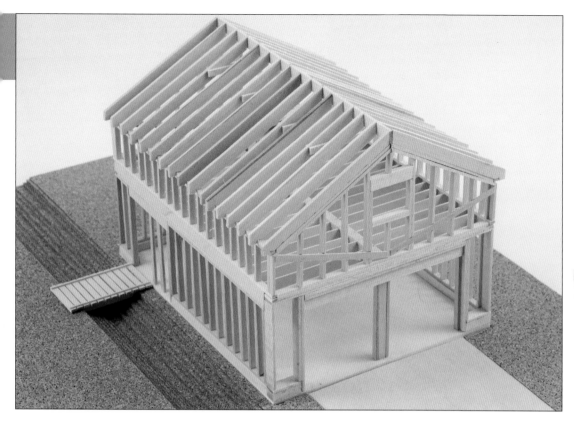

▲ Garage framing model
The tectonic logic of the garage is apparent with this basswood model that accurately depicts the framing members.

Presentation models

These models are used to present the final scheme to the desired audience.

Material thickness

Every material has a thickness that needs to be considered in the process of model building. You should carefully consider the joining of two planes, whether similar materials or not. For example, consider the corner joint in terms of what direction you want the edge of the material exposed. Do you want the joint visible from the front or side? Material dimensions will affect the assembly and should be considered when cutting complementary elements of the model. Heed the carpenter's motto: measure twice and cut once. Accuracy in measuring and thinking out the process will help in creating a well-crafted and accurate model. Different materials may require different joint conditions. Foamcore can be mitered to meet at the corner; each piece is full length. Chipboard and basswood typically are butt-joined and require an understanding of the joint location for accurate measuring of materials.

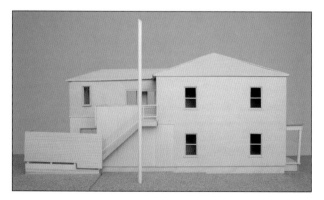

Presentation model constructed from basswood to show the client and contractor.

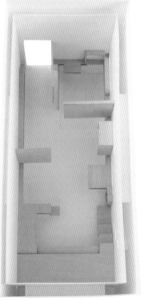

Wood contrasts with white walls to distinguish existing conditions from elements of design.

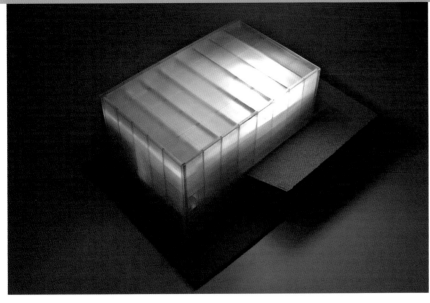

Gluing

White glue like Elmer's or Sobo is commonly used in architecture studios and offices. Elmer's is better for joining porous materials such as basswood, paper, and cardboard and Sobo is better for joining porous to non-porous materials, like plexi to basswood or metal to cardboard. It is best to use a minimal amount of glue so that clean-up at the glue joint and drying times are reduced. Place a dollop of glue on a scrap piece of chipboard and allow it to achieve a tacky quality. This provides a shorter gluing time when it is applied to materials. A small wooden dowel or your finger can be used to apply glue onto an edge surface. Drag the applicator across the edge of the material in a steady pattern. Do not apply too much glue along the edge; only a minimal amount is needed. Hold the glued materials together to allow the joint to dry. Use pressure to seal the joint. Temporary fasteners or drafting tape can be used to hold elements in place, especially when gluing complicated structures.

Sanding

When working with wood, it is critical to use a sanding block to clean up joints and material surfaces. A sanding block can be a rectangular piece of wood wrapped in sandpaper. The sanding block keeps you from rounding the edges of materials. Sand the material in the direction of the grain. By doing so, you can make joints seamless and reduce the effects of residual glue. Sanding across the grain leaves scratches. Do not sand to shorten a piece of material that is too long. You will end up rounding the edges and reducing the crisp edge of the cut. If a piece of material is too short, recut the piece and sand only to clean up the joint.

▲ ▼ Aspects of study

Models enable you to study the way light interacts with your design (top). Here, the building itself becomes a navigating tool as a beacon of light. The image below explores the relative weight of materials in a dynamic spatial interpretation of an El Lissitzky painting.

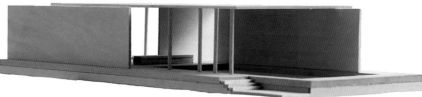

Digital modeling machines

There are a number of new digital modeling machines prevalent in architecture schools today. These include the laser cutter, starch model machine, vertical mill, metal lathe, waterjet cutter, 3-axis CNC mill, 5-axis robotic arm CNC mill, foam cutter, and plastic 3D printer. Some modeling techniques completed by hand in the past can now be constructed using these high-tech modeling tools. More complex shapes and configurations seemingly impossible by hand can now be completed by machine. A limitation of hand modeling is that the material can generally only be manipulated in one axis, so complex, multiple curvatures are near impossible to achieve. These can be formulated by machines. More tedious cuts like topographical model contours, and repeated standard elements such as trusses, can be made by these machines. Usually these new technologies can reduce human error. Just remember, though, that many of the simple tasks of model making should still be taken on by hand. In many instances, time and money are wasted on what seems to be a time-saving device—but in the end is not.

Modeling tips

- You can curve basswood by wetting it and bending it around objects such as jars and tubes; or make your own mold. Use rubber bands to hold the wood in place while it is drying. Basswood can be bent both with and against the grain; however, it is easier to bend parallel to the grain. It is best to use a longer piece of wood than you need and cut it to size after bending. See the steps on the right for the method.

- Wax paper can be used as a gluing surface for complex structural members like trusses. The transparency of the wax allows you to place a drawing underneath and use it as a guide. Glue does not adhere to the wax paper, making it easy to work on. Remove the structure when it is completed.

1 Soak the basswood in water until the material is completely saturated—about 30 minutes.

2 Slowly bend the basswood around an object whose diameter is similar to the bend you wish to achieve. Start at one end and work your way around.

3 If you try to curve it at once, the basswood will most likely break and splinter. Use rubber bands to hold the wood in place while it dries.

The curved basswood

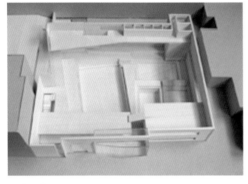

▲ **Design access**
Models need to be visually accessible. This swimming pool interior is visible when the roof is removed.

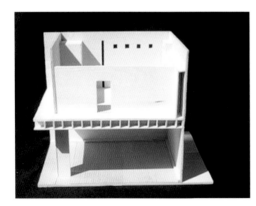

▲ **Structural details**
This model depicts the second floor and its construction detail, onto which the project is situated.

Model bases
The base is an important component of the model and should be highly considered. It establishes the site of the model and has the potential to reinforce design ideas. You should think about whether you want to minimize the base, accentuate it, or exaggerate it.

Often it is easier to construct the base first, but it may also be built in conjunction with the entire model.

Model entourage
Entourage is considered the additional accessory or supporting elements that fills in the context. This could include trees, bushes, people, and cars. Entourage is a challenging component of the model, since it oscillates between realism and representation. Trees can be represented abstractly in a number of ways: with wood dowels, twisted wire, dried baby's breath, or wildflowers. Shying away from realistic trees allows the architecture to be the most prominent element.

Remember that the entourage is supporting information and should therefore maintain the model's color palette and intensity. If a model is made completely out of basswood and then complemented with green trees, those green trees tend to dominate the model. Scale is also an important factor when considering the representation of entourage. Its abstraction needs to be maintained at all scales.

Assembly
The sequence of model construction is an important aspect to consider prior to starting the model. Consider the thickness of the material and account for it in the construction and assembly order. Decide on the hierarchy of joints before cutting any materials. This can also reinforce design intentions. One way to decide the hierarchy is to imagine the direction from which the model will be seen (from above, or in section, for example). Internal structures should be thought of as part of the model, even though they are unseen.

Models can be made to come apart to show several floor plans, or to reveal sections. This introduces more complexity to the construction and assembly. You need to consider the connection between elements and which elements will come apart.

Construction: Dürer's alphabet

Albrecht Dürer was born in Nuremberg, Germany in 1471. He apprenticed with his father, a goldsmith. In 1486, at the age of 15, he also apprenticed as a painter, becoming a keen observer of the landscape. Dürer developed an interest in manmade things and the natural environment, and cultivated both in his art. He was a highly respected painter, engraver, and woodcut designer during the Renaissance.

Dürer saw art as the combination of talent, intellect, and mathematics under a humanistic approach. He understood the need for disseminating his work and used the printing press to aid him in this endeavor. To this end he wrote and published a treatise on mathematics titled *Underweysung der Messung* or *Treatise on Measurement*. This treatise was, in fact, only the second work on any type of mathematics to be published in German.

The treatise gives instructions to the reader on how to "construct" (draw with mathematical precision)

lines, curves, polygons, and solids. In addition to abstract geometry lessons, Dürer gives practical examples of the uses of the theorems, such as drawing in perspective and shading solids. He also shows how the design of typefaces should be mathematically rigorous, based on "scientific" rules of proportion and geometrical construction.

The Roman letter was based on geometric principles and rules. It is this clarity and rationale that defined it as an elegant type. Dürer used similar geometric principles to construct the capitals of a Roman alphabet, providing

detailed instructions for each letter and including images of both the geometric processes and the finished examples.

In addition, Dürer constructed a second alphabet, the *Fraktur* alphabet, using geometric shapes like the square and triangle. The *Fraktur* alphabet was a typeface used in German-language publication. The letters are not in alphabetical order because Dürer built his alphabet incrementally. Essentially, all letters are variations on the letter "I" and so he began with this letter, adding tails or other features as needed to produce the rest of the alphabet.

Upon his death in 1528 Dürer left a legacy of more than 70 paintings, 100 engravings, 250 woodcuts, 1,000 drawings, and three printed books on geometry, fortification, and the theory of human proportions.

▶ **Dürer letter**
Dürer's alphabet uses a simple geometric proportioning system for all letter constructions, eliminating the need to measure. All construction lines can be determined through geometric means.

◀ **Artist at work**
Dürer understood the relationship between perspective construction and space. He conveyed that understanding in many of his drawings and etchings.

Making orthographic drawings

"Geometry, without which no one can either be or become an absolute artist."

Albrecht Dürer

Brief

You are asked to construct a full set of orthographic drawings of one of the letters from Albrecht Dürer's geometric Roman alphabet. Each Dürer letter is based on a specific geometry and proportion. It is imperative that you communicate that precision and proportion in the construction of the letter. Precision is necessary to achieve the accurate proportional relationships described in the Dürer instructions. Read the instructions carefully, rereading as many times as needed, since the language Dürer uses is antiquated. Reconstruct the letter following his instructions; you should not have to measure anything. Use the proportioning system to construct the drawings. The orthographic drawing set will be constructed using your parallel edge, triangles, compass, and lead holder. Construct the elevation, following Dürer's instructions, inside of a 4-in (100-mm) square. You can then use this drawing to construct a full set of orthographic drawings. You should imagine the letter as a 4-in (100-mm) extruded volume, perpendicular to the surface of your elevation drawing. In other words, if your original elevation is considered in the x and y direction, the extrusion should be considered in the z direction.

These lines should be clear and legible on the final drawing within 12 in (30.5 cm) of the surface and from a distance of 3 ft (1 m) they should disappear altogether. Depending on hand pressure, the construction lines should be drawn with a 4H lead. Cut lines should be made using HB. Compositionally, you could think of the different drawings as an unfolded box. In constructing a new set of orthographic drawings for the first time, it is often wise to practice on a material that is less precious than vellum. A preliminary set of drawings can be constructed on trace for practice while the final set can be constructed on vellum.

Composition

You will need to compose the set of drawings onto a single sheet of 24 x 24 in (610 x 610 mm) paper. It is important that the relationship of your plans, sections, and elevations be apparent in this composition. Therefore leave all construction lines on the drawing.

1 Draw two lines. Take any scale measurement that is divisible by nine. Lay the zero on the left line and the nine on the right. Mark off the corresponding increments of nine to set up evenly spaced increments.

2 Make sure to lift your triangle after making vertical lines to avoid smudging the drawing.

3 As you develop the composition, make sure that the line weights in one elevation match the line weights for all the elevations on the same page. Consistency is important.

◄ **Compositional strategies**
The full set of orthographic drawings should include one front elevation (the original letter), two sections and four elevation views including two side elevations, one top and one bottom view. Each drawing is to be placed in a 4 in (102 mm) square.

Making a model

Brief

Construct a three-dimensional model of the Dürer letter using chipboard material. It is good to make the model more than once. Practice models or study models allow you to test construction techniques. The study model will demonstrate problem areas. The second model often resolves the issues present in the first model. You should evaluate your model on its overall craft and accuracy.

Scale

Full scale—the model of each letter is to be considered as if it was inside a 4-in (100-mm) cube.

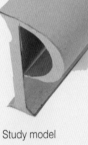

Study model

Final model

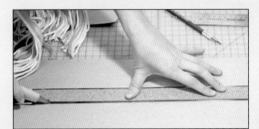

1 Use your straightedge to cut material. Score first, then make a series of cuts. Do not try to cut the material with one stroke.

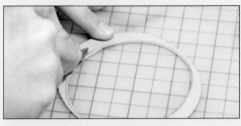

2 Curved elements are more difficult to cut and take more time. Take it slowly, but try to maintain a continuous cut just the same as a continuous line in drawing.

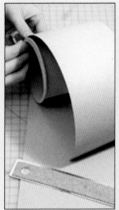

3 Construction sequence is important. Recognize which pieces of material will be exposed (those facing front). This will affect the length of each piece of material.

What you need

- ¹⁄₃₂ in (0.5 mm) and/or ¹⁄₁₆ in (1 mm) chipboard for model
- Cutting mat
- Knife and blades
- Metal straightedge
- Orthographic drawings of letter

Tip

Use internal blocking for additional support. Small triangles also help to make planes perpendicular to one another.

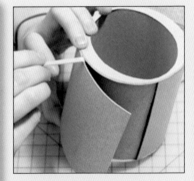

4 Use a piece of chipboard or your finger to apply glue. You do not need a lot of glue to secure two pieces of chipboard. Too much can introduce moisture to the material and cause it to warp.

5 Be conscious of the natural joints in your material. Make them meaningful to the project. Some materials come in limited sizes so thinking about joint connections can be an important aspect to building the model.

6 Lightly sand edges that may have extra glue or were roughly cut. Sand with the grain of the material if it is visible. Don't over-sand.

Conceptualizing an idea

Brief

Using the proportioning system established by the Dürer letter elevations, design a device to hold eight sketching pencils. You can store them individually or as a group. You can only work within the 4 in (100 mm) volume, and only using straight lines.

Consider the 4 in (102 mm) cubic volume that you constructed for the Dürer letter. Remove all the lines other than the construction lines. These lines represent the elements of the Dürer proportioning system. Imagine working only within the 4 in (102 mm) cube.

Your pencils do not have to be wholly contained within the 4 in (102 mm) volume. Consider the design from all six sides. Every orientation of the cube must provide a place for all eight pencils.

Remember the goal of the assignment and the definition of architecture.

Function: store eight pencils
Intention: how do I contain the pencils?
Architecture: aesthetics and compositions

What might provide you with compositional or spatial strategies?

1 Establish the parameters of your "site." For this assignment it is the 4-in (10-cm) cube. Study the cube before you begin designing. Use it as a way to think spatially about a concept. Consider the weight of the pencils and how that will affect what you cut.

2 Apply the Dürer proportioning system to all sides of the cube. This provides the parameters in which you can work. Think about carving into the volume as part of the design process. Consider the length of the pencil and how that will affect what you cut.

3 Begin subtracting portions of the foam. The depth of the cut is based on your notion of how the pencils will be held up. The cuts, if deep enough, will begin to affect the other faces of the volume. Consider the interface with the human hand in the design.

4 Consider all six sides of the model. Any surface could be on top. This aspect of the assignment creates the challenge. Your site is complex, even though as a volume it appears simple.

Concept diagrams for a school program

A series of overlapping boxes indicates a subtle connection between two elements: circulation (orange) and classroom units (gray). This diagram describes how these units can overlap into the hallway as instructional areas.

Tonal variations describe overlapping spaces. An outline reinforces a more subtle relationship between spaces. Here, two classrooms are indicated by the dark outline as overlapping and sharing a middle zone between them.

This detail diagram depicts the specific articulation of a classroom as it meets the hallway. The orange indicates the overlapping zone between classroom and hallway.

Clusters of similar-sized boxes create a negative space between, while the subtle overlapping corners indicate a connection between these distinct elements.

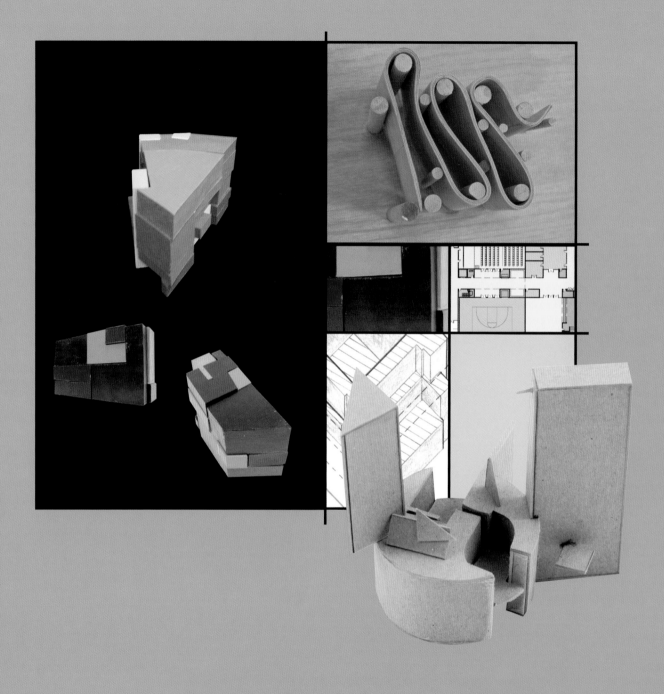

CHAPTER 4
Objective abstraction: axonometric

This chapter introduces readers to the technique of axonometric construction and the work of architect and academic El Lissitzky. If you have ever doodled a cube, then you have most likely drawn an axonometric. They are drawings commonly found in our daily lives, including construction assembly directions and 3-D building maps.

Axonometric drawing is an objective three-dimensional representation that combines plan and elevation in one abstract drawing. It is objective in the sense that it is not a view that can ever be perceived in real space. The axon is measured along three axes in three directions and its ease of construction is possible due to the fact that parallel elements remain parallel in the representation. This differs greatly from the construction of a perspective drawing, where receding lines converge in space.

The three-dimensional axonometric can be derived from a two-dimensional plan or elevation. The construction retains true scale measurements throughout the drawing. The axonometric allows you to see and understand relationships along multiple surfaces simultaneously. It can be used to study form and space and relationships between vertical and horizontal elements. Design iterations that study spatial strategies can be easily constructed and recorded using the axonometric. Using the axon, you can study both positive and negative space—both the form and the space that is the result of that form.

There is a variety of axonometric types including isometric, diametric, trimetric, and oblique projections.

The use of the axonometric drawing can be tied directly to those in art and architecture interested by its abstract quality and its implication of infinity. Architects who embrace the axonometric include Theo van Doesburg, James Stirling, Steven Holl, and Peter Eisenman.

Introduction to axonometric

There are a number of different types of axonometric drawings, including the axonometric projection made up of isometric, diametric, trimetric, and the oblique projection, which is further subdivided into the elevation oblique and plan oblique.

Axon advantages

- You can measure along any axis.
- You can scale easily.
- You can understand volumetric relationships.

Read this!

Eisenman, Peter
Giuseppe Terragni: Transformations, Decompositions, Critiques
Monacelli Press, Inc.,
New York, 2003

Ford, Edward
The Details of Modern Architecture
Volumes 1 and 2
MIT, Cambridge, MA,
1996

The most straightforward axonometric to construct is the plan oblique (which is often referred to as axonometric). Its construction is derived directly from the plan and can be measured and scaled at any point in the drawing. The plan oblique is derived from a rotated plan. The plan can be rotated along any angle, though 30, 60, and 45 degree angles are often used. Each angle provides a slightly different emphasis on the object and thus should be selected with care. A 30/60 rotation emphasizes the left side, the 60/30 emphasizes the right side, while the 45/45 provides equal emphasis on both sides. Be aware of the plan orientation so that emphasis on particular elements can be made before constructing the drawing.

One way to enhance the reading of depth in an axonometric is to distinguish between spatial edges using line weight adjustments. A continuous spatial edge can be drawn where the edge of the object meets open space beyond. This profile line weight is darker than the elevation line.

The basic construction of the axonometric box can be thought of as an extrusion from the plan. The extruded form provides a framework for you to draw within. From the plan, true measurements along the vertical axis can be made. All lines parallel in the plan can be established with parallel lines in axonometric. Elevation and section information can be transferred onto the axonometric through measuring. Any circle that is drawn in plan remains a circle while circles in the vertical plane become ellipses.

◄ **Types of axonometric**
Various types of axonometric drawings can be constructed of the same design with emphasis on different parts.

90° 120°

Isometric Plan oblique

Constructing a plan oblique

1 Rotate your plan to an angle that highlights components of the design. Begin construction by extruding the corners of the box, using a 4H lead. Measure heights using the same scale as the plan.

2 Continue using construction lines, but start to add detail like doors and windows. Take vertical measurements to determine the height of the window off the ground.

3 Find elements that are not parallel to the plan, such as the roof, using heights taken from the corresponding elevations. Plot the height of the low and high points of the roof and connect them with a straight line.

4 Darken in those components of the construction lines that are visible as elevation lines in HB lead. You can leave the lightly drawn construction lines on the drawing.

Quick digital modeling

Three-dimensional modeling programs like Sketch-up and Form-Z have become commonplace in architecture studios and offices. They provide quick and easy ways to model simple spaces and can provide base drawings for hand-drawn overlays. The software allows you the opportunity to rotate and look at a model from any viewpoint. Sketch-up is good for transforming 2D work into 3D study models. It is easy to extrude objects and cast simple shadows. Its rendering capabilities are limited and therefore it is better used as a base for hand-drawn overlays. Form-Z provides more sophisticated rendering and lighting opportunities.

Peter Eisenman

Peter Eisenman (American b. 1932) was a member of the New York Five, a group of influential architects practicing in the 1970s. He later became known as one of the first Deconstructionist architects. Deconstructionism explores the relationship of literary theory to contemporary architecture, especially the literary works of Jacques Derrida. Peter Eisenman's early works were explored in axonometric drawings. This method of representation reinforced the narrative of his design intentions. Without vanishing points, as in a perspective, axonometric drawings imply infinite space. This tradition was pioneered by early 20th-century artists such as El Lissitzky, Theo van Doesburg, and other artists and writers.

Axon variations

The **isometric** is a type of axonometric that provides a lower angle view than a plan oblique. Equal emphasis is given to the three major planes. The isometric does not allow for construction to be extruded directly from the existing plan, but requires the reconstruction of the plan with its front corner being drawn at 120 degrees instead of 90 degrees. The isometric is typically drawn with vertical information true to scale. The measurements are transferred along the receding 30 degree lines.

The **diametric**, another axonometric projection, has two axes that are equally foreshortened, while the third appears longer or shorter than the others.

Variations on any of the axonometric types include the Choisy axon, exploded axon, cutaway axon, transparent-view axon, and sequence axon. The Choisy axonometric (also known as the worm's-eye view), emphasizes a view from below; typically of a ceiling of a building and its adjacent spaces. The exploded axon pulls apart the object into smaller elements, while maintaining a sense of the whole. The location of the exploded elements is typically maintained relative to the original mass with dashed lines.

► **Transparent axon**
The transparent axon depicts overlapping spaces as see-through to allow the interior to be revealed. It is similar to the cutaway axonometric, but shows the removed part as a transparent element. The darkest line, a profile line, indicates the edge between the object and open space.

▲ **Cutaway axon**
The cutaway axon allows for views into interior spaces that may not be visible from an exterior constructed axonometric. Parts of the wall and the entire ceiling are removed to reveal the interior spaces.

Spatial overlap and complex spaces

Providing opportunities for the multiplicity of spaces to be comprehended is an important design tool in architecture. Understanding the types of strategies that can be used to impact the multitude of spaces is key.

Axonometrics provide a drawing tool to help develop and understand well-defined, clear, three-dimensional spaces in architectural design. Because axonometric drawing is three-dimensional, it can depict plan and section information simultaneously. It allows each to inform the other in one drawing.

When using axonometric drawing as a design tool, architects usually think in terms of volume. Using the axonometric drawing, you can begin to see and represent space as a physical thing.

Axons provide a representational tool to depict space three-dimensionally. Once you understand how to define one space, you can overlap multiple spaces to explore the variety of spatial zones established in a project. The transparent axonometric allows you to see how spaces relate and interact with one another. The reciprocal relationship between container and space is made apparent with this drawing type. The number of different ways to define a space depends on the clarity of the elements that form the space.

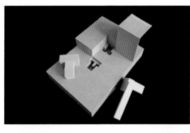

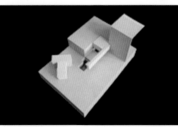

▶ Spatial overlap
A series of spatial models for a small library and reading room. Excavation (top): the volume of the sunken reading room is underground to minimize distractions and control light into the space. Reflective space (center): public spaces and book storage were contained in a volume on the second floor, distinct and discrete from the reading room and other portions of the library. Circulation elements (bottom): elements such as stair towers are housed in this last volume which completes the upper courtyard, as well as providing access in its stair tower on the ground level.

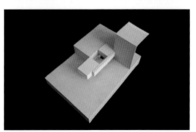

▲ Spatial diagrams
Similar to the axonometric diagrams, these perspectival digital spatial diagrams depict the apparent and implied spaces that are formed after two new elements are inserted into an existing context.

Exploration of properties and processes

Each of these small-scale designs is an exploration of material properties and fabrication processes. They are translations of flat materials into three-dimensional forms that hold space. Added fasteners, such as glue or screws, are limited, forcing the nature of the material itself to make any connections and satisfy the function.

of the piece. Each design is created not in an additive process, but through a sculpting of space with a two-dimensional material. The design process simultaneously involves drawing, experiments with the material itself to discover its limitations and advantages, and full-scale models to test and further

the drawn forms. Process drawings are presented alongside the final product as a way to demonstrate the entire process of thinking and making, from idea, to form, to product.

Designer: Martha Foss

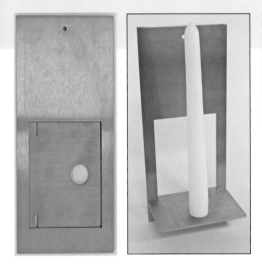

▲ ◀ **Candle holder**
This wall-mounted candle holder is laser cut from one 9 x 4 in (23 x 10 cm) sheet of stainless steel, minimizing waste and exploiting the nature of the production process. The two planar pieces, one extracted from the other, can be packaged and sold flat. These two pieces are then separated and locked back together in a new way, creating the three-dimensional candle holder.

▲ **Pencil/letter holder**
This pencil-and-letter holder is made from bent and laminated maple. The wood is curved, looping back on itself to create a space-containing piece. The first series of curves produces voids to hold letters, and one final gesture creates a place for a pencil.

◀ **Coat hook**
This coat hook is cut and bent from one flat sheet of aluminum. The thin material gains strength when it is bent and held in the three-dimensional position. The manipulation of the material creates the functional form and increases the material's resistance to force. The only fastener added is the screw to anchor it to the wall.

Introduction to analysis

We see diagrams in our everyday life: subway maps, assembly directions, musical notes, graphs, and so on. In architecture, diagrams are the result of an analytic process of abstracting a building or object into its component parts. A single analysis can be represented by a single diagram or series of diagrams. Analyses can be constructed using both drawings and models.

Read this!

Clark, Roger H. and Pause, Michael
Precedents in Architecture: Analytic Diagrams, Formative Ideas, and Partis
John Wiley & Sons, Hoboken, Third Edition, 2005

Key concepts for building analysis

- Parti
- Massing
- Structure
- Circulation
- Axis
- Symmetry
- Scale and proportion
- Balance
- Regulating lines
- Light quality
- Rhythm and repetition
- View
- Part to whole
- Geometry
- Hierarchy
- Enclosure
- Space/void relationship

For a full glossary see pages 140–141.

Analysis is a reductive process; a simplification of one idea in isolation. It is a depiction of a design intention.

Analytical models and diagrams may depict the following:

- formal qualities
- conceptual ideas
- ordering principles
- circulation
- public vs. private
- structure

▼ ▶ Analytical representation

Analysis can help you understand the basic ordering elements of a project. These need not be shown in plan but are often depicted in such abstract forms including plan, section, elevation, and axonometric drawings, or models. The abstraction aids in the reductive process. Diagrams in particular can be used to show arrangements of component parts to the whole.

▲ Context analysis

This diagram identifies distant views of a high rise design within the context of the city. The diagram juxtaposes elevation views with color coded view corridors in plan.

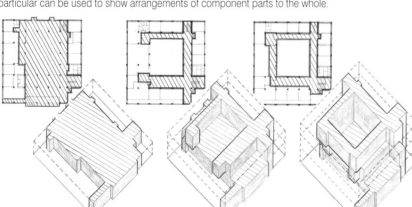

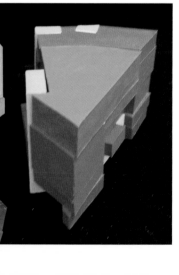

Key concepts for urban analysis

- Figure–ground relationships
- Street patterns
- Street section—horizontal vs. vertical
- Scale—hierarchy of form or space
- Land use
- Typologies
- Neighborhood relationships—changing street grid, formal street variation, building type change
- Perspectival relationships—views
- Edge conditions, surfaces, and materials
- Natural vs. manmade
- History
- Type vs. program
- Open space
- Public green space vs. building
- Access—pedestrian, vehicular, other?
- Adjacencies
- Circulation—vehicular vs. pedestrian
- Pedestrian usage
- Movement
- Water elements
- Climate—sun angles/sun shadows

For a full glossary see pages 140–141.

There is a difference between data collection and analysis. Stating what is already in existence and plotting it in a drawing or model is data collection—the identification of existing information. Analysis implies an interpretation of the data. That interpretation calls on the viewer to think about what they are seeing and provide something more than what is purely an existing condition. Analyses are generally depicted graphically in a diagram.

Analysis can provide the basis for many design decisions. Site analysis provides a deeper understanding of existing conditions, context, and environment. Analysis can be utilized at the beginning of the design process to study the site, the program, formal opportunities, and to represent a conceptual idea. In the middle phases of the design process, analysis can be used to clarify and strengthen ideas. Toward the end of the design process, analysis can be used to explain the conceptual basis for the design, especially during presentations.

The presentation of a project to academics or architects can be made with diagrams, allowing the idea to be understood quickly, while letting the discovery of the details happen through questions or observations. In complex projects, it is often easier to explain the overall project through diagrams than by showing every facet of a project at once.

The "parti" of the project is considered the main idea of the project and can be represented in a diagram. There may be a number of supporting ideas, but typically there is one single main idea that organizes the project.

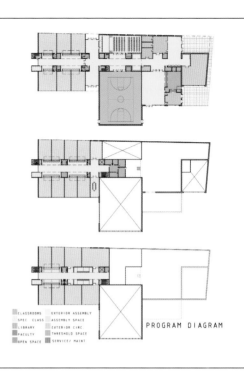

▲ **Privacy analysis**
These analysis plans show the hierarchy of public and private spaces within a school building. Different colors are used to represent areas of access and overlap.

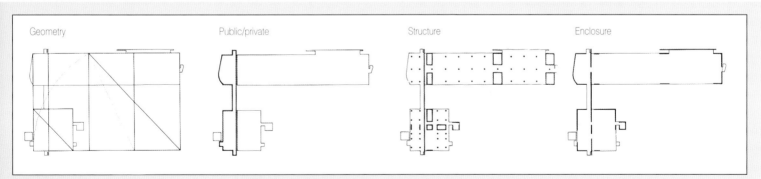

▲ **Diagramming designs**
Richard Meier's designs can be clearly diagrammed based on geometry, public/private, structure, and enclosure, among others.

Richard Meier

Richard Meier (American b. 1934) was a member of the New York Five (along with Peter Eisenman, see page 75). He has designed a large number of buildings in North America and Europe, ranging in scale from private residences to the development of civic buildings encompassing several city blocks. Despite his obvious visual homage to the early Modern works of Le Corbusier, Meier's projects are also rich with the classical ideals of proportioning and ordering devices.

Introduction to El Lissitzky

Compositions possess an order: implicit or explicit.

This order can be derived from geometry.

"Every form is only the frozen snapshot of a process."
Raoul Heinrich France

El Lissitzky, well known as an experimental Russian artist, contributed to the Suprematist art movement during the early part of the 20th century with his abstract, non-representational art. His works, known as "Prouns" (Project for the Affirmation of the New), were geometrical abstractions, both two- and three-dimensional. He was interested in creating the world through art rather than describing it.

Born in 1890 in Pochinok, Russia, Lissitzky later became one of the most influential yet controversial experimental artists of the early 20th century. His list of professions included architect, painter, designer, lecturer, theorist, photographer, and head of the graphic arts, printing, and architecture workshops at the People's Art School in Vitebsk.

Russian artist Kazimir Malevich was a major influence on Lissitzky's work.

At the time, Malevich developed a two-dimensional system of abstract art composed with straight lines and colored forms dispersed over a white neutral canvas. This mode of dynamically arranged forms of squares and rectangles, floating freely on the page, was referred to as Suprematism. Suprematist artists challenged the conventional representations of the world. They thought art should be an interpretation, not a description (much like the description of observation sketching in Unit 9).

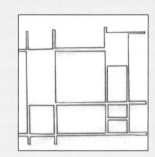

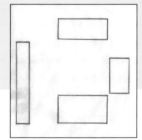

Lissitzky became a Suprematist disciple, embracing the geometric abstraction depicted across an infinite backdrop. The works did not respond to the traditional role of gravity in a painting. Lissitzky created tensions by contrasting shape, scale, and texture of elements throughout the canvas from simultaneous multiple points of view. He used the axonometric as a graphic tool to demonstrate his interest in nonhierarachical, infinite space.

In addition to being a prolific painter, Lissitzky was a visionary architect creating skyscrapers and temporary structures, including his speaker's podium known as the Lenin Tribune. The lectern's diagonal form reinforced the dynamic and gestural qualities of a speaker using it.

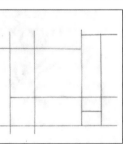

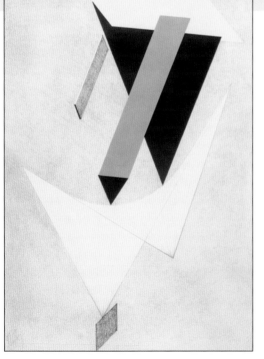

◀ **Two-dimensional geometric form**
El Lissitzky's constructions explored nontraditional spatial relationships through the arrangement of two- and three-dimensional geometric forms.

Analysis of a Piet Mondrian painting looking at structure, color, pattern, and shapes.

Analyze a Proun

Grounded in the traditions of the Bauhaus movement of the early 20th century, this assignment combines analysis and development of space to create a new three-dimensional object generated from an El Lissitzky Proun. Your task is to imagine what exists beyond the Proun's canvas. Think about the painting as if you could see beyond the canvas, from a skewed view from the side, perpendicular to the plane of the painting or from behind. It is open to multiple interpretations. What can you infer from what is there?

Brief

Find a Lissitzky Proun and translate it into 3D. You will analyze, model, and draw your transformation of the Proun. Lissitzky's work is abstract; therefore, you will need to experiment with the transformation into 3D form in an abstract manner with a focus on the development of space. Analyze the painting and then translate that analysis into a new 3D object. You are conceptualizing a 3D space from a 2D representation and then translating it back into a 2D drawing set. You should build a series of 3D models of the Proun exploring the relationships between the planes, volumes, shapes, and interstitial space. Analyze the Proun by looking at geometry, scale, proportion, transparency, hierarchy, depth, and color. This list is not exhaustive; if you think of others, use them. These analysis drawings should be sketched on a continuous piece of trace. You should scale your Proun image so that it fits as large as possible on an 8½ x 11 in (216 x 279 mm) sheet of paper. It is important to remember that the shapes you make have spatial consequences that should be considered with equal emphasis. Making the positive space is just as important as making the negative space. Part of the assignment has to do with your own expression and editing of the Proun into three dimensions. This is a design problem as well as an analytical one. The scale of the object created is 1 to 1—you are working at full scale. Thus the model is not a representation of a form but a creation of the real thing, much in the spirit of Lissitzky himself. The model is supposed to be an interpretation of the Proun and not literally recreate the implied 3D characteristics of the painting.

In developing the new 3D form, you should be recording a narrative (your own thesis) that supports your thinking. Consider what

In creating the transformation of the Lissitzky Proun, the new form must fit inside a 6 in (152 mm) volume. In addition, each of the six sides of the cube must be touched by some part of the new form. This rule requires you to think well beyond the limitations of the flat canvas.

Compose an orthographic set of drawings and an axonometric drawing.

Pencil on vellum for final drawings:

- plans
- sections
- axonometric

diagrams from the analysis phase you use to generate the 3D form and what interested you about them. Then reconsider what interests you after you create a series of study models.

This exercise explores the iterative process of design. It is a developmental process, like writing, that requires multiple edits and adjustments in support of a thesis, narrative, or concept.

Process

1 Find a Proun to analyze. Place trace over it and start to isolate and analyze elements of the image.

2 Make numerous analyses, from which you will select three to develop into three-dimensional models.

3 Create a physical model of each analysis using chipboard; the model should fit inside of a 3-in (76-mm) cube (half the size of the final model). It is often helpful to study ideas at a smaller scale, especially when testing out new concepts before a direction of inquiry is settled upon. Finally, create a new model from your analysis models; this model should be at full scale—the 6-in (152-mm) cube.

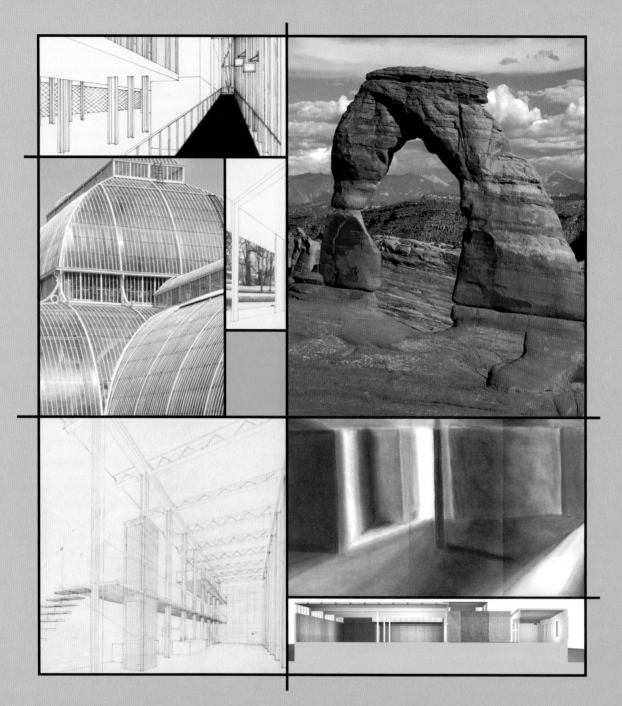

Subjective representation: perspective

This chapter introduces the techniques of perspective construction, its historical importance, and its use over time.

Filippo Brunelleschi, in the 15th century, demonstrated perspective construction through the implementation of a mirror and painting at the Duomo in Florence. Though the exact representations used by Brunelleschi are unknown, it is speculated that he was one of the first to apply linear perspective construction to depict three-dimensional space. Leon Battista Alberti, one of the greatest scholars of the Renaissance, later wrote a treatise on linear perspective construction, *Della Pittura*, making the method available to others.

Perspective construction translates three-dimensional space onto a two-dimensional surface. It is a subjective representation that mimics through a two-dimensional drawing the experience of a space, building, or object. Its construction follows a series of set rules that is applicable to the various types, including 1-point, 2-point, or 3-point perspectives.

Taken from the point of view of a person, the perspective depicts visual experience and perception of space. It is a prescriptive single point of view. In trying to demonstrate the view of an occupant, perspectives, as in photography, cannot mimic the complexity of the human eye, which includes peripheral and binocular vision. Nevertheless, perspective is an accepted representational tool that closely approximates human vision.

Perspective concepts

Perspectives allow you to represent the three-dimensional realm on a two-dimensional surface. They provide an excellent drawing method to visualize architectural design ideas.

The three-dimensional realm can be graphically described through perspective drawings. These differ from other three-dimensional drawings, such as the axonometric, in that they are subjective. A perspective is constructed from the eye level of a viewer, looking in a particular direction from a single stationary point. As described in Unit 19, the axonometric is an objective, abstract, three-dimensional image not representative of real world conditions. Its lines remain parallel to one another, thus maintaining objective neutrality in the drawing. In contrast, parallel lines in perspective converge toward a single point, mimicking a particular view of the world. In perspective construction, elements of the same height that are further away from the observer appear to be smaller than elements that are closer. In addition, lines of an object that are not parallel to the observer are compressed to convey depth. These variations that affect the perspective image have no influence on the axonometric drawing.

The type of perspective is based on the relationship between the viewer and the object being viewed, and on the angle of view from the observer toward the object.

Design application

Perspective drawings are tools that can be used to develop designs. By using trace overlays on top of constructed perspectives, photographs, or digital images, you can manipulate elements and spaces in relation to the experience of the viewer. Learning how to oscillate between plan and perspective, or orthographic drawings and three-dimensional representations, is key to making architectural designs that are grounded in the reality of the occupants. While manipulating the perspective you are manipulating views as seen in three-dimensional space in contrast to abstract representations such as the plan and section.

Picture plane (PP)

Sightline (SL)

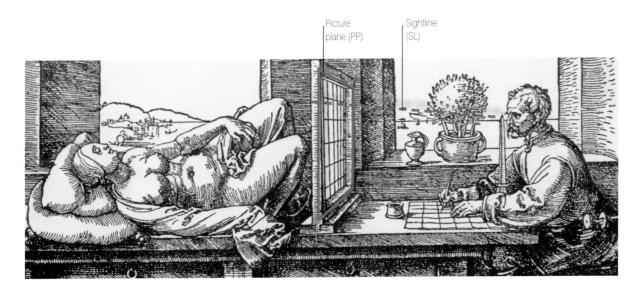

◀ **Key concepts**
This depiction by Albrecht Dürer demonstrates some of the key concepts you need to construct perspective drawings. Where the sight lines cross the picture plane establishes where the image will be cast on the two-dimensional surface.

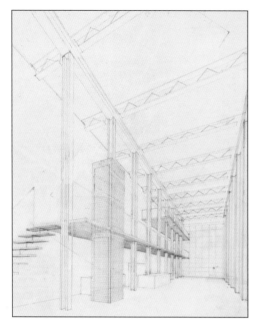

▲ Visible construction lines

This pencil on vellum perspective shows construction lines. Leaving these lines visible enables you to find any construction mistakes easily. These lines also reinforce the hand-drawn character of the perspective.

▲ Scale figures

Copies of the Thomas Eakins rowers are collaged into this pencil perspective to provide scale and context. The orientation of the wood ceiling emphasizes the movement of the rowers.

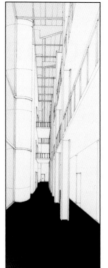
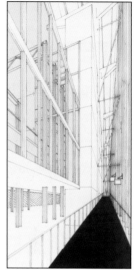

▲ Paired images

These perspectives emphasize two elements: the glazing and the ramp. The image on the left is a 1-point perspective, while the image on the right is a 2-point, providing a greater emphasis on the glazed surface. By pairing up images in a series, you can depict movement through a space seen through key vistas and orchestrated visual sequences.

Perspective terminology

Station point (SP)
Location of the observer in space.

Picture plane (PP)
A transparent plane, intersecting the cone of vision, that receives the projected perspective image and is perpendicular to the viewer. The PP is translated onto the 2-D drawing as a horizontal line that intersects the plan. Its location on the plan in relation to the SP impacts on the size of the drawing.

Sightline (SL)
A line that extends from the SP at eye level, through the PP, to the object. (See Dürer image, opposite.) The perspectival image occurs where the sightlines cross the PP.

Horizon line (HL)
This line depicts the eye level of an average-height viewer. Conventionally, this is established 5 ft (1.52 m) above the ground plane. It can be exaggerated to emphasize the eye level of a child's perspective, for example. It is always a relative distance from the viewer's eye to the ground line;

for someone standing, the HL is at 5 ft (1.52 m), someone sitting in a chair has a HL of 3 ft (91 cm), while someone on a second-floor balcony has a HL of 15 ft (4.57 m)—10 ft (3 m) for the first floor + 5 ft (1.52 m) from the second floor to eye level.

Cone of vision (CV)
The conical volume that depicts the viewable area from the SP. This visual field is typically considered to be a 60-degree cone from the eye. Replicating vision is difficult due to the fact that humans have binocular vision, while the perspective image is taken from monocular vision. Therefore the CV is only a guide to constructing the perspective image. Lines or elements of the drawing constructed outside the 60-degree CV will be distorted.

Measuring line (ML)
This is the only line that can be measured as a true dimension. Any vertical measurement can be accessed from this line. It is typically marked as a vertical line at the intersection of the picture plane and the plan.

Vanishing point (VP)
A point on the horizon line where parallel horizontal lines converge. Each set of orthogonal lines can have one, two, or three vanishing points. (In 3-point perspective construction, the third vanishing point related to vertical line construction is not located on the horizon line [HL], but remains on the picture plane.) In a 2-point perspective, each set of orthogonal lines, positioned non-parallel to the horizon line, has two vanishing points. Any lines that are parallel to the orthogonal lines recede to the same vanishing points. Any lines that are not parallel will have a different set of vanishing points. Locate non-parallel elements using new vanishing points or by translating points on the plan, locating each corner and connecting the points. This method works well for curved elements or small single orthogonal objects in the plan.

Presenting perspective

The variety of design interpretations to any given program is what makes architecture such an interesting and rich profession. Each designer responds to the client, program, site, and building codes in unique ways.

Read this!

Gruzdys, Sophie
"Drawing: The Creative Link."
Architectural Record, Vol. 190, no. 1, pp. 64–67, January 2002.

Rylander, Mark
"The Importance of Perspective Drawing in the Design Process: Philip Grausman's drawing class at Yale."
Crit, no. 15, pp. 30–35, Summer 1985.

Each project can be represented by a number of different drawing techniques, including plans, sections, models, axons, and perspectives. This allows each project to be represented in a portfolio layout using any number of drawing types. Perspective drawings, in particular, closely replicate what our eye sees. When choosing the type of perspectives to draw, you can choose between 1-point, 2-point, or 3-point perspectives. One-point perspectives are typically used to emphasize a strong space along a

single axis, while 2-point perspectives provide ways to see spaces and objects more dynamically. Three-point perspectives are typically used to represent tall buildings or spaces such as skyscrapers. Choosing the right type of perspective to represent the architectural intention is an extremely important decision.

A selection of student portfolios demonstrates how to utilize perspective in the design process and final presentation materials. Each student

was asked to design a room for repose; a space for a traveler during an airport layover. The program included a place to rest, to hang your clothes, to work, and to clean up. Terminology such as "bathroom" and "bed" was removed, with the aim of challenging preconceived notions of these everyday spaces while encouraging invention and new interpretations (see page 120 for this assignment).

Different types of perspective drawings can be used to represent each

project's intention. The perspective techniques include sketching, constructed views, and evocative drawings like charcoal sketches. Perspectives require key decisions before the drawing begins:

- where to stand
- what to look at (cone of vision limits the drawing distortion).

▶ Using 1-point perspective to reinforce axial organization

A single 1-point perspective is able to describe the whole space while reinforcing the axial organization of the plan. The project culminates in the cleansing area along the main axis, which is reinforced in the 1-point perspective drawing. This project sets up a particular sequence of events along a single axis through the space. The student subdivided the room into wet and dry zones and used light to differentiate space, which can be seen in the section. This eliminates any desire for full wall partitions that would obstruct the view through the whole space.

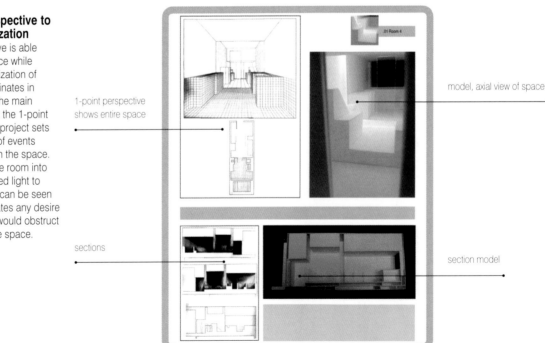

1-point perspective shows entire space

model, axial view of space

sections

section model

► Using 2-point perspective to show detail

Three 2-point perspectives are drawn to depict the positioning of the utilities. The perspective series illustrates three of the four corners in this rectangular room, emphasizing the most important aspects of the room: the central space and the continuous utilities strip that wraps around the room. This student pushes the utilities to the edge of the room, leaving the center space open for occupation. The center becomes the circulation area with easy access to all the key utilities.

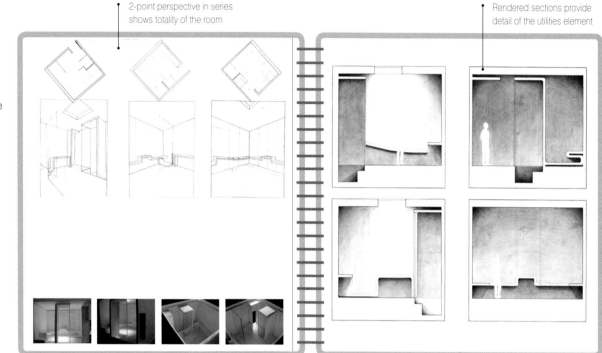

2-point perspective in series shows totality of the room

Rendered sections provide detail of the utilities element

model

orthographic drawings with rendering

model

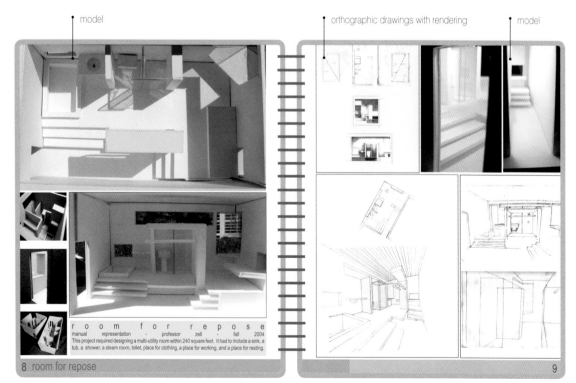

r o o m f o r r e p o s e
manual representation · professor zell · fall 2004
This project required designing a multi-utility room within 240 square feet. It had to include a sink, a tub, a shower, a steam room, toilet, place for clothing, a place for working, and a place for resting.

8 room for repose

9

◄ Using 2-point perspective to show a spatial sequence

The 2-point perspective serves as a way to introduce the viewer to the spatial sequence. The perspective drawing emphasizes the diagonal view established by the architectural elements of the room. A window at the opposite corner is on a diagonal axis with the viewer upon entering the room. Thus the drawing is able to highlight this connection across the space. The idea of views as a structuring device was used to design this space.

2-point perspective

There are a number of different methods for constructing perspectives which vary in difficulty. The method described here uses the plan as a basis for construction. The same principles can also be applied to freehand sketch perspectives and digital perspectives.

Read this!

Ching, Frank
Design Drawing
John Wiley & Sons, 1997

Yee, Rendow
*Architectural Drawing:
A Visual Compendium of
Types and Methods*
John Wiley & Sons, 2007

Lewis.Tsurumaki.Lewis
Opportunistic Architecture
Princeton Architectural Press, 2007

Setting up a 2-point perspective

One of the first things to consider when constructing a perspective is the intention of the drawing, or the focus. What do you want to convey? This will help you establish where to stand, at what height to look from, and what aspect of the design you want to emphasize.

1 Use two 30/60/90 degree triangles to establish the cone of vision. The point of the two triangles indicates the location of the SP. Tape down the plan and lay a large piece of trace or vellum overtop. Place the sheet of paper so that it covers the entire plan and leaves room at the bottom for the image.

2 Next, establish the location of the picture plane (PP). For ease of construction, this horizontal line should intersect a point on the plan, preferably a corner of the plan and one that will be seen in the perspective image.

3 Draw a vertical line from the intersection of the PP and the plan to establish the measuring line (ML). This line should extend into the white space left open for the image construction.

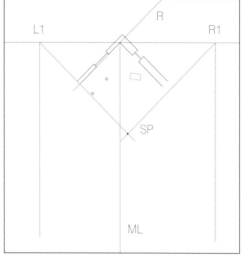

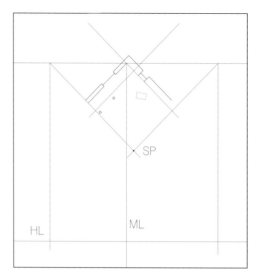

4 To determine the location of the vanishing points it is important to follow these instructions exactly. From the SP, and using your adjustable triangle, draw a construction line parallel to line L of the plan that intersects the SP and crosses through the PP. Repeat on the other side for R.

5 Label the intersections of lines L and R with the PP L1 and R1. At R1, the intersection of the construction line and the PP, draw a vertical construction line, perpendicular to the PP into the open space of the page. Repeat at L1.

6 At this point, you can establish the horizon line (HL) for the drawing. The horizon line can be placed anywhere on the paper and will establish the location of the perspective image. In this case, locate the HL between the plan and the bottom of the page. This should allow you enough room to construct the perspective image. The horizon line is a horizontal line, parallel to the PP.

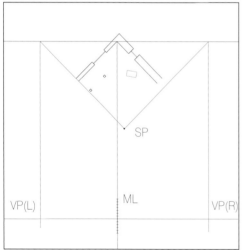

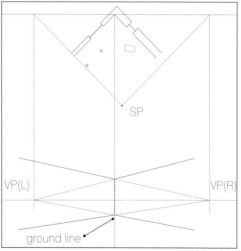

7 Where the vertical lines from the PP cross the horizon line, you will establish the vanishing points. Call them VP(R) and VP(L). The ML should also cross the horizon line. This intersection establishes the location of the eye level for the person standing at the SP. If the person is standing on the ground, the horizon line would be 5 ft (1.52 m).

8 Using the same scale as the plan drawing, mark a series of 1-in intervals above and below the horizon line. Indicate the ground line at 0 ft and the tallest dimension, taken from the elevation drawing, along the ML. You will use these measurements to create the heights in your perspective. Begin constructing the top and bottom of the walls to establish the framework of your space. Lines in plan parallel to line R recede to VP(L). Extend a line from 0 ft and the height of the wall (in this case 10 ft) on the ML to each VP to create the top and bottom of the wall.

9 To obtain vertical information, you must follow a two-step process. Draw a construction line that intersects the SP and any point on the plan and continue it through the PP (label A at the PP).

10 Draw a second construction line, starting at A (the intersection of the first construction line and the PP) perpendicular to the PP into the perspective image area. Repeat for all lines in a given element. Cross the vertical lines with height lines obtained from the ML.

11 Go back and forth between getting vertical information from the plan, measurements from the ML and surfaces that vanish to one of the VPs. Heights can only be taken along assisting planes for elements not along the ML. See "assisting planes," page 93.

12 Repeat for each element in the room.

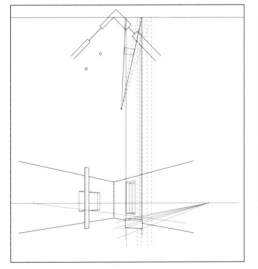

13 All vertical measurements must be translated along surfaces if they do not connect directly to the ML (such as the chest in this drawing). That is, an object detatched from a wall touching the ML must have its vertical measurements transferred across a series of perpendicular planes (even if those planes do not exist as actual surfaces in the design).

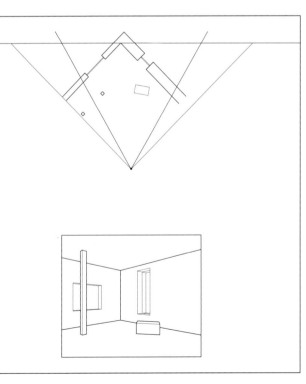

14 Finished perspective. The CV (shown here in blue) establishes the box around the perspective.

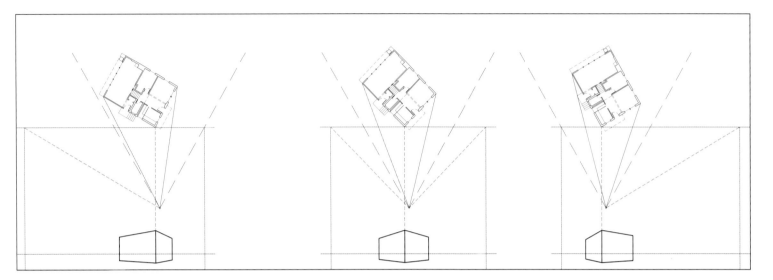

▲ Plan alignments

The plan alignment relative to the SP establishes which elements get highlighted or emphasized in the perspective drawing.

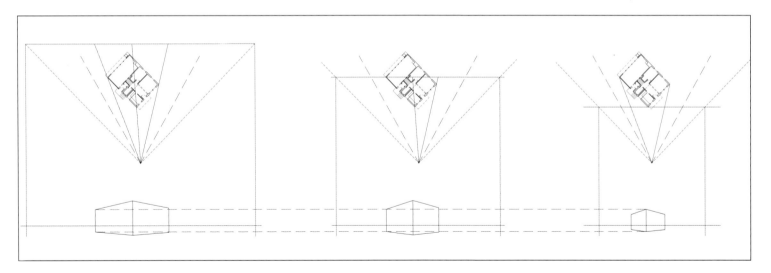

▲ Moving picture plane

The location of the PP determines the relative distance between the vanishing points (VPs). As the PP moves away from the SP, the VP move apart. Where the PP crosses the plan determines the location of the ML. If the ML is constructed off the front of the plan, then the image recedes to the back. If the ML is constructed off the back of the plan, the image will project forward.

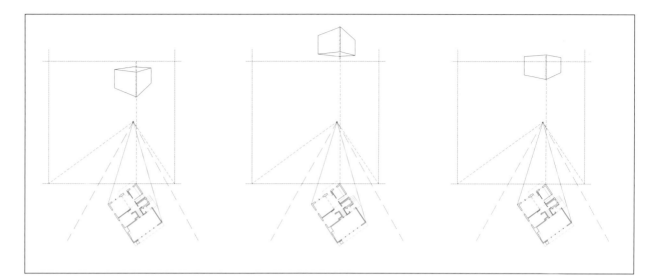

▲ Moving horizon line

As the location of the eye changes from 5 ft to 20 ft to -20 ft the projected image of the object changes from aerial view (+20 ft) to worm's eye view (-20 ft). Note that all people in perspective, no matter how far away, if standing on the same ground plane, will have their eye level located along the HL.

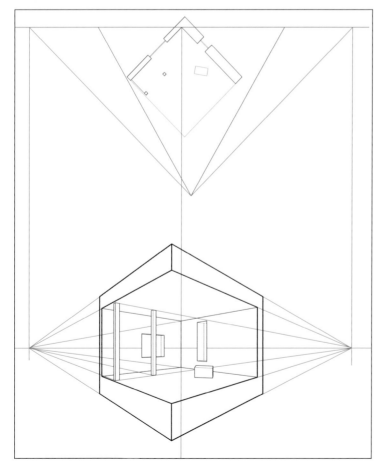

◀ SP location

If the perspective is taken from a person standing outside of the room looking inside you will be able to see the perimeter conditions of the room. When the SP is located outside of a room the thickness of the walls and floors are depicted. Note: 45 degrees is only used for demonstration purposes. The plan can be rotated to any angle; the chosen angle should capture desired views.

▼ Perspective types

Perspective construction includes the 1-point, 2-point with both concave and convex views, and the 3-point.

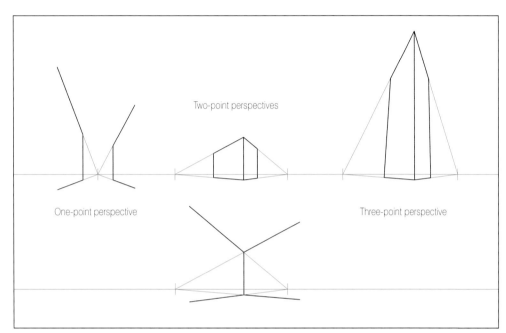

Two-point perspectives

One-point perspective

Three-point perspective

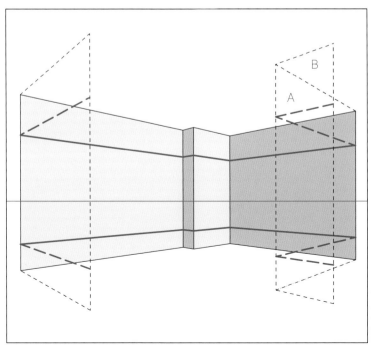

◄ Assisting planes

"Assisting planes" are used to translate dimensions from the ML onto other surfaces of the perspective. If wall A does not exist, but you need the height of wall B, translate the height information across the "assisting plane" (wall A) to wall B.

Perspective tips

A series of relationships between the component parts of the constructed perspective establish the outcome of the drawing.

• The relationship between the SP and PP establishes the actual size of the image being drawn. The further the PP is from the SP the larger the image will be. The SP and PP can be moved independently of one another.

• Moving the SP further away from the object affects the rate of foreshortening of the object. The movement of the SP causes the VP to be further away from one another. This distance may be a physical constraint of your drawing surface.

• The orientation/rotation of the plan relative to the SP and CV establishes which elements are contained/viewed in the perspective.

• Eye level is established by the intersection of the ML with the HL. This is typically located at 5 ft (1.52 m) from the ground, but when an aerial or "bird's eye" view is desired the HL is moved higher, or in a "worm's eye" view the HL is much lower.

• It is best to start the perspective construction with a sketch vignette so that you have some idea of the image you are constructing. The sketch provides the basic structuring elements of the drawing.

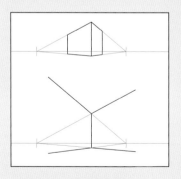

▲ Concave and convex

In 2-point perspective construction, the alignment of receding lines is either concave or convex. Concave shows a view inside a space, while the convex shows the outside version of the space. Though the specific angles of the lines may vary, these concave and convex systems can be used to sketch any perspective view.

1-point perspective

1-point perspective construction is similar to 2-point construction. The main difference for the 1-point perspective is that lines parallel to the picture plane do not converge but extend to infinity.

Read this!

Panofsky, Erwin
Perspective as Symbolic Form
Zone Books, 1993

Because there is no convergence due to their parallel nature, lines parallel to PP are constructed using a parallel rule. One-point perspectives are considered to be more static than 2-point perspectives, especially if they are symmetrical. They have a single focus and are good for depictions

looking down a street or long space. Typically, 1-point perspectives focus on the space between the walls while 2-point perspectives focus on the surfaces that make up the space.

As in any perspective construction, it is important to establish intentions before

setting up the perspective drawing. What do you want to emphasize? Which view best demonstrates the desired intention? As in the 2-point perspective, these decisions will help you establish where to stand, at what height you should look from and what part of the subject you want to view.

In a 1-point perspective the plan is placed parallel to the picture plane and only one VP exists that aligns with the SP. Your point of view is aimed into a space perpendicular to the picture plane.

Constructing a 1-point perspective

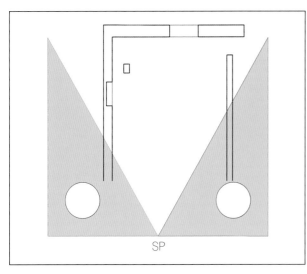

1 Rotate the plan so that the wall you want to view is parallel to the PP. Establish your SP and the cone of vision—what do you want to view and how much of it will you see? How far back in the space do you want to stand? Set up your paper in the same manner as the 2-point perspective (see page 88). Lay trace or vellum over the secured plan.

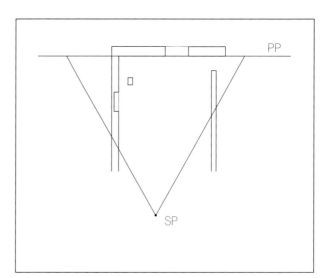

2 Draw the PP to coincide with the back elevation for ease of construction. That is, the horizontal line demarcating the PP should cross the front edge of the wall. Blue lines indicate the cone of vision (CV).

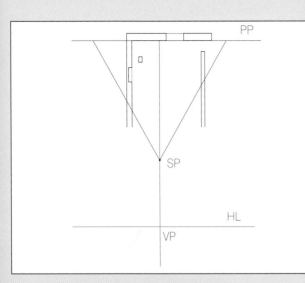

3 Locate your HL and VP on the elevation. The VP should correspond to the appropriate height of a viewer's eyes looking into the space and can be located directly in line with your SP. The SP and VP vertically align since this is a single-view perspective with one focus.

4 Construct the back wall elevation that corresponds to the location of the PP at the same scale as the plan. Draw this in the open space below the plan. This will serve as your ML, or in this case your measuring plane (MP).

5 Start the drawing by connecting the VP to each of the four corners of the elevation. Extend these lines beyond the limits of the elevation. This will provide the parameters of the room: walls, floor, and ceiling.

6 Vertical lines are obtained through the same method as the 2-point perspective (see page 90). Method: SP to the point on the plan; where the line crosses the PP drop a vertical line down.

Note

All lines perpendicular to the picture plane converge at the one vanishing point (VP). All lines parallel to the picture plane should be constructed using a parallel rule.

7 Continue depicting vertical data through the previously described method (see page 95). Use the assisting planes to find the heights of the elements not connected to the ML/MP.

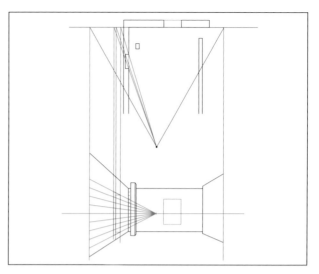

8 Remember to translate vertical heights from the MP to the objects not directly adjacent to it.

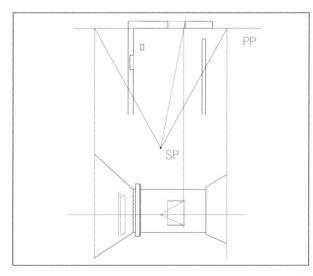

9 Show the depth of the wall at the window opening. Extend a line from the SP through a point on the plan to where it crosses the PP and drop a vertical line down. Use measurements from the MP to draw the corners receding to the VP.

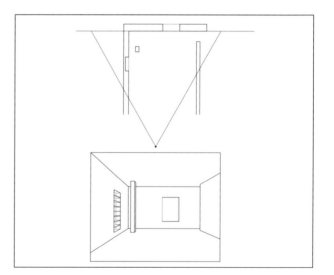

10 The finished perspective. The CV sets the parameters of the box.

▼ Reducing vanishing points

Understanding how the vanishing points work in a 2-point perspective provides the foundation for understanding why a 1-point perspective only has one vanishing point. This image depicts the rotating vanishing points of a 2-point perspective to a 1-point perspective.

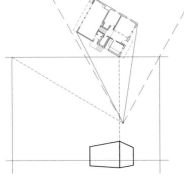

Emphasis on left wall

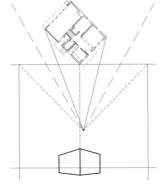

Equal emphasis on both walls

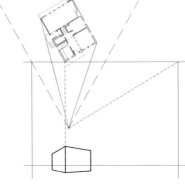

Emphasis on right wall

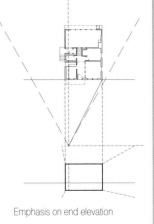

Emphasis on end elevation

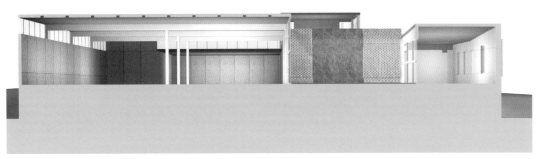

▲ Sectional perspective of a printing press

This sectional perspective for a printing press is intended to convey the programmatic relationship between the printing press room on the left and the office space on the right through the courtyard in the center. While visually connecting the two spaces, it also provides an acoustic and thermal barrier. The green poche emphasizes the cut line and indicates structural systems including precast concrete and light timber framing.

▲ Aerial perspective

The plan perspective emphasizes an aerial view into a space. This 1-point perspective for a traveler's room shows that the service spaces are tucked into two thickened "poche" zones.

Finishing a perspective

Always leave the horizon line in your drawing, even as a light construction line. It establishes where the ground stops and where the sky begins. The horizon line gives the page a bottom and a top.

When finishing your perspective drawing, consider page composition in relation to your design and representational intentions. Should the paper be cropped or cut to meet the perspective or should a box be drawn around the perspective to contain it? Where are the limits of the cone of vision? Vertically? Horizontally? Ultimately you want to ensure you leave enough room on the paper so that the perspective image is not compromised.

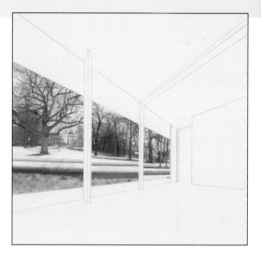

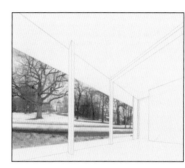

► **Cropping an image**
The image on the near right is cropped too short—the viewer does not feel like part of the space. The cone of vision (CV) marks the limits of the top and bottom of the image, but there is flexibility in marking these limits. The emphasis of the view on the far right is transferred from the columns to the connection between indoor and outdoor space.

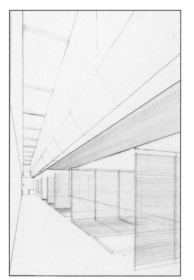

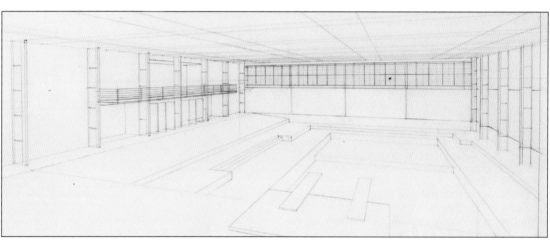

▲ ◄ **Drawings limits of the perspective**
These two images, depicting views inside a natatorium, were drawn using pencil on vellum with construction lines left in place and cropped in different ways. A perimeter box defines the limits of the view for both images.

Vertical extension

A 3-point perspective is constructed in a similar manner to a 2-point perspective, except that all the vertical lines converge to a distant vanishing point. This technique is useful when constructing views looking up at a tall building or looking down into deep spaces. In each case, either the picture plane is tilted or the object is tilted relative to the picture plane. In a sense, all three axes are oblique to the picture plane.

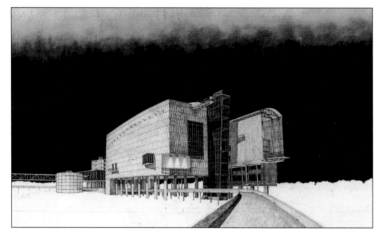

▲ **West Bank Industrial Worker's Club**
This view from the approach ramp was constructed to emphasize both the power of the forms and at the same time the delicate quality of the floating buildings. Similarly the dark sky that speaks of impending doom is contrasted by the bright sunlight. The drawing is pencil on Arches paper.

Replicating experience

Perspective drawings are not solely used as presentation drawings for clients, planning, or academic reviewers. They are necessary throughout the design process to verify plan and section ideas against spatial and experiential ones. They are design tools that aid in developing your ideas. Design changes can easily be made between the perspective and the plan. Familiarize yourself with the techniques of perspective construction so that you can understand and manipulate the variety of images capable of being drawn. While plans and sections help create space, only perspective images replicate experience of that space.

Digital modeling

Digital modeling provides designers with an adaptable process for constructing three-dimensional representations of their developing designs. In programs like SketchUp, Form Z, Rhino, and Revit, you can translate two-dimensional information into three-dimensional models and generate infinite views. Due to its ease of use, SketchUp is often used during the design process for form generation and manipulation, single view perspective, and as an underlay for freehand sketching. The other programs tend to be more complex with a wider range of capabilities, especially for complex geometries. In addition, they are often used for presentation-quality representations due to their superior rendering capabilities. Other three-dimensional modeling programs like Revit represent recent initiatives in Building Information Modeling (BIM) and tie together the entire model so that changes in one view will automatically be updated in all views.

Three-dimensional models can also serve as the basis for digital animations, closely mimicking the experience of someone walking through the design.

Although not a common practice, single perspectives can also be created with any of the two-dimensional programs like Autocad and Vector Works in the same fashion as construction by hand—you simply treat the monitor as a virtual drawing board. When creating still images with digital programs like Form Z or SketchUp, it is important to maintain a critical level of observation to preserve the desired intentions for each representation. It is also necessary to control the CV to ensure that space is not distorted.

No matter which program you learn to draw and model with, it is important to understand the relationships between drawing types developed in both digital and manual representation. Skills training in hand drawing provides a solid foundation with which to consciously and willfully design using digital media.

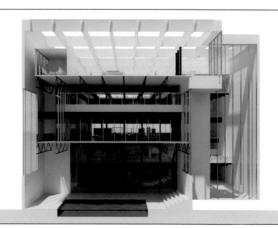

◄ **Spatial expression**
This K-8 school was modeled in Revit 9.1 and then rendered with Mental Ray in 3DS Max 9. The role of the sectional perspective is to express, using color, the spatial relationship between the pool, the gymnasium, and the library. Structural elements depict boundaries and light qualities in the space. It provides the viewer with the ability to see multiple spaces simultaneously.

Architectural element design: opening

By designing a single architectural element you will become aware of the many design decisions involved in each component part of the element and in the relationships of those component parts in creating the overall project.

◀ Reconsidering worlds

A television is not typically considered an opening, but it can be reconsidered as a window on a world of sound and moving pictures.

▶ Framing a view

Openings are abstract thresholds between elements. At Arches National Park in Utah, this single arch frames a view of the distant mountains.

▼ Precedents

The Villa Savoye by Le Corbusier juxtaposes a glazed strip or ribbon window with similar sized unglazed openings. An opening on the roof terrace acts as the focal point of the circulation sequence through the house, framing a view of the adjacent landscape.

Familiarize yourself with as much information as you can before conceptualizing your project. This first phase of data collection will involve site and precedent research.

Getting started

Most designs are not created in a vacuum. Ideas, inspirations, and responses can be drawn from the existing conditions on the site of the project. The various scales of the existing conditions can be investigated. That is, a site might be a room within a building, within a neighborhood, within a district, or within a city. Each of these existing conditions can influence the design. The existing conditions can also expand to neighboring sites, context, and histories. Always consider what is around the site, not just the physical elements like buildings, trees, open space, and transportation networks, but the cultural ones as well. The existing conditions, along with the rules of the program—whether they are code considerations or rules created in an academic setting—need to be considered when brainstorming the project.

Precedent research

Typological precedents—those designs that have come before with the same program—are excellent places to start your research. This is especially important for beginning design students, as what they bring to the design process is intuitive and limited by personal experience. To broaden your knowledge base, familiarize yourself with historical precedents and the meanings behind the designs.

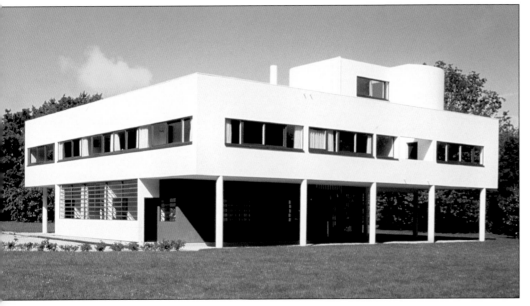

The design problem

When confronting design issues, it is important to challenge preconceived notions and critically evaluate the essence of the design problem. Step back from everyday language and think more conceptually about the problem.

The term "opening" as it relates to architecture is used to define everyday building elements like windows and doors. Opening, as defined by Webster's New World Dictionary, is an open place or part, hole, gap, or aperture. From this definition the term "opening" can be disassociated from the familiar term "window."

When considered abstractly, you can think beyond the familiar double-hung, bay, or slider window. You experience a variety of opening types on a daily basis. Their ubiquitous nature blurs them into the background of the built environment.

Openings are thresholds between two sides. These sides can be unique or similar depending on the context in which you are operating. Regardless of the type of side, the opening participates in both realms simultaneously and independently. The opening affects the experience of a space depending on its size, shape, material, texture, transparency, and so forth. Openings are not neutral elements. Even conventional openings make a statement about their use; for example, residential windows, often of a typical size and scale, are recognizable as different from commercial window types.

Possible functions of an opening
- to let light in
- to frame a view in
- to frame a view out
- to provide a place of occupation
- to demonstrate the thickness of the wall

ASSIGNMENT: **16**

Design an opening

You will be examining the nature of an opening in detail by exploring issues of light, ventilation, significance, size, scale, materiality, proportion, privacy, view, point of view, space, place, security, and control. The project is small, but involves complex decision-making. This is clear from the list of issues mentioned, especially when each issue is considered as a threshold between one side and another.

Brief

You are asked to design an opening for an existing room. The site is an existing corner room on the second floor of a building with given dimensions and sun orientation (see diagram).

- The opening(s) can only be placed on the two indicated surfaces, the south and west walls, in the selected areas. Multiple openings can be located on both walls.
- The ceiling height in each space is different—a dotted line on the plan indicates where the change in ceiling height takes place. One ceiling height is 10 ft (3 m) and the other is 12 ft (3.65 m). Choose which ceiling plane is higher than the other based on your conceptual design ideas.
- A door must be added to the plan along the north wall. Consider the type, size, and method of operating the door relative to the experience of the user in the room, and its relationship to the opening design.
- The opening can take up to a maximum

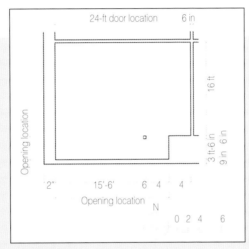

▲ **The room**

You are asked to intervene into an existing room. The program of the room is left ambiguous (it is not a bedroom or a living room) so that the focus of the design is based on the proportions of the room and room orientation.

of 35% of the total surface area of the two exterior walls indicated on the plan.
- Each wall has a different thickness.
- The opening cannot penetrate the roof (no skylights).
- Glass used may be clear, colored, or frosted; no glass block or other types of specialty glass may be used.

Think back to Unit 1 (page 12), and remember that architecture is not a purely practical discipline. Design involves creating a narrative that defines the meaning behind the physical moves of design. Solutions for design should be both practically and poetically driven.

Strong ideas

- The simpler the idea, the stronger the project will be. Simple does not mean mundane or boring. Simple means that an idea is honed down to its essence. It has clarity.

- Architectural moves should support more than one idea. Ideas that have multiple influences strengthen the project.

Process: research

Find three precedent examples that could provide inspiration for your own design. Do not limit yourself to the preconception that opening = window.

Remember that the process of design is iterative. You will start the process, evaluate your initial solutions, and redesign based on the clarity of the narrative relative to the articulation of the idea. You will repeat this process over and over again. Understand that the initial idea you produce is the generator of the architecture and will be manipulated over time. Your initial sketches may not look like the final outcome of the project. This is fine; through the iterative process you will learn to develop your ideas. This takes experience and time.

Sketch initial ideas, including your initial reactions to the assignment and precedent research, in your sketchbook. Any idea that comes to mind should be recorded. Do not try to use all of your ideas in one project. Learn to edit your ideas—too many ideas are just as bad as too few.

Translating ideas to paper or models

• Create three study models at ⅛ scale to investigate the conceptual thinking recorded in your sketchbook. What is the intention of the opening? How does it react to the existing conditions? Is it about light? What quality of light? If it is about view, what is the nature of the view? Is it directional? Is it about viewing out at an object or in at those occupying the space?

• Hardline a plan and section of the room on trace without any design elements at ¼ scale. Use this as an underlay for freehand orthographic sketches.

• Review how to draw glass in plan and section. Typically, glass is drawn using two lines as close together as possible while still maintaining two distinct lines. Remember all materials have thickness. At 1/16 scale glass is represented with two lines roughly ½ in (1.2 cm) apart to scale; at ⅛ scale this might be 1 in (2.5 cm) apart. The two lines representing the glass should never be further apart than 1 in (2.5 cm).

Consider the location of the plane of the glass in the the wall thickness. Should the glass be centered in the wall, flush to one side, or asymmetrical? What does it mean to have glass that is flush versus centered?

Developing the initial design

Select one of your original study models as the basis for your design. Develop your opening ideas, using the hardline drawings as underlays to make changes and modifications to your design. As you continue to think and sketch, create a new study model to explore your ideas at a larger scale. This new study model should be twice as big as the first study model, at ½ scale. An increase in scale requires an increase in detail in both drawings and models.

Using perspective drawings

At this time in the process, it is good to construct a few perspectives to investigate how your ideas in plan and section are executed through the experience of someone looking at or occupying the opening. Use the perspectives as a design tool. You can manipulate elements of the perspective, such as the height of a wall, the location of an edge, or the size of a form, which can then be modified in plan. In addition, use the perspectives to represent floor, wall, and ceiling materials to begin to characterize the space.

Using charcoal drawings

Create charcoal drawings of the opening design to experiment with the way light moves and changes throughout the day. This is a critical design tool that documents how light enters the room through your opening. To understand how light moves in space, place your study model on a work surface and use a desk lamp to cast light through the space. Or take your model outside. Sunlight is scaleless, so shadows cast on the model replicate built conditions.

The Palm House at the Royal Botanic Gardens, Kew, in London, UK

Image folder exercise

Find window precedents and add to your image folder.

Le Corbusier	La Tourette, Ronchamp, Villa Savoye, La Roche-Jeanneret
Frank Lloyd Wright	Fallingwater
Steven Holl	The Chapel of St. Ignatius
Marcel Breuer	Whitney Museum
Tadao Ando	Koshino House, Church of Light, Church on the Water, Vitra Museum
Clark and Menefee	Middleton Inn
Louis I. Kahn	Salk Institute, Esherick House
Konstantin Melnikov	House in Moscow
Carlo Scarpa	Brion Cemetery, Canova Cast Museum
Walter Gropius	Bauhaus
Alvaro Siza	Faculty of Architecture, Faculty of Journalism, Galician Center of Contemporary Art, The Serralves Foundation, Vieira de Castro House
Guiseppi Terragni	Casa del Fascio
Herzog & de Meuron	Roche Pharma Research Institute
Jean Nouvel	L'Institut du Monde Arabe

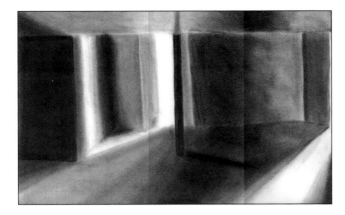

▲ **Charcoal drawing**
This charcoal drawing for the opening assignment emphasizes contrasts between dark and light. The sharp light casting across the space is representative of the setting sunlight in the western sky. Note the reflective quality of the walls around the openings.

The material palette in the space, concrete walls and ceilings along with wood flooring, can influence the design of the project.

◀ **Exploded axon**
This exploded axonometric drawing, on 90lb hot press Arches watercolor paper, emphasizes the layered elements that make up the system of the window. The window wall is pulled away from the space to enable a clearer sense of the component parts of the opening.

Using Arches paper

• It is an opaque surface: you cannot trace on this paper unless you have a light table.

• Erasing is more difficult than on vellum.

• A pencil mark leaves an indentation in the paper even after you erase it, so press lightly.

• It is expensive: this can be intimidating, although you can draw on the back.

• It comes in pre-sized sheets, so offers less flexibility than a vellum roll.

Marcel Breuer

Marcel Breuer (Hungarian b.1902 d.1981) was one of the fathers of Modernism. He employed modular construction with simple forms. He taught at the Bauhaus with Walter Gropius and is perhaps most recognized for his furniture designs. The Wassily chair, constructed out of bent steel tubular members, was in part influenced by steel handlebars on his Adler bicycle. One of his best known buildings is the Whitney Museum in New York City. Its heavy inverted ziggurat-inspired form with a monocle-like window was once controversial. Over time, however, it has been heralded as a bold, inventive building that challenges contemporary notions of aesthetics.

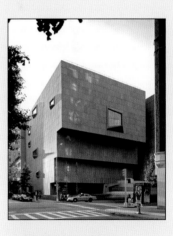

▲ **Window as object**
The Whitney Museum in New York by Breuer: the single small window opening along Madison Avenue was a powerful gesture at a time when the curtain wall of glass was proliferating. This window allows you to look up at the street, not just across it.

The kit of parts

The kit of parts project dates back to the 1950s with the introduction of the nine-square grid problem by John Hejduk at the University of Texas.

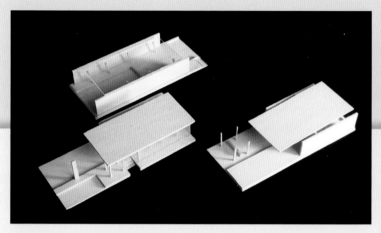

Along with fellow academics Colin Rowe, Robert Slutsky, and others, Hejduk was part of a new trajectory in architectural education that promoted design as a formal issue.

The original "kit of parts" problem included a reduction and simplification in the number and type of formal elements, often repeated, that led to a focus on threshold, enfilade, space, vistas, and movement. These limited

parameters allow you to concentrate on developing the narrative as it relates to the composition of spaces and the sequence associated with those spaces.

Compositional design strategies make up the core of the kit of parts problem. Composition is the active arrangement of parts to create a whole; to establish order. Even with the limited number of parts,

a myriad number of solutions is possible. As problem solvers, architects deal with their own kit of parts in the building codes, zoning codes, covenants, and program requirements.

These basswood models capture the sharp light cast into the space.

Using the kit of parts

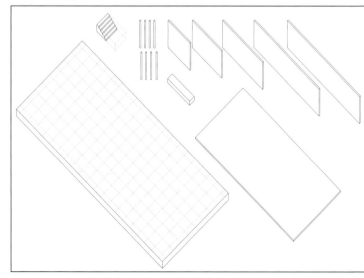

This exercise challenges you to compose a series of spaces, using a prescribed kit of parts, to orchestrate an experience, based on five themes.

Your site is a solid plinth, measuring 2 ft 6 in (76 cm) high, by 80 ft (24.40 m) long, by 32 ft (9.75 m) wide. The plinth is delineated by a 4 x 4 ft (1.22 x 1.22 m) grid.

Brief
• Locate two shallow reflecting pools: one measuring 1 x 38 x 18 ft (0.3 x 11.58 x 5.50 m), and another measuring 1 x 22 x 10 ft (0.3 x 6.70 x 3 m) wide. You may place the pools anywhere, as long as at least two edges of each align with the

grid. They must remain rectangular and may not be placed on the very edge of the plinth.

• Subtract a volume 2 ft 6 in (76 cm) high by 6 ft (1.82 m) wide by at least 10 ft (3 m) long to accommodate an entry stair.

• Define a sequence through the site using eight 6-in (15-cm) columns and five walls measuring 10 ft x 12 ft, 16 ft, 22 ft, 36 ft, and 40 ft (3 m x 3.7 m, 4.9 m, 6.7 m, 11.0 m, and 12.2 m). Place columns at grid intersections and align the centerline of walls with a grid line, except at the perimeter of the plinth where the edge of the wall must align with a grid line. Do not place columns inside the pools.

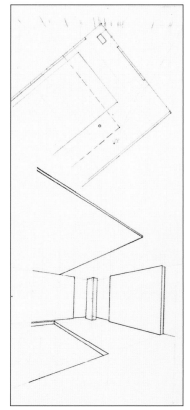

◀ **Capturing space**
Space between the walls, roof, and columns is captured in this constructed perspective. This image orients the view to the space between two walls.

Mies van der Rohe

Ludwig Mies van der Rohe (German-American b.1886 d.1969) is considered to be one of the most influential of the early Modernists. After establishing himself at IIT in Chicago, Mies went on to create a number of influential buildings in the U.S.. His buildings aspired to establish a new style to embody the spirit of the times. Perhaps the first to do this was the German pavilion for the World Exhibition in Barcelona in 1928–1929, the Barcelona Pavilion. It embodied the streamlined aesthetics of the era. The Barcelona Pavilion was an exercise in harmonious proportions and exquisite composition of materials. The expression "Less is more" has been attributed to Mies.

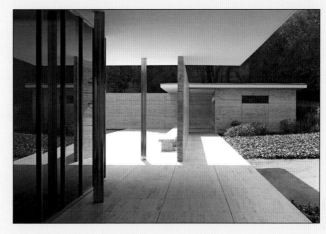

The Barcelona Pavilion.

• Use a combination of walls and columns to support a canopy (see diagram for dimensions). The edges of the canopy must run parallel to the lines of the grid. No wall may cantilever over the edge of the plinth.

• Finally, find a place on the site for a monolith measuring 1 ft 6 in x 2 ft 6 in x 12 ft (45.6 cm x 76.24 cm x 3.65 m). Orient the monolith vertically, horizontally, or on its side. At least two edges must align with the grid.

Process
You will design several spatial compositions using all of the parts in your kit. Use a soft pencil (2B or 4B) or felt-tip pen to freehand trace over a hardline plan of your site (the plinth). Generate at least 12 different spatial compositions based on the following themes:

• ceremony
• contemplation
• dialogue
• imbalance
• tension

Explore each theme at least once. This allows you to be selective about which ideas you develop and clarifies your thought process. Record the definitions of each word along with your own interpretations of them. Brainstorm the meanings of these words. This will provide a foundation for your design.

While sketching in plan, think three-dimensionally about your design. For each plan draw a series of four small perspective sketches that represents the sequence of movement through your design. Do the sketches reinforce the idea? If not, revise the sketch (use trace), then return to the plan and modify it based on the perspective changes. Draw plans and sections at $\frac{3}{16}$ scale so that relationships between the two can be exploited.

Make a model to help establish the sequencing strategy and provide opportunities to study the light qualities of the spaces. In addition, creating a series of charcoal drawings will demonstrate light interacting with the kit elements. Charcoal drawings should be drawn to showcase the character of the materials, textures, and space as light changes throughout the day.

Final representations
• Plans and sections at $\frac{3}{16}$ scale (1 longitudinal section and 2 cross-sections)
• 3 constructed perspectives
• 1 basswood model
• 2 charcoal drawings
• Final presentation images including perspective drawings, diagrams, orthographic projections, and final models.

Chc
2000
k017

Dynamic rendering strategies

This chapter looks at a number of different rendering techniques that enhance the dynamic qualities of representations.

Architectural drawings can evoke a sense of the mood, texture, and atmosphere of a space, transcending mere two-dimensional abstract representations.

Dynamism in architectural drawing can be achieved through variations in medium, vantage point, and composition. In addition, graphic elements and graphite rendering techniques can be layered onto a line drawing to enhance its evocative quality. These explorations can provide the viewer with a greater sense of the architect's intentions by exaggerating certain aspects of the representations. Color, point of view, layout, or the addition of collage elements provide opportunities for you to present your ideas in a more compelling and lively manner. These methods enhance existing graphic constructions while creating opportunities for new representations. Dynamic presentations should support design intentions.

In addition, this chapter will explore the step-by-step process of design while examining space as both an additive and subtractive design tool. The way in which space can be used to describe and diagram existing conditions will be examined along with the methods of translating initial design ideas into spatial explorations. The distinction between additive and subtractive methodologies will be defined.

Rendering techniques

Line drawings alone cannot convey the textural qualities of a space: how a room reacts to light, what materials enrich the space, or the way light and materials interact. It is sometimes necessary to enrich line drawings with indications of material, shade, and shadow.

Read this!

Darden, Douglas
Condemned Building
Princeton Architectural Press,
New York, 1993

Material indications and rendering in a drawing help to convey the texture, rhythm, and scale of a space. Materials can be indicated through a variety of line techniques and are produced on floors, walls, and ceilings ranging from concrete, wood, metal, glass, plastic, and so forth. Material renderings provide tonal value to the drawing.

Metal and stone can be rendered with some sense of inherent reflection or shadow. In some cases, a tonal value is given to only one material to distinguish it from others. Concrete is a good example. It can be rendered using a variety of techniques but the main consideration is that it has a tonal value different than that of metal or wood. Adding shade and shadow can provide more depth to a rendering.

▲ **Shape and texture**
This pencil rendering by Douglas Darden reveals the shape and textures of the elements in this design. By rendering most of the object, the white of the page becomes compositionally important.

The two issues to consider when representing materials are scale and intention.

Scale
Consider at what scale the representation is drawn. For example, brick can be rendered in a number of different ways depending on the scale of the drawing. Start by indicating the horizontal nature of the material. Abstract the material so that in the representation it appears convincing. A drawing at 1/16 scale might require a more abstracted version of brick than a drawing at a larger scale, such as 1/2. Even at this large scale, you will need to consider if there are additional vertical breaks needed that identify individual bricks versus the more general horizontal nature of the brick. Depending on the level of detail desired, every joint of every brick can be drawn.

Intention
Consider what you want to emphasize with a material: horizontality, verticality, or a particular wall or surface? Some drawings are best presented when only certain hierarchical materials are rendered. This limitation on material rendering can reinforce design intentions.

◄ **Material indications**
This pencil-on-Arches elevation drawing endeavors to relate the materiality, construction, and light quality of the shipping containers that comprised the housing units in this project, located in downtown Los Angeles. Careful attention was paid to the details so that the physical reality of the containers was not compromised.

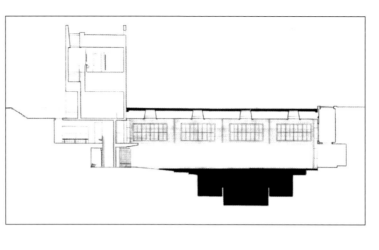

◀ **Connection to the ground**
This sectional perspective makes the section legible through the application of poche. By depicting the cut in black poche and making it thicker, a stronger connection to the ground is implied. This is further emphasized by the pools that dig into the ground. The material renderings of wood and tile on the interior characterize the quality of the pool space.

▲ ▼ **Material rendering techniques:**
The positive shape of a stopwatch is rendered in different ways in graphite. The vertical hatching (top) creates a neutral textured surface, useful for describing wall surfaces. The stippled texture (middle) creates an impression of concrete, but can be time consuming. The darker vertical hatching could be used to depict dark wood surfaces. In three dimensions, hatching is used to define tonal areas (below). Rather than drawing a line where two surfaces intersect, the two planes were rendered with hatching to imply a line.

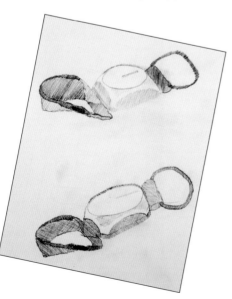

Digital rendering

Computer programs have become extremely sophisticated in their ability to output images with rendered materials and entourage. Though the amount of time it takes to construct and render computer models has decreased significantly over the last few years, it still presents a high level of attention and time commitment to output detailed and beautiful digital images. Architects generally understand the abstract quality of rendering techniques developed during the design process, while clients may want a more "realistic" image to experience the space before committing the money to physically construct it.

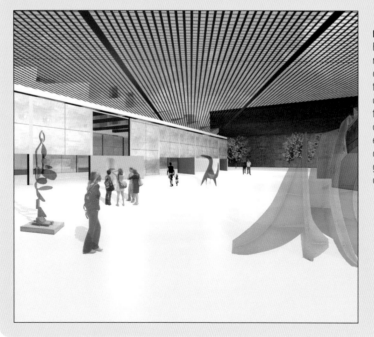

◀ **Realistic rendering**
Realistic digital renderings allow clients to compare their interpretations of the drawings with the intentions of the designer. This image emphasizes the spatial dynamics of a sculpture garden inside a newly designed museum.

Charcoal drawing

One method of drawing that captures the quality of light in a space is charcoal drawing, mentioned briefly in Unit 11 as a sketching technique. This unit will describe in more detail the construction of a charcoal drawing using compressed charcoal.

Read this!

Johnson, Nell
Light is the Theme: Louis I. Kahn and the Kimbell Art Museum
Kimbell Art Foundation, Fort Worth, 1975

Brooks, Turner
Turner Brooks: Works
Princeton Architectural Press, New York, 1995

Louis I. Kahn was one of many architects who understood the importance of considering natural light when designing. He knew how natural light animated a room and brought it to life.

"The making of spaces is the making of light at the same time."
Louis I. Kahn, talk at the Otterlo Congress

Precedents

Drawings from Hugh Ferris and Turner Brooks offer examples of evocative high-contrast black and white images. These images explore the possibilities of design as opposed to being purely representational.

▲ Monumentality
Hugh Ferris used charcoal to evoke a sense of monumentality in his building representations. Note the surface quality of the marks on the page.

The medium of charcoal combined with perspective drawings provides a method to render mood, light, and textural qualities in an evocative manner that transcends the line drawing. Charcoal drawing utilizes contrasting lights and darks to demonstrate how light affects and influences space, materials, and movement. In this method, tone and shade are used to create volumes or planes of solids and surfaces. This drawing type enables you to reveal the experiential nature of a space in a very evocative manner, as well as to design spaces influenced by light.

There are several charcoal options:
• vine stick
• soft compressed (preferred—provides a variety of line types but is a little messy)
• pencil

The soft compressed charcoal stick is ideal for the beginning student. It offers a myriad of possible marks on the page depending on the length of the charcoal stick, pressure applied by the artist and the positioning of the stick, whether vertical, horizontal, or angled. The soft compressed charcoal is similar in shape and size to pastel crayons. You can hold the charcoal stick in a variety of ways to achieve different line types. You can also smear it with your fingers, reducing the marks of any individual stroke on the page.

Methodology
One technique among many to lessen the tension of drawing with such a dark material on a white surface is to use the charcoal to lightly tone the entire drawing surface. Your blank sheet of white paper is shaded to a gray tone with the long edge of your charcoal applied with light pressure. By reversing the page from stark white to a tonal gray, the pressure, both literal and figurative, of making the first mark on the page is lessened. By toning the paper you can now either add black marks with the

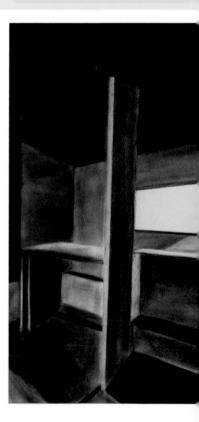

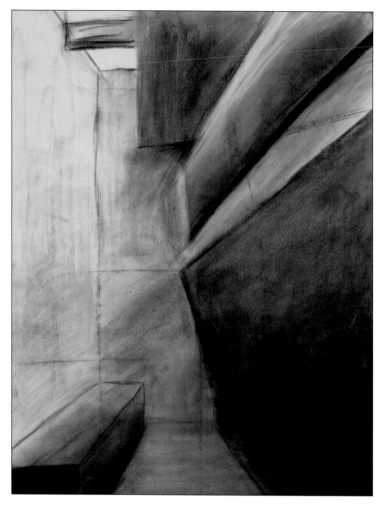

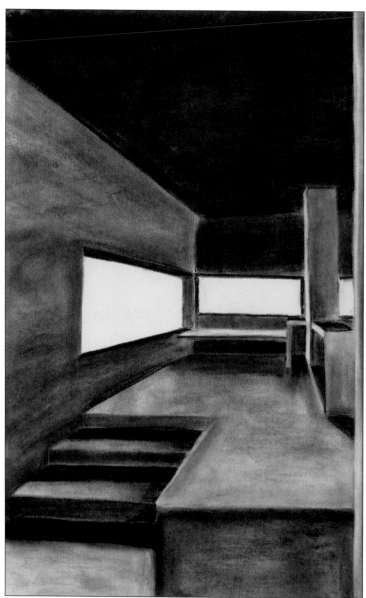

◀ ▲ ▶ Spatial narrative

Charcoal is a dynamic medium that enables dark shadow areas and delicate veils of light to describe the play of light on surfaces. These three charcoal perspectives depict a spatial design narrative through a series of single views. They reveal a strong division of space with vertical elements. Light is used to wash wall surfaces, provide views or direct movement.

charcoal or erase for light or white marks. Tones of gray are possible through rubbing. You can smear the page with the heel of your hand, your finger, or a rag. Concentrate on making marks that are less like lines and more like planes of dark or light. No lines exist in nature, so the marks on the page should be considered spatial delineators—not edges.

There is a "messy" quality to charcoal that liberates you from the need to be precise. Any mistake can be easily fixed by rubbing, smearing, erasing, or adding more charcoal. There is a massaging of the paper to work the image into place. Start light and work toward dark. It is easier to darken the page than it is to lighten or completely erase the black.

Color or not

Similar art forms, such as black and white photography, rely on tonal differences in the image to enhance and reveal the depth of the space. Walker Evans, well known for his black-and-white documentary photography during the Depression, only started using color photography much later in his career. He has suggested that

until one has mastered black-and-white photography, emphasizing tone, shade, and quality of light, one should not try using color film. His suggestion can be heeded by those thinking of shifting from black-and-white drawing to color prematurely. The complexity of color should be tackled after you master black and white.

Shade and shadow

The interaction of architecture and light is an integral component of design.

Representational forms in which you can show the effects of light include orthographic projections, axonometric, and perspective line drawings. The graphic depiction of shadows in these drawings provides additional depth, characterizing the interaction between architecture and light.

Shade and shadow added onto orthographic drawings gives a three-dimensional characteristic to a drawing by emphasizing the depth and space through light and how it interacts with surfaces. Shadows expose the physical relationship between the elements in the space that are receiving the light and the elements that are creating the shadow, the wall, window cutout, and so forth.

Two key elements to consider when constructing shadow drawings:
• Shadows are cast onto a surface (no surface = no shadow).
• A consistent dimensional relationship exists between the element casting the shadow and the surface accepting it.

Light and intention

Become a keen observer of light and how it acts and reacts to surfaces. Place a complex object under a desk lamp and draw it under several different light conditions. Think about when the light can create both short and long shadows. Think about the orientation of the light—will that enhance or obscure part of the design? Be aware of how graphic representations can reinforce intentions.

▲ **Compositional balance**
Long shadows provide compositional balance and change the emphasis from the object to the space between the shadow and the object.

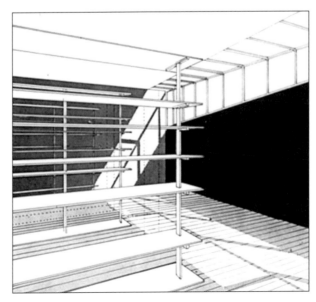

▶ **Interaction of light**
Shade and shadow rendering in this perspective provide a sense of how the light filters into the space and interacts with the shelving system.

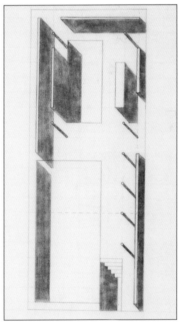

▲ **Indication of depth in plan**
Shadow plans indicate the changing floor depths. They reveal the relative heights of individual elements and the relationship between solid and transparent surfaces.

Indication of depth in elevation

In elevation drawings, shadows demonstrate the relative relationship between elements, indicating the depth of recesses or projections.

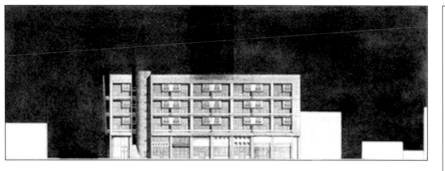

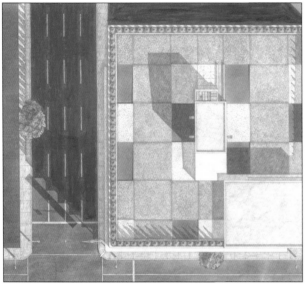

◀ Scale in context

In a site plan/roof plan shadows show the scale and form of a building relative to the topography of the site. They also provide a method of distinguishing your building from the adjacent context.

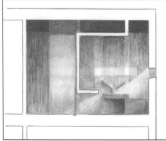

◀ Relative influence of light

In section drawings, shadows show the relative influence of light in a space. The farther away the surface is from the light the darker the rendering.

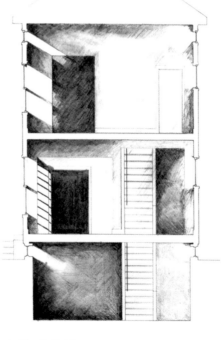

▲ North light

North-facing windows get diffuse natural light. Many artists' studios face north for the evenness of the light quality over the course of the entire day. On rare occasions, light can even get reflected from adjacent buildings, creating some cast shadows into a space.

Always find the local sun conditions for your building site.

Lighting terminology

As a designer, it is important to note the sun orientation relative to any site that you are building.

In the northern hemisphere:
- **Summer Solstice:** June 21 at noon
- **Winter Solstice:** December 22 at noon

Solar charts are available that provide the correlating height and angle of the sun in the sky relative to a specific location. Note on these charts that the summer sun and winter sun move along very different paths in the sky. Closest to the June 21st date, the summer sun rises north of east and sets north of west while on dates closest to December 22nd, the winter sun rises south of east and sets south of west.

The sun can only be cast onto surfaces.

Light source: sun or artificial lighting that acts upon an object.

The rays of the sun are considered parallel for constructing shadows. This is due to the distance light travels between the sun and the Earth— around 93 million miles. In reality, the sun's rays diverge as they reach the Earth's surface, but this divergence is insignificant relative to shadow casting. In contrast, artificial lights typically emit a radial light due to their proximity to the object casting the shadow.

Shade: an unlit surface of an object.

Shadow: the shape of one object cast onto another surface.

Color, collage, and composition

Several other media types can be used to enhance representations. Both collage and colored pencils can be introduced to drawings in an effort to make them more dynamic. Compositional issues also play a key role in emphasizing elements in a representation.

Read this!

Nicholson, Ben
The Appliance House
MIT Press, Cambridge, MA 1990

Woods, Lebbeus
"Lebbeus Woods: Terra Nova
1988–1991", *Architecture
and Urbanism*,
extra edition no. 8 pp 1-171,
August 1991

Pamphlet Architecture 1–10
Princeton Architectural Press, NY,
NY 1998

◄ Abstract overlay

This arresting collage shows ways to overlay abstract information while highlighting important aspects of human scale and usage of the space. This image marries collaged elements, photos, and color with a perspective drawing. It depicts the "potential" as opposed to the reality of the space. For instance, there is a roof on this school building, but the ceiling is depicted as sky to imply a connection to the world beyond.

▼ ► Depicting multiple experiences

The drawings depict the multiple experiences of walking through the gentrified Chelsea Meatpacking district in New York City. The one below and to the right shows a section through a collage that juxtaposes views of the seemingly incompatible industrial High Line and the meatpacking warehouses against trendy galleries, nightclubs, and pastry shops.

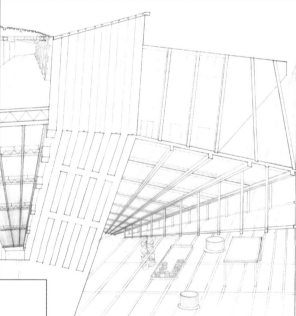

Collage

In the early 20th century, the cubist artists Braque and Picasso introduced the technique of collage. Collage is an abstract method of representation that combines existing images with contrasting materials to create a new image. Typically, materials are applied to new two-dimensional painted or graphic work. Collage artist Ben Nicholson describes collage as "an aggregation of various pieces which create an irresistible spectacle in the eye of the maker."

Collage provides opportunities to rethink the existing. The act of making a collage or remaking an image records thoughts that cannot be articulated in drawing alone. Collage provides a starting point for generating new ideas and evaluating existing conditions.

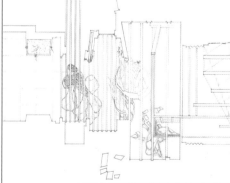

Colored pencils

Colored pencils can be added cautiously to emphasize a dynamic moment in a representation or to further represent an idea. Color is not to be used as a method of applying "realism" to a project. It should still be considered an abstract medium that can emphasize specific elements in a representation or tie them together.

◀ Color and page composition

The page composition of a single image can reflect the design intentions while engaging dynamic color elements. The page is elongated to emphasize the verticality of the architectural design. The red rendered sky is an abstraction. The marks of the pencil are visually apparent and give texture to the sky. The building surfaces are rendered to evoke the quality of materials.

▼ Black and white duality

This composition, a stark black and white image, powerfully conveys the cut in the earth and the horizontality of this idea. The project, for a political prisoner, uses a clear duality of the page to convey the strong single move in the project, a long platform.

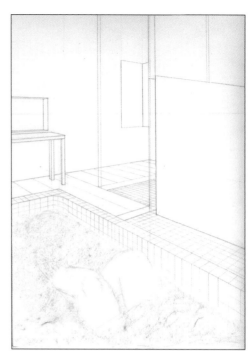

▲ Entourage

Entourage establishes scale. It is common in section and perspective drawings to populate the image with people, while furniture is often added in plan. Depict people interacting with and using the architecture.

Preservation of hand drawing

Advances in digital programs have not completely replaced hand drawings in the profession. Architecture firms such as Lewis.Tsuramaki.Lewis, Tod Williams Billie Tsien, and others utilize a combination of hand-constructed perspectives and digital textures, colors, and entourage to create beautiful composite drawings. Hand drawings are often scanned into Photoshop and manipulated using a variety of techniques. The quality of the hand drawing is appreciated and thus retained.

Many firms use the following processes:
1. Create Form Z model; 2. Print out perspective view; 3. Layer hand drawing onto it; 4. Scan drawing; 5. Manipulate in Photoshop.

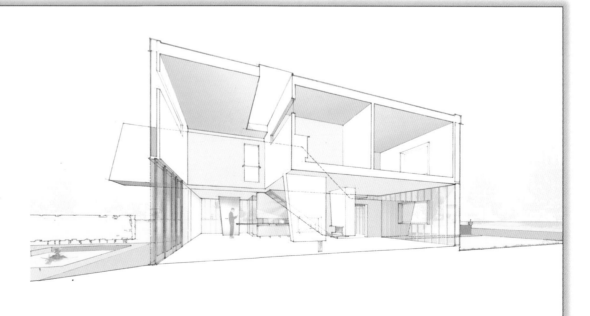

▲ Evocative graphics

Graphic images can also be added to imply a relationship to other drawings or time periods. Graphic lettering, a turquoise sky, and a flying dirigible are all used to enhance the quality of this perspective. Note that the color of the sky is not meant to replicate a real "blue" sky but to indicate that the sky is different than the rest of the image. The CHC and corresponding numbers indicate the name of the competition, "Capital Hill Climb," and entry number K017. The scale, location, and color of these graphics recalls the Russian Constructivist era. The dirigible as collage functions to evoke a sense of the future.

▲ Head shot studio, LA

The drawing was executed from a low angle as a way of emphasizing the height and structure of the design. Both the ground and the sky are left as abstract representations as a way of talking about the placelessness of the site that was the leftover space behind a billboard on Sunset Boulevard. The drawing is ink, gold leaf, and film on linen.

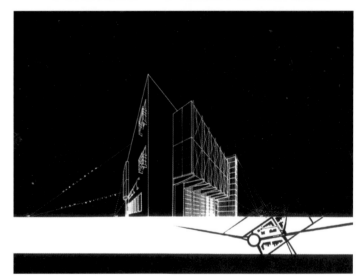

◀ Selective color

Color is selectively added in this pencil composition to both the sky of an exterior perspective and the background of the series of interior perspectives. In this case, a dynamic color is used to tie the elements on the page together. Too much color could detract from the overall clarity of the board. More color does not equal more dynamism. There is a clear hierarchy of images within the composition. The section model replaces the section drawing.

▲ Hybrid drawing

This drawing demonstrates the combination of a perspective and site plan. The inverted perspective (white lines on black background) provides a large dark sky to establish a more dynamic image.

Dynamic rendering

Firm
Bauen Studio

Renderings have the power to change a well-drawn hardlined pencil drawing into something dramatic and dynamic. Rendering techniques range from material application to shade and shadow to realism. Rendered drawings are useful in presentations to clients. Materials, textures, and quality of light can be clearly communicated in these types of drawings.

Project
The addition to a 1950s suburban house consisted of a dining room, mother-in-law suite, and master bedroom suite. This project is located in the Providence District of Fairfax County outside of Washington, D.C. The neighborhood is representative of typical 1950s development patterns, with single family homes situated on small lots. Like many transforming neighborhoods, this one is also experiencing the real estate phenomenon of the "tear-down," where the original house is purchased for its land value, the house is demolished, and replaced with a starter mansion. This not only has a socio-economic effect on the characteristic of the neighborhood, but also compromises its native architectural structures and spatial quality. Generally speaking, most new homeowners respect these existing

structures and are creating additions that are appropriate to the scale of the neighborhood. Unfortunately, these additions do not necessarily reinforce the potential "communal" aspect in the neighborhood.

Traditionally, residential additions are realized as additive elements attached to an existing structure. But when an "addition" is larger than its host, how should it be referred to? The architects addressed this issue by conceptualizing the addition as an element that is not merely attached to its host, but rather as one that is integrated. They have blurred what is typically referred to as "new" and "old." This binomial nomenclature (of black and white) lacks the possibility of the new blending with the old. When a space has characteristics of both, rich ambiguity follows. Spaces which exhibit elements of old and new develop into various shades of gray. For example, a new bookshelf/storage unit defines the boundary of an existing space, becomes a new wood floor which flows into the dining room addition and leads outside the house to become a terrace, ultimately terminating as a planter. Furthermore, this re-orientation to the front of the house onto the street coincides with how the neighborhood is reinventing itself by inverting the 1950s privatized realm, which traditionally opened the house to the rear.

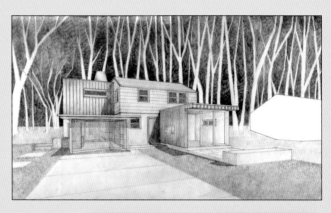

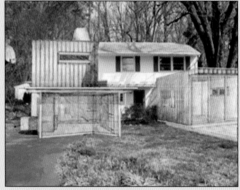

▲ Rendering for purpose
This perspective for a house addition and renovation is shown using two different techniques: material and sky rendering and photocollage. In each case, the perspective was constructed in pencil to show the formal characteristics of the addition. In the top example, the materials were rendered and the background was abstracted, placing a greater emphasis on the transparent elements of the new architecture. A connection between the interior and exterior is emphasized. The collage with the photo (bottom) allows the scale of the new addition to be understood relative to the existing concept.

▼ Fluid diagrams
These diagrams indicate the fluid nature of the addition with the existing house. Rooms that are new have more detail, including floor patterns and furniture.

Addition and subtraction

For the last few decades, there has been a trend in urban design that emphasizes rethinking the city street as a spatial container and not just the result of the buildings or objects that line it. This conceptualization of space can be applied at a variety of scales including the city, the street, a building, a room, or an object.

Read this!

Architectural Graphic Standards
John Wiley & Sons
10th edition, 2007

Design tips

Train yourself to think about the following when you are designing:

Research/history: this could include but is not limited to typology studies: see what others have done before you and learn from the past;

Existing conditions: you always have a context to work within; know everything you can about the site and the context—what is the history of the site? This is not just about the physical aspect, but the social and cultural context as well.

To facilitate this conceptualization process, space must be considered a physical entity; a shapeable thing that is concisely defined rather than residual. It is a medium to work with and within rather than the resultant of walls, floors, and ceilings. Space can be visualized

when carved out of a solid element whether in a physical model or three-dimensional computer modeling and when thought of as a cast of an interior space. The process of carving, ultimately a process of reduction, is very different from the more typical

additive process of joining materials together to represent space.

This type of conceptualization of space contrasts with the additive conceptualization of the earlier kit of parts assignment (see page 104).

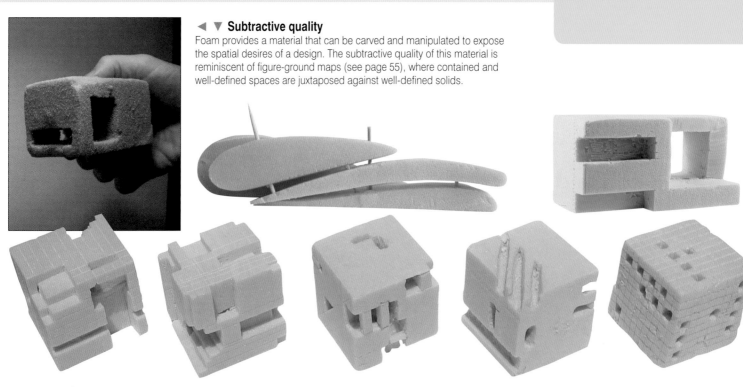

◀ ▼ Subtractive quality
Foam provides a material that can be carved and manipulated to expose the spatial desires of a design. The subtractive quality of this material is reminiscent of figure-ground maps (see page 55), where contained and well-defined spaces are juxtaposed against well-defined solids.

▶ 3D figure-ground maps

Figure-ground maps of urban environments can be recreated as physical three-dimensional models. The methodology of making these models with a laser cutter enables the simultaneous construction of a positive model (left), in which buildings are solid additions, and a negative model (right), where the spaces between buildings are solid and the buildings themselves are subtracted. These models of the Pompidou Center in Paris demonstrate the space as a three-dimensional entity.

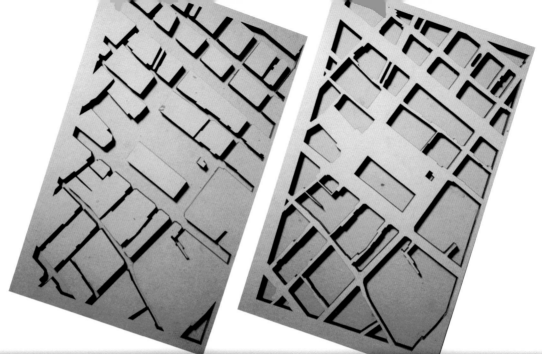

Spatial analysis

This sequence of studies created in SketchUp depicts a variety of spatial volumes defined by the design of an outdoor classroom. The outdoor classroom in the center, the rectangular form, implies a series of intersecting spatial volumes at a variety of scales. Some volumes of space are defined by the cornice line of the perimeter buildings (see image 2), while other spaces are defined by the landscape elements of the outdoor classroom at the scale of a person (see image 4). Images 3 and 4 indicate a spatial connection between the site and adjacent circulation spaces.

1
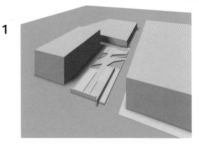

2
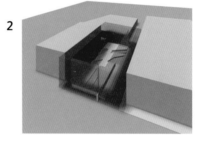

3
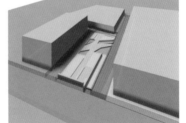

4
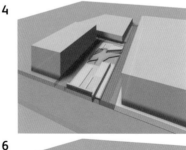

5
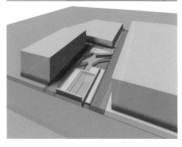

6
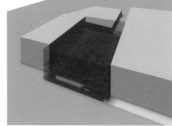

Space for a traveler

Brief

Design a temporary place of occupation for one person pausing after an overnight flight. The room is to be located inside the airline's arrival lounge at Heathrow Airport in London with a view of the tarmac and can represent either:

• a middle room with only one exterior wall condition, or
• a corner room with two exterior wall conditions.

The traveler may use the room for bathing, changing clothes, work, or relaxation. It should include a dressing area with space for a suitcase and hanging clothes, a place to wash, a place for bathing, a steam room or sauna, a toilet, a TV, a radio, a coffee maker, a place for magazines, a space for writing, and a place of rest such as a chaise-longue.

Process

Your task is to design an innovative, thoughtful space for the traveler. You are asked to suspend any preconceived notions of familiar objects. Words like bed, closet, bathroom, and shower have not been used to dissuade you from

Rem Koolhaas

Rem Koolhaas (Dutch b. 1944) is a writer turned architect, theorist, and urban planner. In 1978 he wrote his seminal treaty, *Delirious New York*. In this manifesto, Koolhaas explores the history of New York City and the consequences of the 1807 matrix that divides the city into 2,028 blocks. His office, OMA, The Office for Metropolitan Architecture, established in 1975, has built critically acclaimed structures around the world. Koolhaas' work can best be typified for his interest in programming and diagramming and analyzing how these inform the organization of the building. For his design of the Seattle Public Library, Koolhaas analyzed historical precedents coupled with speculations of future uses of the library based on computer advances in the storage and displaying of information and potential adaptations to how future generations will socialize and interact.

▶ **Exploring relationships**
This collage diagram explores the link between the acts of cleansing and viewing. The view is obstructed by the moving water during this act.

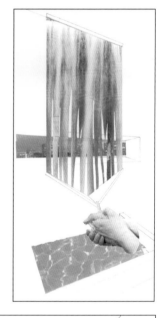

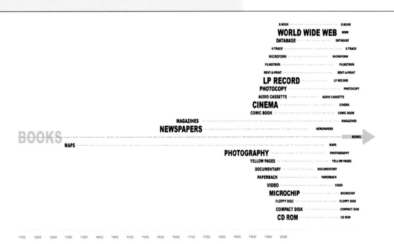

▲ **Analysis diagram**
A typical, analytical design diagram by Rem Koolhaas taken from the Seattle Public Library competition design process integrates text, data, and architectural form.

▶ **Hierarchical connection**
Service elements are pushed to the edge of this "room for repose" space. All are kept to a low height to maintain a visual connection with the raised element at the end of the space—the bath.

assembling familiar notions of these and simply arranging them in the space. A re-conceptualization of items found in a hotel room or bathroom is key to this project. Ask yourself: what is the essence of a shower, bed, or closet? What is the scale associated with each? How does a person interact with each?

Pragmatics alone will not be sufficient to solve this problem.

You must critically examine activities and associated rituals. Pay particular attention to body measurements, movement, routine, and scale. Due to the intimate nature of the space, consider materials carefully.

The dimensions of each wall will be determined by you, but the overall area is limited to 240 sq. feet (23 sq. meters). The smallest room dimension is 6 x 40 ft (1.82 x 12.2 m) and entry must always occur along the shorter wall. The view from the room will be to the south. A corner room occupies the southeast corner of the floor. The clear height in the room is 12 ft (3.65 m). The ceiling height may not be modified to less than 6 ft 8 in (2.02 m). Assume a roof thickness of 18 in (45.72 cm), a 12-in (30.5-cm) block exterior load-bearing wall and interior perimeter walls of the room at 6 in (15.24 cm) minimum. Walls added inside the room may be any thickness. You may change the floor level but entry into the room must be at one level. The floor is 42 in (1.06 m) thick and can be carved into up to 36 in (91.4 cm).

Starting the design process

Prepare yourself
Research includes conceptual analysis of activities associated with the program, diagramming movement, defining terms, historical research, and site documentation and analysis.

• Make a series of at least five sketches that represent the action of showering from the point of view of the person taking the shower. Think about movement, action, and especially the space required for the activities and rituals associated with the bathroom. Is there a particular sequence of action that can be conveyed in drawings?

• Define "ritual," "repose," "procession," "threshold," and "routine."

• Research body proportions and dimensions associated with bathing, relaxing, and minimal sleeping spaces.

• Ask yourself: what is a good height for sitting, leaning, or standing under things?

• Measure and document the space your body occupies while performing activities such as sitting, lying down, and reading.

Find historical precedents
Research bathrooms and hotel rooms. Consider other examples that deal with the challenge of a small space such as submarines, train cars, ships, or RVs.

Come up with ideas
Assess and analyze the research that you have accumulated. Compare it to elements in the brief. Try to articulate your own ideas from this research and analysis.

Explore your ideas
Consider how to separate or combine wet and dry spaces. How can a ritual be conveyed? Think about body movement through the space. Consider each element. For example: Sink—what is a sink? How tall? Where does the water come out? Where does it drain? What material? Why there? Is it also used for a shower? What is the difference? Is it a fixture or just a stream of water and a drain? Do you need a basin? If so, why? When do you use it? Upon entry? Apply these types of questions to every element in the room.

Focus on the relationship between fixtures, walls, and occupied space at the scale of the individual, while recognizing the significance of the body, its measurements, and its manner of movement.

Make three study models at ⅛ or ¼ scale, exploring different ideas. Create a series of sketch perspectives of views inside the spaces. Diagram your ideas. Keep them simple. Repeat these exercises throughout the process.

Sketch your ideas on trace or in your workbook. As you become more confident with your designs you can finalize it on vellum or Arches. The final set of drawings should be done at ⅜ scale and should include several sections, a plan, and various three-dimensional representations including a model.

▲ **Analysis diagram**
Record your design ideas in your sketchbook. Using a variety of representation techniques allows you to see the design from many points of view.

Veterans Memorial competition

Visit these

Jewish Memorial, Berlin

World Trade Center Memorial, New York

Websites

www.deathbyarchitecture.com

http://www.architectureweek.com/cgi-bin/calendar.cgi?d

Architecture design competitions are a means for architecture firms to acquire work and to achieve recognition. Competitions test both theoretical and practical design ideas. Young firms have the opportunity to compete for projects against more established firms. Unfortunately, competitions do not always provide the winners with the opportunity to build the winning project. Many competition hosts promote "ideas competitions" where a search for potential solutions is sought, but a confirmed interest in hiring or building the winning design is not clear.

What to expect

If you win a competition you may not win the design commission. The competition committee may select to build the second-place design. This may be due to expense, or an inability to build the winning project.

Competition brief

Design a Veterans Memorial for a University on its urban campus for up to 400 veterans.

Designers

Bauen Studio, winning entry and building commission.
www.bauenstudio.com

Memorial design requires an understanding of the problem at hand and a thorough knowledge of the existing site conditions.

The design for the Veterans Memorial looks to reclaim residual space on an urban campus using two strategies:
• to create a more formalized space, and
• to orchestrate a visual sequence within the campus environment to create connections between circulation and place.

By reclaiming this space from purely path and landscape elements, the memorial establishes clearly defined public spaces for the campus community and the general public to occupy.

Concepts

Three parallel elements organize the site; two spatial, one vertical. A black granite wall, contemplative garden, and public plaza are situated in a manner that allows for multiple readings of the space (see spatial diagrams on age 76). Interwoven within the garden is a paved ground plane abstracting the American flag with 13 strips and 50 lights. Birch trees to the north and east act as framing devices and help contain the space. Orchestrated views ensure a balance between the spaces being visually protected and appropriately open for ceremonial activities.

The black granite wall is double-sided. Its southern elevation faces the campus and serves as a backdrop to campus life, and the northern, contemplative, side reflects the intimate nature of war and loss. The public side features a laser-etched mural depicting iconic images of conflicts. The private side, however, is the focal point of the memorial, with each soldier represented by a single stainless steel plate. The 278 plates, which reflect the faces of the visitors, unite the dead with the living. They are designed to be touched and lifted; singly reflecting the individuality of each soldier, and collectively representing the bond soldiers form in times of war. The plates are organized randomly; however, the physical search for names on the wall allows the visitor potentially to engage intimately with the memorial and discover the common threads that tie fallen soldiers together.

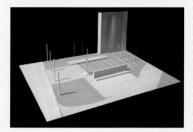

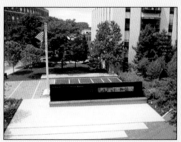

▲ **Range of representations**
A basswood model (top) was used to test the spatial clarity of the project. Continuity was emphasized by the limited number of model materials. Perspective representations (center) were used for fundraising efforts to present a realistic image of what was to be built. The bottom photograph shows the finished wall in context.

◀ ▼ **Conceptual inspiration**
The conceptual inspiration came from tree specimen identification tags (below left) and the tags worn by military personnel (left). The modified version (below right), congregated onto a black granite wall, can be touched and held by memorial visitors.

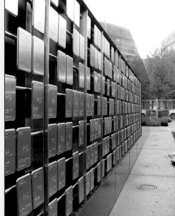

Architectural mock-ups

Representations of architectural ideas through scale models and drawings have limitations. The reality is that they are just that: representations.

The study of architecture is most often limited to the making of representations. Students often graduate without ever having constructed elements at full scale. The construction of full-scale objects and buildings in an academic setting can provide students with a unique opportunity to allow the representation of an idea, its size, scale, and spatial effects, to become reality.

Phase 1: Temporary plan installations

Beginning architecture students placed plan installations of their 240-sq. ft (23-sq. m) room for a traveler (see page 120) using temporary materials like tape, chalk, string, cans, light, and people. Leaving the environment of architectural representation meant that they could begin to understand, at full scale, the impact of their design. They tested the real dimensions of their projects, as a plan convention (there were no

implied vertical walls in most of the interventions) and how people interacted in and reacted to them. Once the installations were in place, people could walk through the full-scale designs to experience the relationship of the spaces in plan and begin to get a sense of the spaces they created.

Phase 2: Full-scale mock-up

Next, students constructed a full-scale mock-up of the "room for a traveler" project. The mock-up helped facilitate the students' spatial understanding of a design. The project was constructed using string and paper. This completed the students' translation of architecture as representation to architecture as real space. Structural, spatial, and material considerations became apparent in the full-scale mock-up. For many this was the first time they truly understood the spatial implications of their design.

▼ **Making space**
Students begin to construct the room for a traveler using rope and paper. This temporary space provides students a look at the processes associated with construction, teamwork, and space-making.

Schools

If you are interested in this type of investigation, from representation to construction, many architecture schools are now embracing a design/build component in their curricula. As schools continue to diversify their course offerings, you should verify your options for this design/build component with each school's stated curriculum.

Places to consider:
• Vermont School
• Rural Studio at Auburn University
• UNC Charlotte
• University of Washington
• Yale University—Building Project

Translating design skills to larger-scale projects
Even though this book is intended as an introduction to architecture representation and design, it also provides you with a foundation for designing responses to larger and more complex problems. Everything is applicable regardless of scope and scale. The myriad issues that you discover when thinking about seemingly simple elements such as the opening (see page 101) can be adapted to each element in architecture. When multiple elements come together you will be prepared for the resulting complexity.

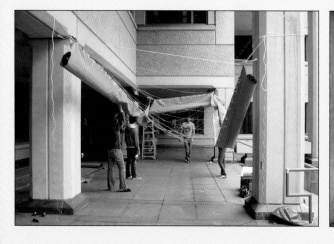

Accessing the profession

This chapter will clarify methods of accessing the profession, the current degrees available from architecture schools in the U.S., and the different program types. This information, along with general advice, can help you figure out your best path to joining the profession.

In addition, this chapter addresses some of the mysteries and myths about the architecture profession. They are perpetuated by television, lay people, the media, and with the common overuse of the term, *architect*.

A career in architecture

If you are interested in the profession of architecture or the built environment, there are a number of ways that you can get involved. The level of involvement will depend on your time commitment and your level of interest.

For those who are interested in a more advisory role, joining a community group that is directly involved with development in a neighborhood would be a good place to start. Most cities have neighborhood groups and CDC (Community Development Corporations) that are involved in the built environment. Neighborhood groups provide an advisory role to the planning commission or other local decision-making body. This type of group, depending on the neighborhood, can be very powerful.

CDCs, usually nonprofit groups, are more directly involved in building the neighborhood. They engage the local neighbors to shape community-led projects. They develop housing, open space, economic initiatives, and grassroots initiatives while creating an avenue for neighbors to communicate.

Websites

www.NAAB.org
www.archcareers.org
www.ncarb.org

These websites provide up-to-date information on the changing landscape of architecture education, internship requirements, and examination changes.

If your interest in the built environment exceeds a purely advisory role you can apply to architecture school. If you're not sure if architecture school is right for you, you can enroll in courses such as photography, sculpture, art, figure drawing, drawing, digital drawing, or drafting. Each course provides some aspect of creative thinking that is applicable in the architecture profession and will open your mind to more careful observation of the world, along with stimulating your creative energies.

In the U.S., you do not have to make a commitment to architecture immediately after high school. You can attend undergraduate school majoring in a discipline other than architecture, then enroll in an architecture graduate school. Many universities have undergraduate programs that allow you to experiment with the discipline before making a commitment.

Walter Gropius

Walter Gropius' (German b.1883 d.1969) involvement in the creation of the Bauhaus School of Design in Dessau, Germany, in 1919 is one of his most significant contributions to the Modern Architecture movement. He hired radical artists László Moholy-Nagy, Paul Klee, and Wassily Kandinsky, among others, to create an interdisciplinary school that brought together sculpture, industrial design, graphic design, textiles, and architecture. The Bauhaus embodied an energetic spirit of the times that embraced standardization and prefabrication to reinvent architecture's roles in a changing world.

Gropius emigrated to England and eventually moved to Cambridge, MA, where he taught at the Graduate School of Design at Harvard University. His teaching theories became the basis for many curricula in schools of architecture around the U.S. He later founded The Architecture Collaborative (TAC), which became a well-known and respected architecture firm.

Paths to licensing

To obtain a license in the U.S. you must first obtain a professional degree from an accredited school of architecture, complete IDP (Intern Development Program) training, and then take a seven-part licensing exam. The type of school you attend and the length of time needed to complete the required IDP training vary from individual to individual but the licensing exam is now consistent across the country.

B.S. in Architecture (pre-professional degree)
Attending a pre-professional architecture degree program allows you flexibility when you attend graduate school. Some coursework completed in the undergraduate program may be credited in the master's program, allowing you more opportunities to take elective courses.

B.S. in another degree Bachelor of Arts
Obtaining a four-year liberal arts degree before attending a master's degree program provides you with a broad-based education. This type of background enables you to select a graduate school based on your own educational desires. This path usually requires the longest time spent in graduate school.

Only professional degree programs in architecture are accredited by NAAB (National Architecture Accrediting Board). No undergraduate programs are accredited. Some undergraduate programs are part of professional programs, but don't get accredited separately. Graduate school can last anywhere between one and three years, depending on your undergraduate education.

Professional degrees, accredited

B. Arch (Bachelor of Architecture): this is an accredited 5-year professional degree.

M. Arch (Master of Architecture): this is an accredited first professional degree. The length of time you spend in a master's program depends in large part on the program you enroll in and your undergraduate education. Some schools provide credit for architecture courses taken during the undergraduate education, while others allow you to skip

entire semesters of the curriculum. This is the terminal degree in architecture.

Arch II, post professional: this is a second professional degree which is not an accredited degree.

D. Des (Doctor of Design): this is usually a multiyear advanced research degree.

PhD: this is the typical route for history/theory professionals.

Understand that picking an architecture school should not be about the quickest path to licensing. When selecting, think about your learning desires and the agenda of the school. Schools frame the methodology of design in many different ways. Find a school that complements your interests.

IDP (Intern Development Program) training
The training requirements for IDP usually take about three years to complete. Some schools provide 6-month internship opportunities that count toward IDP credits. Verify with each individual school.

Licensing Exam
This seven-part exam is usually taken after completing the IDP training, although some states allow you to enroll in IDP and ARE concurrently.

Myths

To be an architect, you have to be good at math.
You need to know basic geometry, algebra, and calculus. The required math course for most architecture schools is basic calculus. More important than having high-level math skills is having a creative, open mind.

To be an architect, you have to be a good artist.
Though knowing how to draw is certainly a valuable skill, it is not necessary to know when entering design school. More important is a willingness to learn and practice. Sketching and drawing are skills that can be taught. Good sketches are those that convey an idea or intention.

Architects make a lot of money.
Money shouldn't motivate you to become an architect. Starting salary from graduate school might be around $35,000–$45,000 depending on location, market, construction cycle, economy (local, national, and global), experience, and type of firm.

You must specialize in residential, commercial, or industrial design.
Design is a skill applicable to all scales and programs. You do not need to specialize in one area over another. Firms certainly get pigeonholed with designing certain types of projects and it takes an educated client to understand that architects who are well trained can design anything from furniture, to a building, to a city.

Manual vs. digital representation

Hand drawing provides the most direct way to transfer thoughts onto paper. The knowledge of how to construct three-dimensional images, to think using your hand on paper, and to analyze ideas through sketches provides an excellent foundation for architectural design.

In today's profession

- Know how to draw by hand, make models, and use digital programs.
- It is also important to know when to cross over between the two.
- Know how to sketch.
- Construct drawings by hand, then scan, render, and color.
- Physical models are still highly important design tools.

No matter how sophisticated digital software becomes, drawing by hand will always be necessary. It provides the most direct connection between your ideas and the page. Digital programs are tools of design just like the pencil. You need to learn when to use each, what their capabilities and limitations are, and determine which tools are best for the task. Knowing the variety of tools you have available allows you to stay in control of them.

Pros of digital drawing

- Multiple people working on drawings; a streamlined communication process
- Don't have to redraw an entire drawing when making changes
- Data assessment—solar charts, shadows, solar gain, structural issues; component parts available through building information modeling (BIM) software

Cons of digital drawing

- Output can be time-consuming
- Resolution between the computer screen and paper can be tricky
- Time to commit to output beautiful renderings

Frank Gehry

Frank Gehry (Canadian b. 1929) has become internationally recognized for his sculpturally composed buildings. His 1980s house renovation in Santa Monica, CA, made him an architecture superstar. His early work explored the use of inexpensive materials arranged in dynamic compositions. More recent work challenges the relationship between structure and skin. He revolutionized his design process through the use of three-dimensional digital modeling programs. Many of the technologies used by his firm were originally developed for the automobile and aerospace industries.

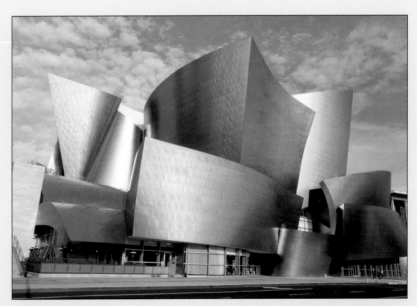

◀ **Sculptural composition**
Clad in non-conventional materials such as titanium, and questioning the formal relationships of floor, wall, and ceiling, Gehry's visceral works, such as the Walt Disney Concert Hall in Los Angeles, stand in powerful contrast to the rectilinear world in which they are situated.

SINGLE Speed DESIGN—from digital to fabrication

The "digital revolution" in architecture has allowed architects to quickly visualize complex geometries. But the jump from the screen to reality has not been so seamless: actual materials are less pliable than digital matter, resisting the translation from computer to reality. However, this bridge between what we design and what we build is an important next step to take to understand the real implications of digitally generated form. This large-scale model of a building, named the ACC Bench, was developed in the software CATIA. Factors like the flexural ability of plywood were input as generative rules for developing the curves. Finally the three-dimensional form was converted into a two-dimensional projection so that pieces that are curved in two axes could be cut from perfectly flat material. Interestingly, the orthographic projection became most important in making the leap from digital to reality.

Architects
SINGLE Speed DESIGN,
Jinhee Park and John Hong.

▼ Digital model
This screenshot of the CATIA model shows the construction components in 3D form. Factors such as plywood flexure and sheet size become generative rules for the curvilinear forms.

▶ 3D becomes 2D
The curvilinear forms were converted into 2D projections for templating.

▼ Model as furniture
By bending a thin material into a honeycomb structure, the structural concept was tested at a larger scale.

▼ From 2D to 3D
The 2D plywood forms were bent into the 3D volumes: full-scale digital templates allowed the simple translation from 2D to 3D.

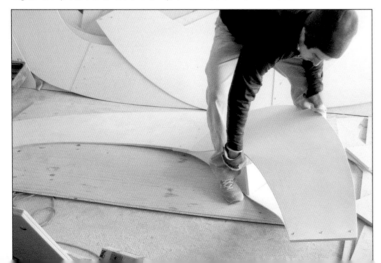

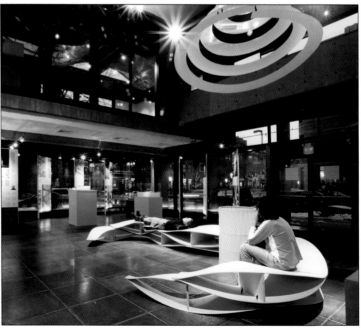

Your portfolio

A portfolio is a carefully composed visual record of your work. It is not necessarily a collection of all of your work, but a collection of projects that demonstrates a specific aspect of your designs. It is a high quality representation of your designs as well as your design process.

You will want to consider which projects to include in the portfolio and how much of the project to include.

▶ Portfolio presentation

The presentation of the portfolio content is important—you are not only presenting the content of each project, but the booklet itself is a reflection of you, your skills, and your aesthetics. Be concise; edit your work. Summarize project information in a clear, concise manner, keeping in mind that your audience has never seen nor heard of each particular project. Text and graphic explanations are important but should be brief.

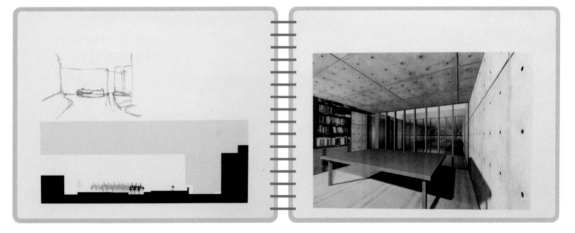

Depending on the audience, you may need one of the following portfolios:

Entry into architecture school: This portfolio would include any image that expresses your creativity and thought processes. Undergraduate admissions committees are not expecting architectural images in this portfolio.

Internship portfolio: This portfolio includes theoretical design projects from school and any additional relevant coursework like photographs, paintings, or sculpture.

Competition/grant/fellowship portfolio: Depending on the brief, this may emphasize one aspect of your work over another. If asked for, the portfolio may include only hand drawings or other hand crafted art work.

Professional portfolio: This portfolio includes finished images of your completed built work to show potential clients.

The content of each portfolio is very different, but with digital technology it is relatively easy to customize each portfolio. In your portfolio, you want to emphasize your ability to think through

problems; that is, highlight your process of design. As digital drawings and models become ubiquitous, your problem-solving skills set you apart from others applying for jobs, school, or grants. For process images include sketches, study models, process models, and diagrams. In addition, the process representations need to be supported by beautiful, well-crafted final presentation drawings and models. Show a variety of work in the portfolio, including orthographic drawings, three-dimensional images, and models represented in manual and digital methods.

Everything about your portfolio should be carefully considered, from the page size, layout, number of images per page and per project, location and size of images, and the amount and size of text. Fix or modify any drawings that do not meet an "excellence criteria" before including them in your portfolio. Establish a pattern for your portfolio; a system that is flexible but recognizable from page to page. Look at how books and magazines are organized. Consider creating a two-page spread versus a single-page layout. Think graphically about the booklet itself. The portfolio itself is a process, not just a collection of images.

Paper

Good paper takes ink better. Printing on standard paper sizes or smaller is more economical. Buying the right paper brand for your printer also makes for better printing. Heavyweight, coated matte, or glossy paper is good for portfolio printing.

Text and fonts

Text is visual information that must be considered as part of the composition. Keep text short. Pick fonts that are neutral and support the images. Don't center text; align it with an edge of an image. Never use title capitals. Never stretch text. Limit your use of bold and italics. When flipping through the portfolio, if you notice the layout before the content of a page, you should rework it. If you see the font before you see the content, find a new font. Use text wisely.

Organization

Put your best work at the beginning of the portfolio. You need to capture your audience's interest with your best design and best representations. Usually the first project is also one of your more complex projects. Generally provide 1–4 pages for each project. This will depend on the complexity of the project, the type of representations you have for the project and your audience.

Binding

There are several binding options, including spiral, wire, book, and velo. Spiral binding is a decent cheap option. Do not use cheap plastic binders or clear covers. There are excellent, durable binders made of leather or metal, but these can be cost-prohibitive when sending out multiple copies of your portfolio. Making your own binding with tape and fasteners is an option. If you want to add or delete pages from your portfolio, this will impact which binder you use.

Pattern

Place repetitive elements in the same location on each page. Just like in this book, each chapter has a number associated with it which is located in the same place, on the first page of the chapter, on the same side of the spread. Do not let the organization of the book disrupt the content of the book.

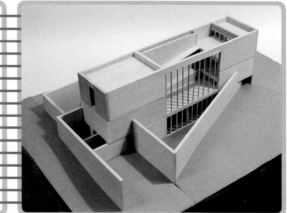

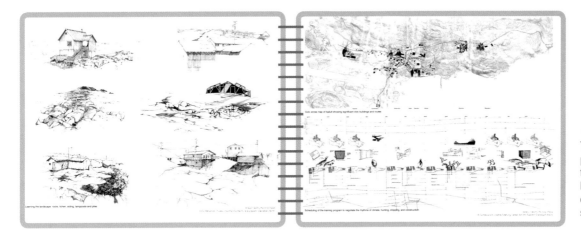

◀ **Highlighting your skills**
The quality of these portfolio pages is greatly enhanced by the quality and quantity of the linework in the sketches. Show off your best work and your best skills in your portfolio.

Diversity of work

Your portfolio is a collection of images that best represent your abilities and interests. Therefore, depending on the audience for the portfolio, including other types of non-architectural work is encouraged. You will need to maintain the same high standards for this work as you did for the architectural representations. Do not allow personal feelings or sentiment to sway your decisions in this area. For example, include photographs and artwork that are critical and compelling, but not because it has an image of your favorite pet. In general, include images of photography, graphic design, painting, sculpture, drawing, and furniture.

As you gain experience in the profession, start to include professional work in your portfolio. Remember to credit the appropriate firm and state your role in the design, drawing, or development of the images you present. Details from construction document sets are good to include, especially if you worked on, designed, or contributed to them in some way. Make sure you understand the content of the detail and

be prepared to explain it to someone else.

Documentation— what you will need

Do not include original work in your portfolio. You should either scan or photograph your artwork.

To document your models and charcoal drawings you will need a digital camera. If you plan to shoot inside, you will need lights and a black or white sheet as a backdrop. You can also shoot outside using the sun as your light source. Models cast shadows in the sun,

when oriented in the same direction, as the actual building would. Be aware that white materials have a tendency to get a little washed out in the sunlight. Overcast days provide gentle, flat light that is best for shooting.

To document your flat work you will need a scanner. You can get a small-format inexpensive scanner that allows you to scan your own work and piece it together in Photoshop. You can also find professional shops or copy stores that have large format scanners. These stores charge a range of

▼ **Using the page**
Your portfolio pages are similar to your drawing sheets. Use the white of the paper as part of your composition strategy. Note how the sectional perspective is tied directly into the white of the page.

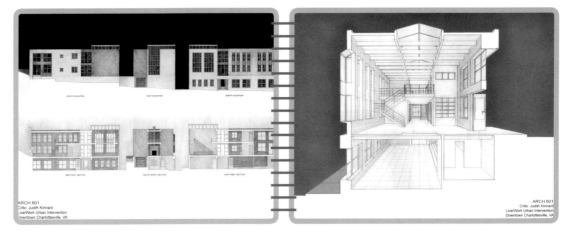

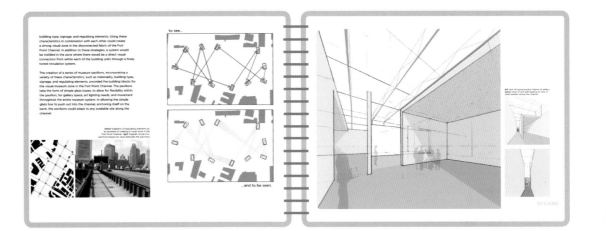

▶ Scale of images

The text on the lefthand page is considered as a single box and reads much like the other two blocks of images on the same page. The hierarchy of the spread is established on the righthand page with a large perspective image.

prices, usually based on square footage or area of the paper to scan. Images should be scanned at a minimum of 300 dpi in grayscale or color. Save the images as a jpeg or tiff; tiffs are better because they retain more information but for your portfolio either is fine.

You should document final design images and design process for a project so that in the future you have a greater selection of images from which to choose. Include idea sketches, study models, and process models as documentation.

You need not worry about your project or model being lost or destroyed if you have documented it thoroughly.

You will need access to digital programs like Adobe Photoshop to clean up images and Adobe InDesign to organize your page layouts.

Resumé

Your resumé is also a representation of you. It will be visually assessed in the same manner as your portfolio. It is therefore critical to select a good

font. Font choice for your resumé should be consistent with your portfolio. Do not allow the font to be the subject of the resumé— let the content be the focus. Be descriptive and clear about your previous jobs and your roles related to each job. Include all relevant work experience, interests, and goals. You can treat the resumé like a design problem: assess the existing logic and common formats, learn from them, and modify as needed. Update your resumé and portfolio often.

Read this!

Kane, John
A Type Primer
Prentice Hall, 2003

Lupton, Ellen
Thinking with Type: a Critical Guide for Designers, Writers, Editors, & Students
Princeton Architectural Press, 2004

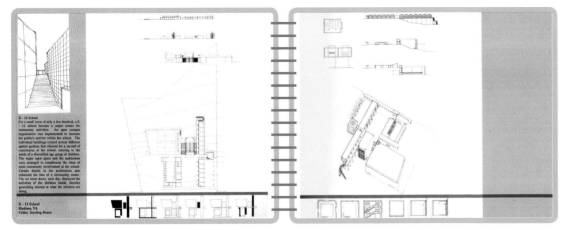

◀ Hierarchy of elements

These portfolio pages present a hierarchy of images with a variety of representation types exhibited. A sketch image on the left is typically repeated for each type of project and marks the start of each project.

Internships

Internships offer you the opportunity to engage with professionals in a variety of fields related to architecture. You may have the opportunity to work on all phases of a project from schematic design to construction administration. This position in a firm will allow you to see first-hand how different practices create and think about architecture.

One thing to understand when participating in an internship is that interns are at the low end of the hierarchy of the office. You are typically performing repetitive work during the beginning of your career. This should not discourage you—see the opportunity as part of this learning process and absorb everything you can about practice. In the office environment, realize that you are part of a team. Listen and give your opinion. Recognize that design is a small portion of the activities that go on in the office. Pay attention and ask lots of questions.

Finding an appropriate internship takes time and patience. You want to find a firm that allows you to grow and learn while investing in your education as an architect. Your first internships are usually filled with familiarizing yourself with how firms conduct business, office standards, and the firm's philosophy on design. You will become knowledgeable about local and national building codes and the general process of how to take a conceptual idea through to construction.

Interning in an architecture office is a required component of becoming an architect. A degree from an accredited Masters of Architecture program along with multiple years of work in an architectural office, under the guidance of a licensed architect, constitute a component part of the licensing process.

The years in an office, working as an intern, prepare you for many of the practicalities of the architecture profession. Your internship plays a critical role in what and how you learn about the profession in more detail.

Look for firms that allow you the most flexibility with work types. You do not want to be building models or completing red lines for three years. Will the firm provide you with opportunities to visit job sites, attend job meetings, or investigate construction or material techniques that are not commonplace in the office? Your responsibility will grow as you gain more experience.

▲ **The intern's role**
During the process of design, interns assist in both manual and digital methods of representation, including drawing on the computer and constructing models for review by project architects, clients, and contractors.

Working for a nonconventional office—Design Corps

Cause:

North Carolina is home to one of the largest farmworker populations in the U.S. According to the National Center for Farmworker Health, migrant farm labor supports a $28 billion fruit and vegetable industry in the U.S., the majority of which is hand harvested. Despite their integral role in the food economy, migrant and seasonal farmworkers are some of the most economically disadvantaged people in the U.S.—many earn less than $10,000 annually and over 60% of families have below-poverty-level incomes. Low income correlates to poor housing conditions, which are often substandard or nonexistent. Even "Gold Star" growers, who are providing some of the best housing options, only meet state codes which require only one wash tub for every 30 workers, one shower for every 10 workers, one toilet for every 15 workers, and do not require mattresses or telephone access in case of emergency. Overcrowding, inadequate sanitation and unsafe structural defects are just some of the realities of farmworker housing.

Design Corps has developed the Farmworker Housing Program to build quality new housing on farms where there is a need. The program is a true partnership that involves the farmers and the workers in the process of developing the design and making it affordable to both through the assistance of federal funds, which are secured by Design Corps. This project, a pilot for housing in North Carolina, is designed for former farmworkers who have lived in the challenging farmworker housing conditions and are themselves determined to set higher standards for farmworker housing.

Method:

Design Corps' vision is realized when people are involved in the decisions that shape their lives, including the built environment. This design process involves a synthesis of ideas from three major stakeholders; the farmer, the farmworker, and the State Housing Finance Agency. This participatory process is composed of meetings, surveys, discussions, and is integrated with material and manufactured housing research to provide housing options that are affordable, durable, and sustainable.
www.designcorps.org

Design Corps design process components:

1. Participatory process
Farmworker surveys, site visits, and research are key components in their participatory process. Their vision is realized when people are involved in the decisions that shape their lives, including the built environment.

2. Healthy housing
The ambition is to improve the lives of farmworkers through design that responds to principles of decent and healthy housing, consideration for cultural customs, and daily routines. Housing conditions directly affect farmworker health, sanitary conditions, and nutrition.

3. Manufacturing process
This project employs the benefits of manufactured housing, including economy, speed, and minimization of waste. In recognition of some of the limitations of manufactured housing, including standard dimensions and material options, this project is a synthesis of a manufactured unit and a site-built portion that integrates the manufactured unit into the site. Addressing issues of solar orientation, cross ventilation, and square footage, the site built portion is completed by a General Contractor. Working with a General Contractor allows for modifications to the manufactured portion and introduction of as many energy and sustainable material strategies as possible.

4. Sustainability
The design integrates strategies that respond to issues of sustainability, economy, and durability. Some strategies include passive solar, light-colored enclosure systems, cross-ventilation, and low-flow fixtures. An outdoor garden is designed to assist with solar gain and also to address and ameliorate conditions of food insecurity in farmworker populations.

Impact:

The project outcome addresses the cause in a significant manner: How does the solution function in context? What changes or resulting outcomes were documented in participants, communities and/or audiences?

▶ **Design for others**
This shed for FEMA trailer residents on the Gulf Coast was designed and built by Design Corps after Hurricane Katrina in 2005.

Timeline of architects

RENAISSANCE TO INDUSTRIAL REVOLUTION

1300	1400	1500	1600	1700	1800	1900

Filippo Brunelleschi 1377–1446

Leon Battista Alberti 1404–1472

Leonardo da Vinci 1452–1519

Albrecht Dürer 1471–1528

Michelangelo 1475–1564

Raphael 1483–1520

Andrea Palladio 1508–1580

Gian Lorenzo Bernini 1598–1680

Francesco Borromini 1599–1667

Claude-Nicholas Ledoux 1736–1806

Thomas Jefferson 1743–1826

Sir John Soane 1753–1837

Karl Friedrich Schinkel 1781–1841

INDUSTRIAL REVOLUTION TO PRESENT

1800	1900	2000

Joseph Paxton 1801–1865

E.E. Viollet-le-Duc 1814–1879

Henry Hobson Richardson 1838–1886

Otto Wagner 1841–1918

Antoni Gaudí 1852–1926

Louis Sullivan 1856–1924

Frank Lloyd Wright 1867–1959

Charles Rennie Mackintosh 1868–1928

Adolf Loos 1870–1933

Piet Mondrian (artist) 1872–1944

Walter Gropius 1883–1969

Ludwig Mies van der Rohe 1886–1969

Le Corbusier 1887–1965

Antonio Sant' Elia 1888–1916

Hugh Ferris (illustrator) 1889–1962

El Lissitzky 1890–1941

Alvar Aalto 1898–1976

Louis I. Kahn 1901–1974

Marcel Breuer 1902–1981

Giuseppe Terragni 1904–1943

Carlo Scarpa 1906–1978

Charles (1907–1978) and Ray (1912–1988) Eames

Oscar Niemeyer 1907–

Eero Saarinen 1910–1961

Paul Rudolph 1918–1997

Frank Gehry 1929–

Aldo Rossi 1931–1997

Peter Eisenman 1932–

Richard Rogers 1933–

Alvaro Siza 1933–

Richard Meier 1934–

Michael Graves 1934–

Norman Foster 1935–

Raphael Moneo 1937–

Renzo Piano 1937–

Robert A.M. Stern 1939–

Tadao Ando 1941–

Tod Williams Billie Tsien 1943–

Morphosis 1944– Contemporary firm date 1972

Rem Koolhaas 1944–

Steven Holl 1947–

Zaha Hadid 1950–

Douglas Darden 1954–1996

Archigram **1960s**

Machado and Silvetti
Contemporary firm date 1974

Patkau (Patricia and John)
Contemporary firm date 1978

Glossary

Additive design
The joining of two planar elements to create space.

Analysis
A reductive process; a simplification of one idea in isolation.

Assisting planes
Planes created in perspective construction to facilitate the transfer of height measurements to non-coplanar surfaces.

Axial
A strong single relationship between parts that are aligned with one another along an axis. Radial and linear are two types of axial relationships.

Axonometric
An objective three-dimensional representation that combines plan and elevation information on a single, abstract drawing. It depicts a view that cannot ever be perceived in real space. The axon is measured along three axes in three directions and its ease of construction is due to the fact that parallel elements remain parallel. There are many types of axonometric drawings, including paraline projection, (plan) oblique projection, and isometric.

Composition
The arrangement of parts including their placement, quantity, geometry, and scale in relationship to themselves and to the whole.

Cone of vision
The conical volume of 60 degrees taken from the eye of someone located at the station point in perspective construction. Distortion begins outside the 60-degree cone.

Construction lines
The lightest lines in a drawing, used to ensure alignments between elements in a single drawing or between two drawings such as plan and section. Typically these lines are visible when viewed up close but disappear at a distance of 3 ft (90 cm) or farther.

Cut lines
In plan or section these are the darkest lines representing cut elements.

Diagram
The process of visually abstracting a building or object into its main ideas.

Elevation
A two-dimensional drawing depicting a vertical cut outside of an object, looking toward its face. Imagine a plane perpendicular to the ground that does not intersect with the building or object. Elements outside of the object, for example the ground, are rendered as a cut line. The object or building itself is not cut through; all of the lines related to the building are elevation lines. Elevation lines vary with distance from the projected picture plane. Elements farther away are lighter than those that are closer.

Elevation lines
These delineate between spatial edges. Typically elevation lines farther away from the cut are constructed with a lighter lineweight than those surfaces closer to the cut. All elevation lines are lighter than cut lines.

Enfilade
The alignment of openings between rooms that provides a view along the length of the adjacent rooms. The Shotgun, a typical U.S. vernacular-style house, is an excellent example of the enfilade condition.

Entourage
Elements like people, cars, trees, bushes, and other landscape elements added to drawings to provide scale, character, and texture.

Figure-ground plan
A diagram of the building fabric which uses black and white to depict buildings and space, respectively. No other delineations are made—no streets or pavements, for example. It provides a method to understand patterns of the built environment and the relative size and shape of figural spaces.

Hidden lines
These are dashed lines that depict objects or planes that are technically not visible in a drawing. For example, hidden lines are used to show objects above the cut line in plans.

Hierarchy
The emphasis of one element over all others; useful for diagramming.

Horizon line (HL)
In perspective construction, the horizon line is the height of the viewer standing at the station point.

Isometric
A type of axonometric projection that provides a lower-angle view than a plan oblique. Equal emphasis is given to the three major planes. The isometric does not allow for construction to be extruded directly from the existing plan but requires the reconstruction of the plan with its front corner being drawn at 120 degrees instead of 90 degrees. Vertical information is typically true to scale. The measurements are transferred along the receding 30 degree axes.

Measuring line (ML)
In perspective construction, the vertical line established from the intersection of the picture plane and the plan. All measurements must be taken from this line.

Negative space
The residual, or leftover, space outside of an object or building. Negative space should be considered as a design opportunity.

One-point perspective
A type of perspective construction with a single vanishing point.

Orthographic projections
Two-dimensional abstractions of three-dimensional objects; orthographic projections include plan, section, and elevation.

Parti
The graphic depiction of the main idea, or concept, of a project.

Perspective
Perspective construction is a subjective representation that aims to translate the experience of a three-dimensional space, building, or object onto a two-dimensional surface. It is a prescriptive single point of view. A perspective cannot mimic the complexity of the human eye, which perceives peripheral and binocular vision, but it is an acceptable representational tool.

Picture plane (PP)
In perspective construction, a transparent plane, intersecting the cone of vision, that receives the projected perspective image and is perpendicular to the viewer. In the two-dimensional construction of perspective its location helps to determine how large the perspective image will be.

Plan
A horizontal cut through an object, building, or space, typically directed down. Imagine a plane, parallel to the ground plane, intersecting a building or object. The cut represents those elements sliced by the plane and is rendered with the darkest lineweight. There are a number of types of plan drawings including site plan, floor plan, roof plan, reflected ceiling plan, and figure-ground plan.

Poche
This word comes from the French pocher meaning "to make a rough sketch." It is typically understood to be the solid elements in a building rendered in solid black.

Profile lines
These define the edges between an object or plane and open space in axonometric drawings.

Program
The uses of a building or space.

Proportion
The compositional relationship between parts.

Section
A vertical cut through an object, building, or space. Sections describe vertical relationships and help define the spatial characteristic of the building. Imagine a plane, perpendicular to the ground plane, intersecting a building or object. As in the plan, the information that is cut by the plane is rendered using the darkest line weights.

Sightlines
In perspective construction, the projected lines connecting the eye to the object being viewed. The perspectival image occurs where the sightlines cross the picture plane.

Station point (SP)
The location of the viewer in perspective construction.

Subtractive design
The method of carving into a solid element to create space.

Threshold
The point at which two spaces or elements join together.

Two-point perspective
A perspective construction with two vanishing points.

Vanishing point (VP)
The point (or points) at which parallel elements in a perspective converge.

Resources

Bibliography

Brown, G. Z., and Mark DeKay. *Sun, Light & Wind Architectural Design Strategies*. 2nd ed. Hoboken, NJ: John Wiley & Sons, Inc., 2001.

Ching, Francis D. K. *Architecture Form, Space, and Order*. 2nd ed. Hoboken, NJ: John Wiley & Sons, Inc., 1996.

Ching, Frank. *Design Drawing*. John Wiley & Sons, Inc., 1997.

Fraser, Iain, and Henmi, Rod. *Envisioning Architecture: An Analysis of Drawing*. Hoboken, NJ: John Wiley & Sons, Inc., 1994.

Laseau, Paul, and Tice, James. *Frank Lloyd Wright: Between Principle and Form*. New York, NY: Van Nostrand Reinhold, 1992.

Uddin, M. Saleh. *Hybrid Drawing Techniques by Contemporary Architects and Designers*. Hoboken, NJ: John Wiley & Sons, Inc., 1999.

Yee, Rendow. *Architectural Drawing: A Visual Compendium of Types and Methods*. 2nd ed. Hoboken, NJ: John Wiley & Sons, Inc., 2003.

Pressman, Andrew: Editor-in-chief. *Architectural Graphic Standards*. Hoboken, NJ: John Wiley & Sons, Inc., 2007.

Clark, R. and Pause, M. *Precedents in Architecture*. Van Nostrand Reinhold, 1996.

Websites

www.greatbuildings.com

www.mapjunction.com

http://nolli.uoregon.edu

www.deathbyarchitecture.com

Architecture Organizations

The American Institute of Architects (AIA)

The professional organization that represents American architects. With over 80,000 members, the AIA supports high professional standards (code of ethics) and provides access to resources, education, and advice.
1735 New York Avenue, NW
Washington, DC 20006-5292, USA
1-800-AIA-3837, www.aia.org

American Institute of Architecture Students (AIAS)

This nonprofit, student-run organization is the voice of architecture and design students. The AIAS promotes both education, training, and professional excellence.
1735 New York Avenue, NW
Washington, DC 20006, USA
202-626-7472, www.aias.org

Association of Collegiate Schools of Architecture (ACSA)

Founded in 1912, over 250 schools in the U.S. and Canada now make up the membership association of the ACSA. The promotion of quality architectural education is the main focus of the body.
1735 New York Avenue, NW
3rd floor
Washington, DC 20006, USA
202-785-2324, www.acsa-arch.org

National Architectural Accrediting Board (NAAB)

NAAB is the accrediting agency for professional architecture degree programs. Available on their website is the most up-to-date list of accredited degree programs in the U.S. and Canada.
1735 New York Avenue, NW
Washington, DC 20006, USA
202-783-2007, www.naab.org

National Council of Architectural Registration Boards (NCARB)

The mission of NCARB is to safeguard the health, safety, and welfare of the pubic. NCARB works on professional practice standards as well as applicant registration standards.
1801 K Street, NW, Suite 1100-K
Washington, DC 20006-1310
202/783-6500, www.ncarb.org

Related Organizations

The American Architectural Foundation (AAF)

The AAF educates the public about the importance of architecture and design on improving lives.
1799 New York Avenue, NW
Washington, DC 20006
202-626-7318, www.archfoundation.org

www.archcareers.org

This website, part of the AIA, lays out the procedures to become an architect. They highlight the 3 E's of the process: Education, Experience, and Examination.

State Architecture Board of Registration

www.ncarb.org/stateboards/index.html
Individual state boards will provide the requirements for licensing in that state. Registration, examination, and practice requirements are regulated by this agency.

U.S. Architecture schools accredited with NAAB

Academy of Art University
Andrews University
Arizona State University
Auburn University
Ball State University
Boston Architectural College
California College of the Arts
California Polytechnic State University,
 San Luis Obispo
California State Polytechnic University, Pomona
Carnegie Mellon University
Catholic University of America
City College of the City University of New York
Clemson University
Columbia University
Cooper Union
Cornell University
Drexel University
Drury University
Florida A&M University
Florida Atlantic University
Florida International University
Frank Lloyd Wright School of Architecture
Georgia Institute of Technology
Hampton University
Harvard University
Howard University
Illinois Institute of Technology
Iowa State University
Judson College
Kansas State University
Kent State University
Lawrence Technological University
Louisiana State University
Louisiana Tech University
Massachusetts Institute of Technology
Miami University
Mississippi State University
Montana State University
Morgan State University
New Jersey Institute of Technology
New York Institute of Technology

NewSchool of Architecture
North Carolina State University
North Dakota State University
Northeastern University
Norwich University
Ohio State University
Oklahoma State University
Parsons School of Design/New School University
Pennsylvania State University
Philadelphia University
Polytechnic University of Puerto Rico
Prairie View A&M University
Pratt Institute
Princeton University
Rensselaer Polytechnic Institute
Rhode Island School of Design
Rice University
Roger Williams University
Savannah College of Art and Design
Southern California Institute of Architecture
Southern Polytechnic State University
Southern University and A&M College
State University of New York at Buffalo
Syracuse University
Temple University
Texas A&M University
Texas Tech University
Tulane University
Tuskegee University
Universidad de Puerto Rico
University of Arizona
University of Arkansas
University of California at Berkeley
University of California at Los Angeles
University of Cincinnati
University of Colorado at Denver/Boulder
 & Health Sciences Center.
University of Detroit Mercy
University of Florida
University of Hartford
University of Hawaii at Manoa
University of Houston

University of Idaho
University of Illinois at Chicago
University of Illinois at Urbana-Champaign
University of Kansas
University of Kentucky
University of Louisiana at Lafayette
University of Maryland
University of
 Massachusetts-Amherst (Candidate)
University of Miami
University of Michigan
University of Minnesota
University of Nebraska, Lincoln
University of Nevada, Las Vegas
University of New Mexico
University of North Carolina at Charlotte
University of Notre Dame
University of Oklahoma
University of Oregon
University of Pennsylvania
University of South Florida
University of Southern California
University of Tennessee, Knoxville
University of Texas at Arlington
University of Texas at Austin
University of Texas at San Antonio
University of Utah
University of Virginia
University of Washington
University of Wisconsin-Milwaukee
Virginia Polytechnic Institute and State University
Washington State University
Washington University in St. Louis
Wentworth Institute of Technology
Woodbury University
Yale University

Index

Credits

Quarto would like to thank and acknowledge the following for supplying the illustrations and photographs reproduced in this book.
Key: a above, b below, l left, r right.

Page 12 Charles Bowman/Robert Harding World Imagery/Corbis
Page 13 Richard Einzig/arcaid.co.uk
Page 15ac Private Collection/ Archives Charmet/The Bridgeman Art Library/©FLC/ADAGP, Paris and DACS, London 2007
Page 17 Library of Congress
Page 18c Alinari Archives/Corbis
Page 18ar Bettmann/Corbis
Page 18b Library of Congress
Page 19al Alinari Archives/Corbis
Page 19ar Rembrandt Harmensz. van Rijn Graphische Sammlung Albertina, Vienna, Austria/The Bridgeman Art Library
Page 19 Foster + Partners
Page 24 Patkau Architects Inc
Page 33 German Ariel Berra/Shutterstock
Page 37 Library of Congress
Page 40 Library of Congress
Page 41 Álvaro Siza
Page 45 Courtesy Steven Holl
Page 51t Hunterian Museum and Art Gallery, University of Glasgow

Page 68al Bettmann/Corbis
Page 68bl Bettmann/Corbis
Page 68br Bettmann/Corbis
Page 75 Courtesy Eisenman Architects
Page 79 Courtesy Richard Meier & Partners Architects LLP
Page 80 Eileen Tweedy/Victoria and Albert Museum London/The Art Archive/©DACS 2007
Page 84 Bettmann/Corbis
Page 100ar Michael Hare/Shutterstock
Page 100c Shi Yali/Shutterstock
Page 100bl Edifice/Corbis/©FLC/ADAGP, Paris and DACS, London 2007
Page 103 Angela Hornak/Corbis
Page 102 Dennis Gilbert/Esto/View
Page 102 Jeff Goldberg/Esto/View
Page 105 Richard Bryant/Arcaid/Corbis/©DACS 2007
Page 108 Copyright 2007, Estate Douglas Darden
Page 115br Lewis.Tsurumaki.Lewis, Upside House, 2001 sectional perspective
Page 120 Seattle Diagram, Office for Metropolitan Architecture
Page 126br Oscar White/Corbis
Page 128bc Kurt Krieger/Corbis
Page 129 Single Speed Design, www.ssdarchitecture.com
Page 135br Design Corps

The author would like to thank and acknowledge the following for supplying other illustrations reproduced in this book.
Chapter 1: Billy Algiere (student), Brian Gregory (student), Allyson Abbott (student), Michael Mandeville (student), Kristin Kowalik (student), Marc Roehrle (architect), Tony Wen (student), Pooneh Fassihi (student), Rob Levash (student), Caitlin Navin (student), John Hong (architect), Jinhee Park (architect), Chris Aubin (student), Kyle Jonasen (student), Aleta Budd (student), Gina Siciliano (student), Mariana Creatini (student), Da Tha Nguyen (student). **Chapter 2:** Marc Roehrle (architect), David Gamble (architect), Eunice Park (student), Mary Hughes (painter), Danielle McDonough (student), Tony Wen (student), Anisha Grover (student), Steve Fellmeth (student). **Chapter 3:** Marc Roehrle (architect), Matt deCotis (student), Kristin Kowalik (student), Sarah Laliberte (student), Andrew Johnson (student), Heather Card (student), Allison Browne (student), Ryo Inoue (student), Angela Giavroutas (student), Fatiya Diene (student), Gina Siciliano (student), Brienne Frey (student), Hokchi Chiu (student), Kathryn Pakenham (student), Bridgette Treado (student), Chris Aubin (student), Michael Mandeville (student), Lauren Miggins (student), Eunice Park (student), Steve Fellmeth (intern), Brian Gregory (student), Renee McNamee (student), Pooneh Fassihi (student), Kyle Jonasen (student). **Chapter 4:** Marc Roehrle (architect), Michael Mandeville (student), Allyson Abbott (student), Martha Foss (architect), Mariana Creatini (student), Da Tha Nguyen (student), Brian Gregory (student), Brett Pierson (student), Renee McNamee (student), Brienne Frey (student), Andy Lay (student), Kris Loper (student). **Chapter 5:** Marc Roehrle (architect), Brienne Frey (student), Luke Palma (student), Sierra Sharon (student), Chris Minor (student), Amit Oza (student), Edgar Veliz (student), Brian Andrews (architect), Allison Abbott (student), Anisha Grover (student), Brett Pierson (student), Mike Carroll (student), Ben Stracco (student), Dave Swetz (student). **Chapter 6:** Brian Andrews (architect), Steve Fellmeth (intern), Kathryn Pakenham (student), Marc Roehrle (architect), Kornelia Znak (student), Anisha Grover (student), Renee McNamee (student), Elizabeth Maher (student), Randa Ghattas (architect), Laura Boyle (student), Nawaz Kamthewala (student), Mariana Creatini (student), Da Tha Nguyen (student), Karina Melkonyan (student), Kathleen Patterson (student), Phil Chaney (student), Tiffany Yung (student), Brett Pierson (student), Mitch Muller (student), Brienne Frey (student), Allison Browne (student), Mike Carroll (student). **Chapter 7:** John Hong (architect), Jinhee Park (architect), Phil Chaney (student), Marc Roehrle (architect), Sarah Roszler (architect), Gina Siciliano (student), Andrew Grote (architect), Ben Wan (student), Bryan Bell (architect).

Special dedication to my husband: Marc Roehrle
Additional thanks goes to Michael MacPhail, Andy Grote, Mary Hughes, Mark Pasnik, Lucy Maulsby, and Chris Hosmer, my friends and colleagues, who provided frank and informative discussions about drawing and design. Without the unwavering support and inspiration from my husband, Marc Roehrle, this book would not have been completed. I would also like to thank my family for their encouragement throughout the process.

Thanks to all my students over the years and especially to my spring 2007 manual representation class: Allison Browne, Hokchi Chiu, James Mcintosh, Renee McNamee, Karina Melkonyan, Lauren Miggins, Kathleen Patterson, Brett Pierson, Stephanie Scanlon, Tony Wen, Tiffany Yung, Kornelia Znak.